PHOTOGRAPHY:
THE EARLY YEARS

PHOTOGRAPHY: THE EARLY YEARS

A Historical Guide for Collectors

George Gilbert

HARPER & ROW, PUBLISHERS

NEW YORK

Cambridge London
Hagerstown Mexico City
Philadelphia São Paulo
San Francisco Sydney

1817

FIRST EDITION

Designer: Michael Perpich

Library of Congress Cataloging in Publication Data

Gilbert, George, 1922-
 Photography: the early years.

 Bibliography: p.
 Includes index.
 1. Photography—History—19th century. I. Title.
TR15.G55 770′.9′034 78–20163
ISBN 0–06–011497–5

80 81 82 83 84 10 9 8 7 6 5 4 3 2 1

CONTENTS

INTRODUCTION

T he history of inventions is a chronicle of the effort to solve one
or another of life's vexing problems. Only rarely does an ex-
perimenter's inadvertent discovery replace the trial-and-error
method. Edison's search for the filament for the electric light bulb and
the preflight kite tests of the Wright brothers until that day when one
dared to ride the sail aloft over the sands are the rule.

More than half a century before the electric light, gas-powered vehi-
cles and air flight, the invention of photography resulted from a number
of independent researches in several countries at the beginning of the
nineteenth century. Practical results had been achieved in both France
and England by the 1830s. By the 1840s the world had become excited-
ly aware of a number of systems vying for attention in the salons and
the exhibition halls. By the 1850s the art/science of photography was
taking quantum leaps into color theory, three-dimensional (stereo) pho-
tography, unique mass production and incredible miniaturizations and
enlargements. Photography, in the form of low-cost likenesses of family
members, reached into every home during the lifetimes of the inventors
of those images obtained on metal, paper, glass, porcelain, ivory—even
patent leather. In a world of sailing ships, whale oil for home lighting,
windmill and waterwheel power for milling and peat or wood stoves for
home heating, the presence of the photograph in the homes of the poor-
est farmers and factory workers was astonishing.

It has been pointed out with pride by American scientists, physicists
and their down-the-line marketing agents that from the time of the in-
vention of the transistor in the 1950s to the time when most American
homes owned a portable transistorized radio was only a thousand days.
Given the absence of modern communications and the limitations of
transportation in the 1840s, it is all the more to the credit of the inge-

nious men and women who pioneered photography that nearly every major European city boasted a photographic gallery within months of the August 1839 announcement of the Daguerre process. And within a year this first practical process of photography was serving a social role in every civilized country of the world.

Today's photographic generation, weaned on the filmed and taped images that dance on the screens of home television sets, the classroom documentary slide or film projector and the community drive-in theatre, tends to group together all early forms of photography under the single generic, *tintype*. The intent of this book is to give the tintype the honor it deserves and to clarify the role of the processes that preceded and succeeded it.

Art collectors and historians have been combing the attics of private homes and the trunks at local historical societies in their search for those early images that document the roots of the photographic scene and the lives of the nineteenth-century citizenry. A plethora of images has survived the ravages of time primarily because the earliest processes required extreme protective encasements from the moment of their creation. Daguerreotypes and ambrotypes, along with some ferrotypes, have been handed down from generation to generation in their molded or leather cases. Millions of the earliest cartes-de-visite and the later tintypes were protected in sturdy family albums.

As it has become clear that some of the earliest photographs have more than curiosity value for historians and sociologists, it becomes necessary to understand and appreciate the technical, cultural and social differences between the technologies of daguerreotypy and ambrotypy, the Talbotype and the melainotype.

I am happy to credit my editor, Nahum J. Waxman, with suggesting the concept of this book; and to acknowledge the research assistance of such stalwart photo-history enthusiasts as Allen and Hilary Weiner, Matthew R. Isenberg, Eugene H. Rifkind, Pearl Korn, Cliff and Michelle Krainik, Stewart Wilensky, Jerome and Shirley Sprung. I was helped in locating a number of key photographs by staff members of the Museum of the City of New York, the New-York Historical Society, the Library of Congress and the New York Public Library.

I wish to thank members of the Photographic Historical Society of New York who provided their files, homes and hospitality to make this work possible. Their magnificent support and kindnesses constitute a reward of its own sort.

George Gilbert,
New York City
and Lake Copake

PHOTOGRAPHY: THE EARLY YEARS

THE DAGUERREOTYPE
The Marvelous Mirror

The invention of photography had nothing to do with the invention of the camera. Cameras had existed in a number of forms from the sixteenth century, and most of the gentlemen scientists of France and England who sought to make various chemicals respond in a controlled way to the action of light already owned one or more of them.

In the sixteenth century artists had devised for themselves a variety of optical instruments to guide their draftsmanship. The optical knowledge was there because the lensmakers had already created telescopes, which permitted the eye to see magnified images of the moon and the planets, and microscopes, which brought to the eye large, bright images of items too small to be seen unaided.

It was child's play, then, to develop a tool for the artist who needed the accuracy of the lens to check field perspective. The lens system did not enlarge a distant plant or a minute amoeba; it reduced the size of all before it, bringing an entire countryside down to the dimensions of a small windowpane. Further, the image could be projected onto a distant blank white wall or a white sheet of paper.

In the artist's box the image was directed by means of a mirror to a pane of glass with a ground-glass (matte) surface. There the artist could see the entire world reduced to a miniature view, one that he could trace to assure accurate linear perspective, the distant steeple's height appearing in exact proportion to the size of a nearby tree or garden wall. Of course, when the light was dim at day's end, the image within the *camera obscura,* the lensed box, also dimmed. If only the artist could "fix" the image onto the ground glass or onto tracing paper; then he could continue his work on into the night.

Examples were already known of light's ability to "fix" itself upon fabrics, leather, wood and other materials. Sunlight, for instance, was known to lighten dyed objects exposed to it; thus the sun-bleached curtains that the homemaker views with dismay. Thus, too, the way that fallen leaves on the forest floor, blocking the light, leave their own shape and shadow on those below them.

In the eighteenth century experimenters sought the right blend of chemicals and sunlight that would affix an image on a prepared surface. The first major

practical process followed the breakthrough in France that began with the work of a chemical experimenter, Joseph Nicéphore Niépce (1765–1833), and ended with the success of his partner and survivor, the artist-showman-experimenter Jacques Louis Mandé Daguerre (1787–1851).

While most early scientists sought a process that involved an instant response to sunlight, Niépce and Daguerre were working out a process that was to achieve success only as a two-step procedure: first the creation of a potential image, then the realization—what we call today developing.

From the start of their individual efforts, undertaken without knowledge of each other and in different parts of France, the two were readying plates to be fitted into the camera obscuras, hoping for sunlight's action to generate an immediately visible image. In 1826 Daguerre learned of Niépce's partial successes when Chevalier, a Parisian lensmaker, advised him that Niépce had ordered camera obscuras to carry out experiments that were similar to those Daguerre had undertaken earlier. Niépce's major work had been with a light-sensitive material, iodide of silver, which darkened on exposure to light.

The two experimenters corresponded for some years about their common goals, but it was some time before Daguerre found a way to make practical use of the iodides. In 1835, two years after Niépce's death, Daguerre noticed one day that vapor from a few drops of mercury that had leaked from a broken thermometer had caused the appearance of an image on an exposed plate stored overnight in a cabinet. Inadvertently he had discovered the principle of the development of an exposed (latent) image.

The basic principle of the techniques of both Niépce and Daguerre was that once the camera obscura had been aimed at a subject, a chemically sensitized metal plate was inserted into the camera and, for a brief period, exposed to the light that was allowed to enter only through the lens. Many experiments were conducted before an image could be recorded on the plate. The second step, taking the exposed plate back into a light-protected work area (the darkroom) for further processing, became the basis of most practical photographic processes for years to come.

In the two-step daguerrean process, the light-sensitive chemicals remained on the exposed plate where no light or only a very small amount of light had fallen; where bright light had reached, the chemicals could be washed off or otherwise removed. This variable alteration of the chemical coating permitted an image to be formed on the highly polished, mirrorlike surface of the silver plate. For the image to be visible, the mirror surface had to reflect a dark background. Seen against a white background, the mirror revealed only a veil of the negative image, with dark hair showing white and light faces appearing dark on the shimmery metallic surface of the plate. For many, to this day, the marvelous and delicately formed daguerreotype image offers a still unmatched perfection.

●ıı● THE PERIOD OF THE DAGUERREOTYPE ●ıı●

1800 1810 1820 1830 1840 1850 1860 1870 1880 1890 1900

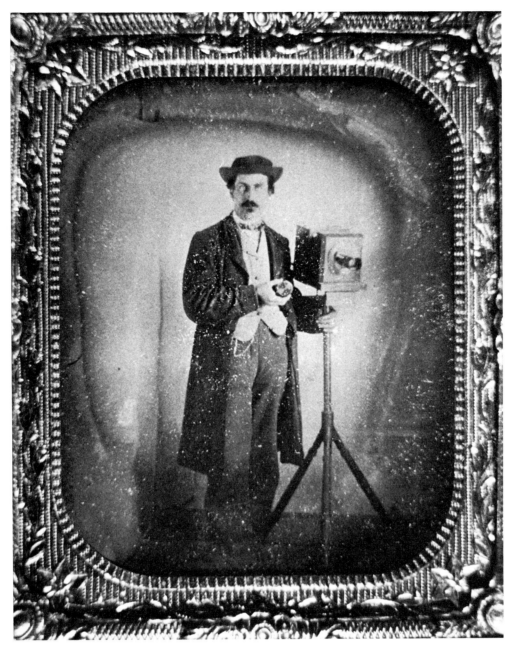

An unknown daguerreotypist posed in a daguerreotype with his
Lewis-type camera, bellows separating lensboard and forward
section from the plateholding section at back. (*Collection A/HW*)

Daguerre announced his success publicly early in 1839, and later that year, un-
der dramatic circumstances that assured him a life pension from the French gov-
ernment, gave the process to the world (except for England, where patents were
obtained and royalties sought and obtained). Within weeks daguerreotypes were
being made in all the capitals of Europe. A new industry and an art form had
been born.

Joseph Saxton (1799–1873), an American engineer with an inventive mind, was
an employe of the U.S. Mint in Philadelphia in 1839 when he learned of daguerre-
otypy in the *United States Gazette,* a publication which, like much of the press of

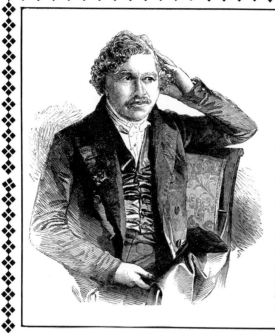

- DAGUERRE, FROM A
 DAGUERREOTYPE BY
 ANTOINE CLAUDET

Recognized as the "father of photography," Jacques Louis Mandé Daguerre (1787–1851) was not the first person to take a photograph, nor did he invent the word "photography." His contribution was the creation of the first practical system of photography, developed after years of experimentation along lines initiated by Joseph Nicéphore Niépce. The mirror-silver daguerreotype bearing Daguerre's name was superseded by on-glass images for direct viewing or for making on-paper exact duplicates. Painter-showman-photographic experimenter, Daguerre created a system that produced images still striking for their artistry and clarity.

the world, carried news of Daguerre's startling August announcement. Saxton was then working with machinery that could exactly duplicate engravings, many of which were essentially portrait likenesses. Intrigued by the news of a device that could faithfully reproduce a likeness, he improvised one of the first cameras made in America.

Using a cigar box mounted with an ordinary reading (magnifying) glass as his lens, Saxton took a picture on October 16, 1839, from a second-story window of the Mint. His plate was a strip of polished silver from which coin blanks were cut. Saxton's daguerreotype of the State Armory and the Philadelphia Central High School, measuring 1¾ by 2⁵⁄₁₆ inches, has been preserved by the Historical Society of Pennsylvania. His success was recorded in the October 25, 1839, issue of the *United States Gazette.*

Saxton occasionally made daguerreotypes as an amateur, but his overriding interest in the development of machinery for the purposes of the Mint limited his interest in the subject. In 1844 he left the Mint to become supervisor of the Office of Weights and Measures in Washington, D.C., a position he held until his death.

Saxton was the first American to make a daguerreotype but was not the first to make a daguerreotype in America. That honor went to an Englishman, D. W. Seager, who resided in New York City in 1839. It has been established that he made the first daguerreotype in the United States on September 27, 1839, a street scene including parts of St. Paul's Church and the Astor House in New York City. Shortly thereafter he gave a number of lectures on daguerreotypy in New York City and then faded from the public scene. Little else is known of him. It is often claimed that Prof. John William Draper of New York University, who did a daguerreotype portrait of his sister, Dorothy Catherine Draper, in the summer of 1840, created "the first daguerreotype in America," but his achievement was actually the first daguerrean portrait, all of the prior photographs having been of buildings, outdoor scenes and the like.

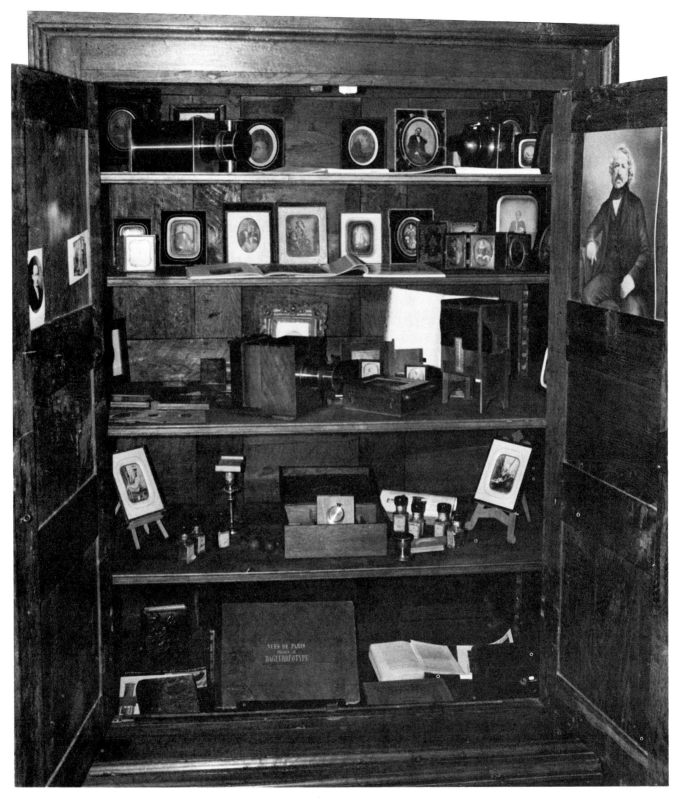

A daguerrean treasure cabinet in the home of French collector-historian Edmund de Seze contains two quarter-plate cameras (top shelf, left, and middle shelf, center), a mercury fuming chamber (middle shelf, right), and numerous daguerreotypes, including some in half-plate and smaller sizes. Bottles on the next-to-bottom shelf have tints to rouge cheeks and gild buttons. (*Collection AL*)

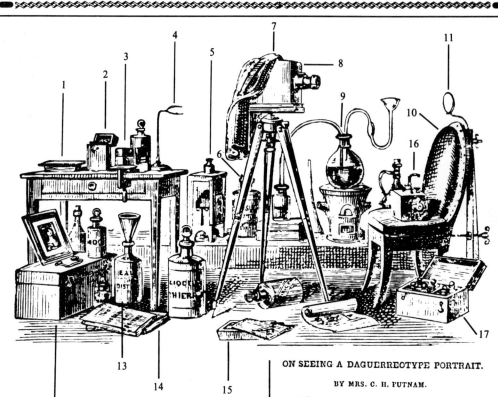

ON SEEING A DAGUERREOTYPE PORTRAIT.

BY MRS. C. H. PUTNAM.

What means this vain, incessant strife,
 To hide thyself in fitful gleams—
Now standing like a thing of life?
 Then fading like a poet's dreams.

More like a fiction fancy weaves,
 Than ought we know of earthly kind—
Or visioned form that memory leaves
 Upon the tablets of the mind.

The shadowy flitting of a thought,
 O'er recollections misty page;
From secret depths intrusive brought,
 And vanished quick by reason sage.

I like thine airy semblance well;
 It speaks of forms in spirit land,
Where kindred souls together dwell,
 A pure, unspotted, happy band.

It tells me of that better state,
 Where sin and sorrow never come;
But peace and joy for ever wait,
 And purest pleasures ceaseless bloom.

It tells me, too, that those we love,
 And cherish in our hearts below,
Shall wear those well known forms above,
 And only brighter, purer grow.

Who can be without a Daguerreotype of him or her they love? that embodiment—as it were, of the form's spirit—that exquisite and perfect impress of the features? Yes, it does raise the mind from earth to heaven, and bring to the imagination the fairy, spiritual forms of the dear departed, and makes us hope and wish to join them in eternity.

1. buffing block
2. plate storage box
3. plate vise
4. plate rest for gilding
5. mercury chamber with alcohol burner at top
6. fixing solution
7. darkcloth for focusing
8. half-plate camera
9. retort for distilled water
10. posing chair
11. head rest
12. eqpt. carry case
13. distilled water
14. technical manuals
15. plateholder and plate
16. quarter-plate smaller camera on chair
17. chemicals box

THE DAGUERREAN'S TOOLS

In the early world of the daguerreotypist there were no factories to manufacture the basic equipment or the photographic materials that would be consumed with each exposure. However, Daguerre's wife had a relative, Alphonse Giroux, who was a cabinetmaker, and it was in his workshop that a modified version of the camera obscura was made along the lines of the one used earlier by Niépce.

The camera made by Giroux and copied later by most others was essentially a wooden box, open on the side, that would slide into the open side of a slightly larger box. The boxes were handsomely constructed of mahogany, cherry, walnut or other fine woods. The lens was fitted at the end of the larger box; the ground-glass (for finding and focusing the image) was part of the smaller one. Usually the photographer adjusted for focus by sliding one box toward or away from the other box. The box shape survived almost a dozen years before the lighter and more readily adjustable Lewis system of collapsible leather bellows was introduced in America in about 1850.

The daguerrean photographer's plate was a silver-on-copper sheet, factory cut to the dimensions of the plateholder, a thin, flat storage case with a sliding cover to protect the light-sensitized plate before it was placed in the camera. This plate had to be brought by the photographer to a mirrorlike brilliance, for the factory-delivered product, while well shined, was not given the flaw-free, mirrorlike finish upon which the delicate image would have to rest.

Other daguerrean equipment owned by thousands of photographers included the buffing stick and pumice pots and oil bottles to aid the polishing; an iodizing chamber; a handsome rosewood mercury fuming box with a mercury column thermometer and an imposing brass calibration scale; retoucher's colors; and a host of other gadgets. Only a handful of the cameras (possibly a few hundred) have survived in America, and only a few scattered examples of the workbench equipment are known in museums or private collections today.

∷ JOHN PLUMBE, JR.: A DAGUERREAN VISIONARY

In the world of the 1840s a number of important concerns kept dinner-table and fireside chats lively. The country still reflected the unrest of the Jacksonian period. Slavery was a burning issue, and the abolitionist movement already had the eloquence of Frederick Douglass. Most Americans danced to the tune of Manifest Destiny, and the proponents of a transcontinental railroad were confident that they were anything but foolhardy visionaries.

One of those visionaries was to become one of the first photographers in America. He was the creator of the earliest known photographs of the Capitol of the United States and some of the few surviving portraits of slaves. One of his photographs documents for all time Samuel F. B. Morse's demonstration of the telegraph to a seated Congress. He was also one of the first to merchandise photographic services through a chain of galleries.

His name was John Plumbe, Jr. A Welshman, he traveled widely before the Age of Photography as a railroad surveyor, and by the mid-1830s he had established himself as an advocate of the connection of East and West by railroad. He actively proselytized for this idea as a resident of Dubuque, Iowa, a community at the very edge of the Great Wilderness.

On a trip to Washington, D.C., late in 1839, Plumbe heard the news of the invention of photography and read a description of the daguerreotype process. He

immediately saw its commercial potential, and he opened his first studio, Plumbe's Daguerreian Gallery, in Boston only a few months later in 1840.

His Boston gallery a success, Plumbe opened a second in New York, then another, the first portrait studio in Washington, D.C. By September 1845 he had galleries operating in fourteen cities, from his pioneer operation in Boston to Louisville, Kentucky, in the south and as far west as his "hometown," Dubuque, Iowa.

Plumbe's position in the public eye was such that the anonymous author of a short story of 1846, "The Daguerreotype Miniature," set it in part in the Plumbe Gallery in New York, and Plumbe himself appears in the story. Fearing his having taken license in depicting a living person within a fictional situation, the author apologetically dedicated the work to Plumbe.

> Perhaps the author has been guilty of too much freedom in using your name and that of your gallery in the pages of this work. But it is a well-known fact to publisher and authors, that, however intrinsically good cheap novels may be, it is a *sine qua non* nowadays, that they contain something which may strike the general eye, and touch the public pulse. Hence the introduction of well-known and celebrated men and places is a stroke of policy on the part of an author that may do him good.

In "The Daguerreotype Miniature" Plumbe is described as "a gentleman with a good figure, a keen black eye, broad benevolent forehead and a dark mustache." He gives the hero of the plot a gift, a daguerreotype likeness of the heroine. Arthur, the hero, wears it from then on over his heart—a truly fortuitous habit, for it deflects the blade of the villain's dagger. Who but the heroine will be on hand to nurse the wounded, but safe, hero back to life! No reader would deny that a Plumbe portrait was a sensible investment at twenty-five cents—practically a gift from Plumbe.

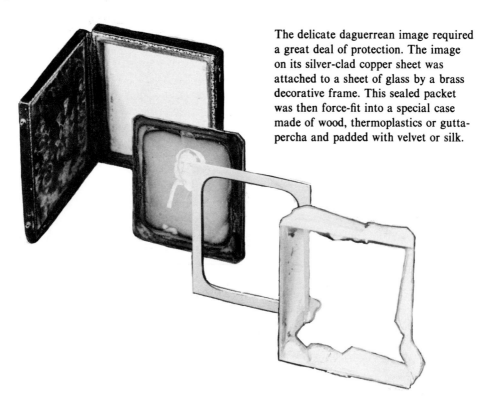

The delicate daguerrean image required a great deal of protection. The image on its silver-clad copper sheet was attached to a sheet of glass by a brass decorative frame. This sealed packet was then force-fit into a special case made of wood, thermoplastics or gutta-percha and padded with velvet or silk.

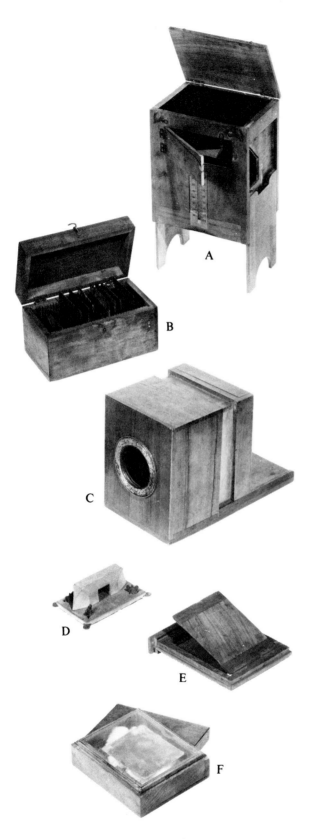

A. Mercury chamber for developing.
B. Plate storage box.
C. Quarter-plate camera (no lens).
D. Plateholder for buffing.
E. Plateholder for camera.
F. Polishing block.

MAKING THE DAGUERREOTYPE

1. **Readying the Plate** • The polishing of the silverplate was done in or out of the darkroom with a buffing stick, a small paddle not unlike a short oar that was covered on one side with a cloth padding over soft chamois or other leather. The photographer worked the flat silver on the polishing surface with pumice and oils until a brilliant lustre was achieved, free of specks or scratches that would mar the delicate image.

2. **Sensitizing the Plate** • Once polished, the plate was set in ordinary room light onto a shelf in a closed wooden box containing a tray of iodine. The fumes rising from this tray for a few minutes interacted with the silver to form an iodized silver. The plate, now sensitized, was loaded in a darkroom into a waiting plateholder.

3. **Exposing the Plate** • The plateholder was brought outdoors or into the studio, where the camera had already been aimed at the subject and focused. The plate was inserted and the exposure made, in the early years for as long as fifteen or thirty minutes, and later, with faster lenses, for less than a minute, depending on the amount of daylight reaching the subject from windows or skylight. Early in the history of daguerreotypy, German Petzval-type lenses provided speeds of approximately $f/4$ and a design accuracy that assured acceptable portrait sharpness of the image.

4. **Developing the Plate** • The exposed plate, securely protected in its plateholder against chance light, was removed from the camera and returned to the darkroom for "development."

In the darkroom the plate was taken from its holder and placed in a new box, a mercury chamber with a built-in thermometer and a spirit lamp to heat mercury to create fumes. The mercury fumes reacted with the exposed iodized silver to form an image as the photographer watched the process through a tiny viewing window incorporated in some of the boxes. Once the image made by the mercury attaching itself to the exposed portions of the silver iodide could be seen the plate was removed from the chamber and plunged into cold water to harden the delicate surface. Then the plate went into a fixing bath of hyposulfite of soda, the fixing agent discovered by Sir John Herschel and adopted by Daguerre. A further water wash, and sometimes a treatment with a gold toning bath, completed the process.

5. **Presenting the Daguerreotype** • The delicate image, about one-millionth of an inch thick, was protected under a panel of glass, adorned with a gilt frame and set into a protective case of pressed paper, leather or the molded thermoplastic of the period.

Left: Niles' National Register, May 30, 1840, reports the announcement of "Daguerotype Miniatures" by Robert Cornelius in the *Philadelphia Chronicle:* "Nothing could possibly be more true than these representations of the 'human face divine.'" *Right:* Plumbe's advertisement in *The Anglo American* of New York (March 1845) announces new lower prices, "reduced to that of ordinary ones at other places." His postscript: "Wanted—Two or three skilful operators."

Gabriel Harrison, an operator for the Plumbe Gallery in New York City, writing in the March 1851 issue of *The Photographic Art-Journal,* leaves us a memorable glimpse of the new experience that photography provided for those being introduced to the art of Sitting. He describes the visit to the studio of the Old Maid.

It was in the year 1844 when operating for Plumbe, that sleepy John, as he was called—and who, by the by, we were often obliged to toss in a blanket to keep his winkers and blinkers from being everlastingly shut—one morning conducted into room No. 8, which happened to be my sanctum sanctorum, a rather tall, slick, shingle-like specimen of the genus Homo, feminine gender, whose every look and motion indicated her to be an Old Maid.

After certain movements peculiar to such productions she drawled out—

"Well Mister, I want to have my dogre-o-type taken and put into a case with a red cover."

I assured her it should be done and retired to prepare the plate, leaving her seated in the operating chair. I soon returned and after fifteen minutes hard labor succeeded in a somewhat flattering position; but just as I was about to draw the slide, I observed that her breathing moved her head sufficient to prevent a good result in the camera, and remarked to her to be careful and not suffer her respiration to move her head while the picture was being taken; I then drew the slide and retired to my sideroom.

At the expiration of about sixty seconds, I heard to my dismay, a loud drawling, Oh, me! I rushed into the room, John after me, when lo and behold, there she lay, stretched out at full length on her chair, her head back, her mouth livid with blue, and uttering just audibly—

"I can't hold my breath any longer."

This was enough for John, who, thinking she was either going to faint or die, flew to my stand, seized a large bowl of hyposulfite solution, and returning, dashed the contents into her face. The screech that followed was truly awful.

She sprang to her feet and flew at poor John with the ferocity of a tigress, around the room they went, he throwing down camera stands, chairs, tables, and everything that came in his way, to impede her progress. At last he darted out the door, rushed down the stairs and through the reception room, where there were many persons waiting for their pictures, shouting at the top of his voice "Mad woman! mad woman!"

I do not know whether they took the cry for mad dog or not, but certain it is, those in the gallery were in an instant following him down the stairs in the most frightening consternation. A large mob was soon collected around the door, and when I descended I found three or four gentlemen endeavoring to

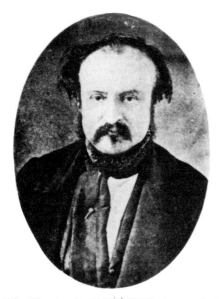

The inside of a Plumbe gallery daguerrean case carries the legend Manufactured at the Plumbe National Daguerrian Depot, New York. (*Collection C/MK*)

John Plumbe, Jr. (1809–1857), dreamed of a transcontinental railroad while he built America's first photographic portrait studio chain. His 1846 documentation of Washington, D.C., buildings and monuments includes the earliest known photographs of the Capitol. (*Collection C/MK*)

The ornate gold leaf imprint on Plumbe case reads Plumbe's Daguerreotypes. 50 Cents. 75 Court St. Boston. Gold Medal Awarded to Plumbe. (*Collection C/MK*)

raise a Lamberthian lady, who, in her flight not being able to descend sufficiently rapid had rolled from the top to the bottom, without much injury, however, to her immensity. Soon the tempest of the excitement was calmed, and the poor operator whose labors in his fascinating art the world can never fully appreciate, was wending his way homeward.

Harrison's account of the events of that day concludes with a description of a tinting and gilding by the setting sun of fantastic little clouds "into shapes and forms commemorative of the event."

The very next day in the life of the Plumbe Gallery began with an event as soul-searing as that of the previous afternoon was mirthful, Harrison relates.

Oh! how sad was the face of the first customer who saluted me on entering the Gallery.

Her pale lips, though motionless, spoke despair—her dark sunken eyes told of intense suffering, and her black tresses raggedly gathered over her broad white temples indicated the agitation of her mind. Her garments coarse, but neat, loosely encircled her well shaped frame. When she spoke, her tremulous, anxious voice sent a thrill like an electric shock through me. In wild accents she addressed me.

"Oh! sir, my child Armenia is dead, and I have no likeness of her; won't you come immediately and take her picture."

On a scantily furnished couch lay the victim of the fell destroyer, marble like and cold—the mother, on her knees beside the bed leaned over her darling, her only child, with her face buried in her hands, and giving way to low heart-rending choking sobs. For a moment I dared not disturb that mother's anguish.

"Madam."

"You here," she said, as she started to her feet. "Oh! a thousand, thousand thanks!"

Gently we moved the death couch to the window in order to get the best light, though but a ray. What a face! what a picture it did reveal. Though the hand of God is the most skillful, yet I thought, had the sculptor been there to chisel out that round forehead, to form that exquisite shoulder, to mark that playful smile about those thin lips, and to give the graceful curves of those full arms that lay across her now motionless heart, what a beautiful creation would come from his hands.

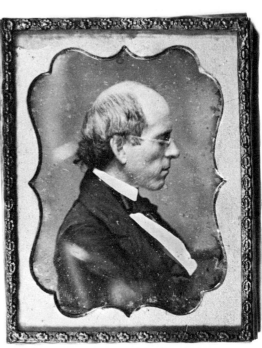

A 25-cent ninth-plate daguerreotype made at Plumbe's Boston studio, the Plumbe National Daguerrian Gallery, was actually produced by an "operator." Plumbe traveled extensively between 1840 and 1845, opening galleries in fourteen cities. (*Collection J/SS*)

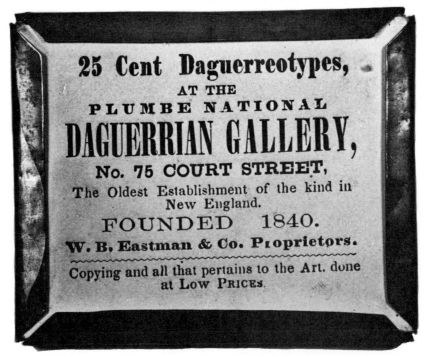

The back of a Plumbe daguerreotype reveals an advertising card for his gallery. W. B. Eastman & Co. was the operating manager for the Boston unit of the Plumbe chain. The backs of images, when removed from their outer cases, frequently reveal gallery, sitter, date, or sitter's age. (*Collection J/SS*)

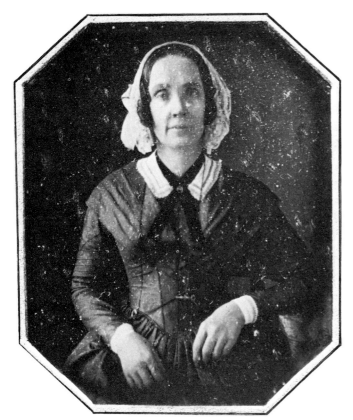

Mrs. Francis Luqeer (1794–1876) by Plumbe Gallery. (*Collection N-YHS*)

A similar portrait; unidentified sitter. (*Collection C/MK*)

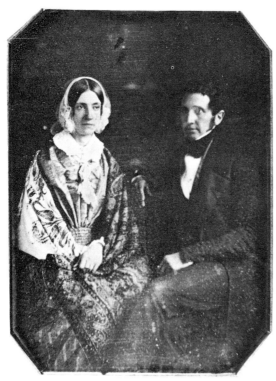

A seated couple by Plumbe Gallery. (*Collection MusCNY*)

A standing pose; unidentified subject. (*Collection L/HJ*)

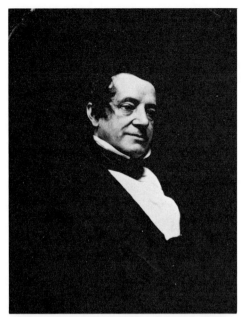

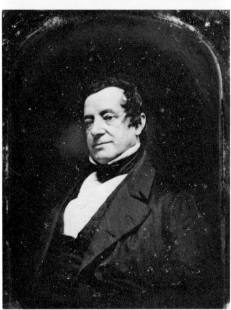

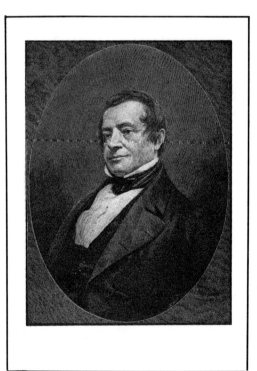

Plumbe's daguerreotype of Washington Irving (1783–1859) has been the basis of numerous etchings and paintings of the novelist. (*Collection LofC*) Reversed print, especially prepared by the New-York Historical Society, shows how etchers such as T. Johnson were guided by the daguerrean image in creating steel line art. (*Collection GG*)

The mother held up a white cloth to give me reflected light to subdue the shadows. All was still, I took the cap from the camera. About two minutes had elapsed, when a bright sun ray broke through the clouds, dashed its bright beams upon the reflector, and shedding, as it were, a supernatural light. I was startled—the mother rivetted with frightful gaze, for at the same moment we beheld the muscles about the mouth of the child move, and her eyes partially open—a smile played upon her lips, a long gentle sigh heaved her bosom, and as I replaced the cap, her head fell over to one side. The mother screamed—

"She lives! she lives!" and fell upon her knees by the side of the couch.

"No," was my reply; "she is dead now, the web of life is broken."

The camera was doing its work as the cord that bound the gentle being to earth snapped and loosened the spirit for another and better world. If the earth lost a flower, Heaven gained an angel.

John Plumbe, Jr., undertook a number of experiments that he hoped would lead to a process for the duplication of his daguerreotypes, and finally in 1845 he announced the *Plumbeotype.* At that time, publishing technology could not reproduce daguerreotypes; the printing procedure for the reproduction of photography did not evolve until the halftone printing system of the 1880s. Illustrations based on photographs were created by etchers, and these were exact line simulations of the photograph that were readily reproduced in black ink on newsprint. The Plumbeotype that Plumbe announced was printed artwork of this sort, first in outline and cartoonlike form; later Plumbeotypes had the etchinglike detail found in the journals of the time where master craftsmen were employed. The advantage of the Plumbeotype was its low price, only a fraction of the cost of a daguerreotype.

Its success was assured when, during the display in Washington, D.C., in 1845 and 1846 of Titian's great nude *Venus,* Plumbe obtained permission to take daguerreotype views and then produced Plumbeotype representations of the bold painting. These were placed on sale wherever the painting was later exhibited. Plumbe's contributions to the popularization of daguerreotypy had by this time become so evident that the *New York Herald* dubbed him "that American Daguerre."

Some maintain that Plumbe opened his Washington, D.C., gallery primarily to be near the Congress whose members he hoped to interest with his railroad dreams. Writing in *The Plumbeian,* a publication he created to promote his galleries, Plumbe noted on January 1, 1847:

> We continue to press the matter [the transcontinental railroad] upon Congress until, after devoting nearly all our time for upwards of three years, upon the line, exhausting all of our means (pecuniarily) we at last after being laughed at as a madman, were obliged to resort to taking Daguerreotype likenesses, in order to keep up the soul of our undertaking, by supporting our body.

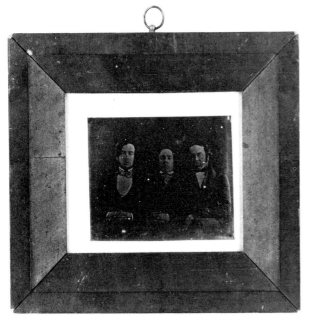

One of the earliest dated Plumbe Gallery images is a family portrait of Stephen, Henry and George Childs, taken November 15, 1842. A note on the back of the photograph (*right*) explains that the sitters are (*left to right*) Henry, George, and Stephen, the oldest brother or father. The names are actually inscribed on the plate. The quality of the image is poor compared to others taken by Plumbe. (*Collection LofC*)

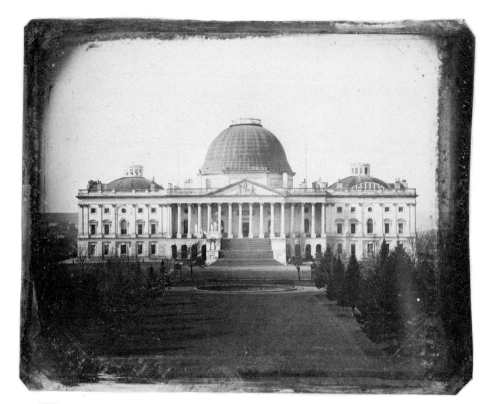

The earliest known photograph of the Capitol was taken by Plumbe in February 1846. It shows a front view from the east, with the copper-covered wooden dome designed by Charles Bulfinch. It is one of a number of Plumbe views discovered in a San Francisco flea market in 1972. (*Collection LofC*)

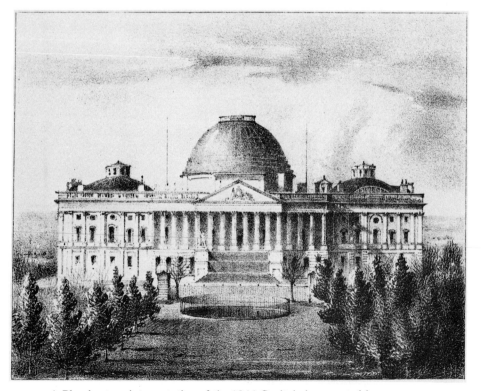

A Plumbeotype interpretation of the 1846 Capitol view created by Plumbe. The Plumbeotype was evidently the result of a lithographic process which gave gallery artists use of the original daguerreotype as a guide for creating an art effect. A few Plumbeotypes survive in museums and other archives. (*Collection LofC*)

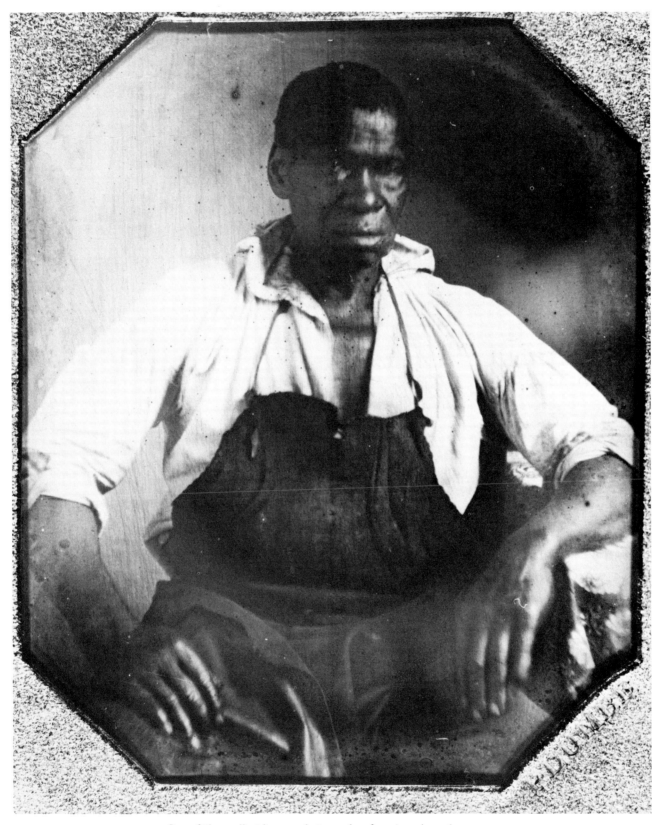

One of the earliest known photographs of an American slave, a portrait of Isaac Jefferson, was probably made in the Washington, D.C., Plumbe National Gallery. It is a quarter-plate image, shown here twice its actual size. The imprimatur Plumbe, at lower right, is commonly found on Plumbe Gallery images. (*Collection TWMcGLibr,UofVa*)

His gallery was favored by many notables, including John Quincy Adams, John C. Calhoun, Henry Clay, Sam Houston, James K. Polk, Martin Van Buren and the P. T. Barnum star, General Tom Thumb. Many of their daguerrean portraits are now in the Library of Congress.

While the overwhelming body of work of the Plumbe galleries was the creation of tens of thousands of likenesses, Plumbe will also be remembered for some of the earliest views of Washington, D.C., a group of photographs made in 1846 showing the Capitol and various other buildings. The curators of the Library of Congress, where these views remain a part of the nation's photographic heritage, have discovered in one the actual wire strung by Samuel F. B. Morse to permit his dramatic demonstration of telegraphy to the Congress. (The Plumbe photographs

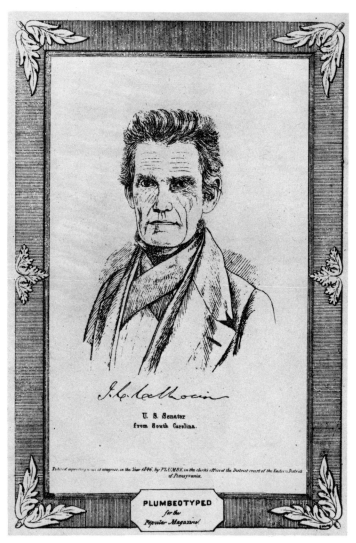

John C. Calhoun, the Senator from South Carolina, was one of a number of Washington, D.C., luminaries who posed for Plumbe. Here the portrait is translated into a Plumbeotype. Plumbeotypes of well-known figures were offered for sale to the public in place of costlier daguerreotype copies. The line art interpretation was by G. Werley; Plumbe registered the print for copyright protection in 1846. (*Collection LofC*)

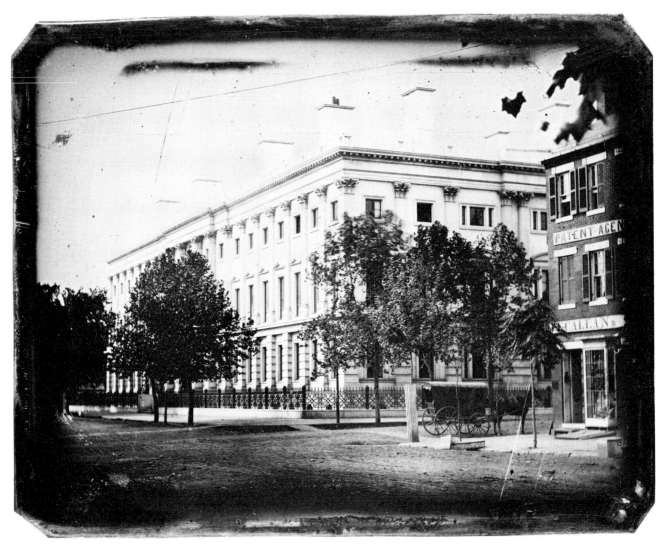

This 1846 view of the General Post Office at Seventh and E streets
in Washington, D.C., shows a trace of the Samuel F. B. Morse
telegraphic wire (*upper left*), a remnant of a historic demonstration
for Congress. (*Collection LofC*)

of Washington were located by chance in a San Francisco outdoor flea market in
1972; all had been removed from their protective cases but fortunately were pro-
tected by binding tape that secured glass panes over the delicate images.)

Plumbe's Washington gallery was also the source of one of the earliest photo-
graphs of an American slave, Isaac Jefferson, a black from the Monticello estate
of Thomas Jefferson. "The photograph shows Isaac probably at the time he was
working in Petersburg in the late 1840s," notes Edmund Berkeley, Jr., curator of
manuscripts of the University of Virginia Library. Isaac Jefferson was variously a
tinsmith, a metal trades craftsman and a blacksmith. The workman's portrait,
Berkeley says, is "one of the oldest identified depictions of a slave."

Plumbe continued to travel on behalf of his advocacy of the westward extension
of the railroads. Perhaps because he was away almost continually from his base of
operations, he failed to see the inroads that competition made on the early success
of his far-flung galleries. Part of his subsequent failure has been traced to the dis-
honesty of some of his agents; much had to do also with the lax administration of
the chain. In 1847 all of the galleries were sold to meet the demands of creditors.

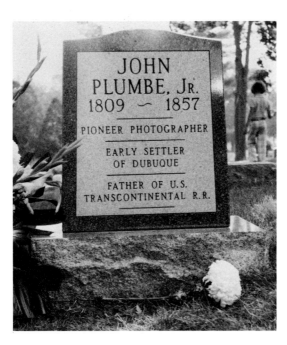

Plumbe's grave in Dubuque is marked by a recently erected tombstone placed there by photographic historians seeking to permanently honor the nearly forgotten pioneer photographer.

When the gold rush came, Plumbe saw in it the opportunity to rebuild his fortune. He met with no luck during his five years in California and returned to Iowa destitute, to die at his own hand in 1857.

The final blow to his morale was the announcement of the plan for his much-dreamed-about East-West railroad; it was to follow a northerly route, not the southern trail he had been championing for a lifetime.

John Plumbe, Jr., had launched America's first photographic studio chain; he had created a new art form, the Plumbeotype; and he had made memorable photographs that enhance our knowledge of our past.

In the 1970s photographic historians placed a black granite monument on Plumbe's grave in a Dubuque cemetery to commemorate his place in American history as a photographic pioneer and artist.

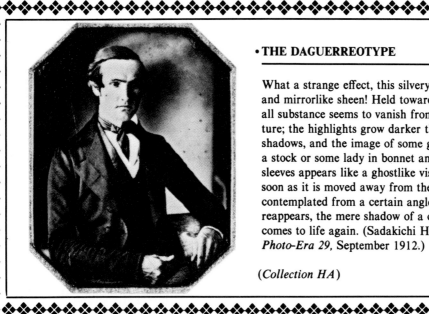

• **THE DAGUERREOTYPE**

What a strange effect, this silvery glimmer and mirrorlike sheen! Held towards the light, all substance seems to vanish from the picture; the highlights grow darker than the shadows, and the image of some gentleman in a stock or some lady in bonnet and puffed sleeves appears like a ghostlike vision. Yet as soon as it is moved away from the light and contemplated from a certain angle, the image reappears, the mere shadow of a countenance comes to life again. (Sadakichi Hartmann, *Photo-Era 29,* September 1912.)

(*Collection HA*)

THE CALOTYPE
The First Photographs on Paper

In the summer of 1977 two workmen at the Kodak plant in Harrow, England, were assigned to a unique project: the recreation of equipment used in the 1830s by one of the gentlemen scientists who developed what is now the universal system of photography. The two men were asked to use their woodworking skills to produce four working cameras in the style of the era of calotypy, to be equipped with actual lenses of the period taken from the vaults of the Kodak Museum.

The project, conceived by Brian Coe, curator of the Kodak Museum in England, was to honor the centenary of the death of William Henry Fox Talbot (1800–1877) with a display of 650 modern prints made from original negatives exposed by Fox Talbot 140 years earlier. To add an extra touch to the exhibit, four of England's most talented contemporary photographers (Patrick Thurston, Sam Haskins, Ian Berry and Ian Yeomans) were lent the recreated cameras for picture taking in some of the original settings of the famed Fox Talbot pictures. Authenticity was further enhanced by establishing calotypy (from the Greek *kalos,* beautiful sketch) as the procedure to be followed in photographing the English gardens and fields where Fox Talbot had set up his tripod and camera. The pictures would be made on light-sensitized paper rather than on modern-day films.

To make the reenactment the more authentic, a three-foot-square box tent of Victorian design was set up on the Fox Talbot estate near Wiltshire. There the photographers processed their exposed paper plates in the field, exactly as had been done in the early 1800s, using the primitive darkroom of the practitioners of what was then called heliography (sun-pictures.) None of this posed as much a problem for the fascinated modern-day photographers as did the determining of the correct exposures. However, after some experimentation the photographers worked out their timing: twenty seconds for a Haskins nude and up to twelve minutes for a Yeomans still life.

The processing of the exposed paper in the manner of Fox Talbot in an "exciting bath" (developer), followed by a water rinse and the fixing of the image in hy-

THE PERIOD OF THE CALOTYPE

| 1800 | 1810 | 1820 | 1830 | 1840 | 1850 | 1860 | 1870 | 1880 | 1890 | 1900 |

posulfite of soda took only a few minutes. The paper print was then taken from the darkroom tent into the open sunlight for drying. The resultant print was a negative; whatever had been light or white now showed as grey or black, and what had been black was now reversed to white.

One additional step was required to create positive prints (in which black hair appeared black and white skin white). This stage was then, and is today, a process accomplished in a darkened room. In that light-protected environment, the newly made negative was placed in contact with a second sheet of sensitized paper and both were exposed to a few seconds of sunlight. Only the second sheet was then developed, washed and fixed, following a process identical to that used in making the negative.

Technologically, Thurston, Haskins, Berry and Yeomans had stepped backward 140 years. The results obtained were scarcely different from those obtained in their own studios today, even though the recreated cameras were clumsier to load and use, the exposures were uncomfortably longer, and the conditions for processing were unpleasantly rudimentary.

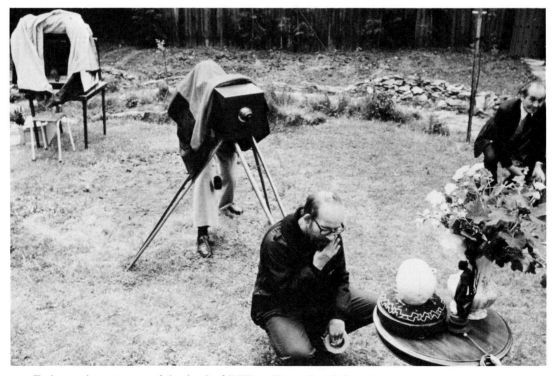

To honor the centenary of the death of William Henry Fox Talbot, the inventor of the negative-positive system of photography, a team of twentieth-century photographers made photographs with re-created Talbot—era cameras following calotype procedures. A field table-tent was used to load plateholders and develop images. (*Photography HSh and* Sunday Telegraph, *London*)

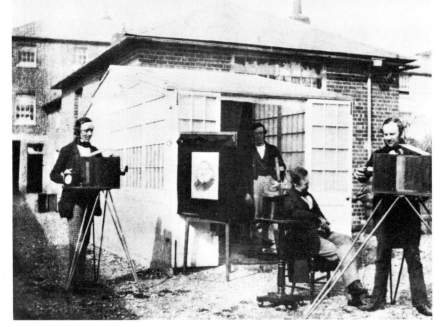

A Talbotype taken in 1845 at Fox Talbot's printing center in
Reading. A copy photograph and a portrait sitting are in progress.
(*Collection SM*)

 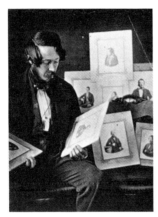

Left: A portrait from the David Octavius Hill/
Robert Adamson Album, which contains 100
calotypes. (*Collection A-G-F*)

Right: Frederick Langenheim (1809–1879)
looking at calotypes. With his brother William
he tried unsuccessfully to promote calotypy in
the United States. (*Collection NYPL*)

Only a handful of individuals in the world today can muster the tools and tech-
niques for daguerreotypy. However, Brian Coe had proven that anyone with any
camera, large or small, can share in the rediscovery of photography's earliest on-
paper photography moment. Today, as in the nineteenth century, photographs
may be created directly on sensitized enlarging paper—a paper negative in a size
suited to the camera in which the sheet of paper is fitted.

Fox Talbot's process, which he patented in 1841, was a two-step procedure. The
first step was the on-paper exposure that produced a negative image. The second
step was the paper-to-paper exposure that reproduced the negative as a positive
print. This positive Talbot called the Talbotype; it was also known as the salt
print, since it was the chemical action of silver salts on the paper that made the
paper sensitive to light. In a later modification of the procedure, the negative was
waxed to increase its translucency, giving a positive print that was slightly superi-
or to one made without the waxed negative. Positives made this way were known
as wax-paper prints.

A portrait made in this manner is more likely to be flattering than one made
from any of today's finest cameras. Since the print is made through the granular-
ity of the paper of the negative, the final image will be slightly softened, lessening
noticeable wrinkles or age spots. This softened and enhanced quality is part of the
allure of the process.

The Langenheims adapted calotypy to the newly emerging technique of stereography, creating stereo-pair paper negatives as the first step toward making large numbers of additional prints later. (*Collection MRI*)

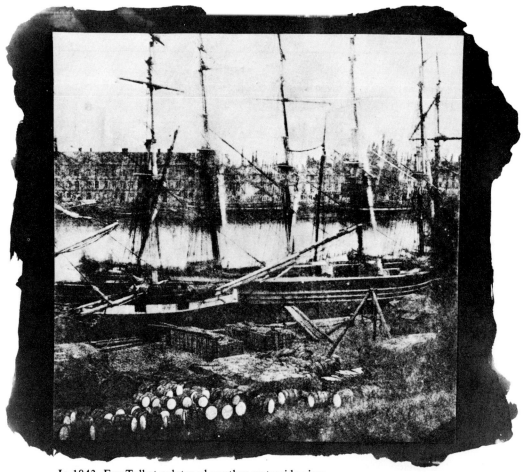

In 1843, Fox Talbot calotyped another waterside view, *Harbor at Rouen.* (*Collection SM*)

∷ FOX TALBOT AND THE PAPER PRINT

William Henry Fox Talbot, a gentleman scientist of some means, was an avid experimenter in the photographic art at the same time that Daguerre across the Channel was completing work on his process. Unaware of Daguerre and his private experiments, since 1833 Fox Talbot had been conducting his own investigations into the feasibility of pictures made by the sun. Even in his youth he had been interested in trying to fix an image on paper fitted to a camera obscura.

In his memoir, *The Pencil of Nature,* published in London in 1844, Fox Talbot describes his decision to explore methods for fixing an image on paper.

> One of the first days of the month of October, 1833, I was amusing myself on the lovely shores of Lako Como in Italy, taking sketches with Wollaston's camera lucida [an optical drawing aid], or rather I should say, attempting to take them: but with the smallest amount of success.... After various fruitless attempts I laid aside the instrument and came to the conclusion that its use required a previous knowledge of drawing which unfortunately I did not possess. I then thought of trying again a method which I had tried many years before. This method was, to take a camera obscura and to throw the image of the objects on a piece of paper in its focus—fairy pictures, creations of a moment, and destined as rapidly to fade away. It was during these thoughts that the idea occurred to me—how charming it would be if it were possible to cause these natural images to imprint themselves durably, and remain fixed on the paper.

Thus it was that in the fall of 1833, Fox Talbot undertook his first adult experiments to create "photogenic drawings." At first his efforts were made without using a camera. At his home, Lacock Abbey, he thought about some of the writing on chemistry by his contemporaries who had noted that silver nitrate acted peculiarly in the presence of light, evidently darkening or "spoiling," a phenomenon that until then no one had thought worth further investigation. Taking sheets of his wife's writing paper from the library desk, he sensitized them by bathing them first in a weak solution of common table salt (sodium chloride), then, when that had dried, in a strong solution of silver nitrate. The interaction of the chemicals created silver chloride, itself a light-sensitive salt that is insoluble in water.

To test his creation, Fox Talbot pressed such items as ferns, feathers and lace against the salted paper, securing them to the paper under glass. The partially covered paper was then exposed to sunlight, which gradually caused darkening of the exposed areas. When the opaque object was removed, its white image could be seen clearly defined on the paper. (Today the Fox Talbot Museum on the grounds of Lacock Abbey features displays of these earliest photographic results.)

Fox Talbot next sought to prevent the subsequent darkening of the white areas. In one procedure he washed the exposed print in a solution of common table salt or potassium iodide as a means of rendering inert the remaining silver nitrate. Using even this relatively inefficient bath as a fixing agent, Fox Talbot could now handle his shadowgraphs in ordinary daylight without their darkening appreciably. The incomplete processing of some of these early experiments in heliography and "photogenic drawings" has resulted in their fading to the point where now only the Fox Talbot signature is visible.

Fox Talbot's next step led directly to the kind of photography with which all are familiar today: he loaded salted paper into small camera obscuras, miniature versions of the lensed boxes created by optical shops to enable artists to trace perspective on landscapes. Within months after the start of his shadowgraph experi-

ments in 1835 and certainly by August of that year (as proven by a dated photograph by Talbot of the latticed windows of his study), Talbot created photographic negatives on paper in the small cameras. He had deliberately ordered miniatures of the usual camera obscuras, knowing that the optical laws of light make an image brighter in a small box than in a large one. The nearer the lens was to the sensitized paper, the brighter the image upon the paper. Even with these specially created devices, his efforts to obtain blackened negatives of scenes in and around Lacock Abbey required half-hour exposures.

The negative-to-positive process that Fox Talbot dubbed *calotypy* in his patent application in 1841 needed only the action of sunlight on the salted paper. After processing, these were sun-exposed onto second sheets of salted paper to create the positive, "very perfect, but extremely small pictures; such . . . as might be supposed to be the work of some Lilliputian artist."

The pictures were small, some as tiny as one square inch, because of the reduced size of the cameras. Some cameras were the size of a child's play block, so small that Talbot's wife delighted in calling them his "little mousetraps." On a summer day he would load a group of these with sensitized paper and train them on the Abbey.

> After a lapse of half an hour, I gathered them all up, and brought them within doors to open them. When opened, there was within each a miniature picture of the objects before which it had been placed.

Detail and accuracy were precise. The famed lattice window negative, only one inch square, was mounted on a card on which Fox Talbot added a legend:

> Lattice Window (with the Camera Obscura) August 1835—When first made, the squares of glass about 200 in number could be counted, with the help of a lens.

In January 1839 reports reached England of a talk given before the French Académie des Sciences by the physicist and astronomer François Arago, concerning Daguerre's improvements of Niépce's experiments. In *The Pencil of Nature* Fox Talbot described his reaction to learning of the French research.

> I was placed in a very unusual dilemma (scarcely paralleled in the annals of science), for I was threatened with the loss of all my labours, in case M. Daguerre's process proved identical to mine.

Fox Talbot took immediate action. On January 25, 1839, Michael Faraday introduced examples of his fellow Englishman's successes at the regular Friday evening meeting of the Royal Institution in London. A week later, Fox Talbot's paper, "Some Account of the Art of Photogenic Drawing," was read at the Royal Society. In a second paper read three weeks later, sufficient technical details were provided to enable anyone to repeat the Talbot process.

The great scientist Sir John Herschel had seen examples of the competing Daguerre and Talbot processes. On January 29, 1839, he noted in his diary: "Three requisites: (1) Very susceptible paper: (2) Very perfect camera; (3) Means of arresting the further action."

Neither Daguerre nor Fox Talbot was then familiar with Herschel's discovery in 1819 that hyposulfite of soda dissolved silver salts. Herschel now made a new test that he showed to Fox Talbot only days later, on February 1, 1839. Herschel sensitized paper with silver nitrate, then exposed half of the paper to sunlight while closely covering the second half. After exposure, all of the paper, now half-black, half-white, was sponged over with hyposulfite of soda and then exposed

once again. He noted in his diary: "The darkened half remained dark, the white half white." The fixing agent had dissolved away the unexposed silver.

With Herschel's permission, Talbot described the improved fixing procedure in a letter in the journal of the French Académie des Sciences. (It was from Talbot's description that Daguerre came to learn of "hypo.") Talbot, once partial to fixing with the bath in common table salt, adopted the use of Herschel's invention, and since that time, all silver-based photography has employed hypo as a fixative in the darkroom.

For his development of the negative-positive process, Fox Talbot was awarded a medal by the Royal Society in 1842. His financial situation was far from secure. He thought himself entitled to earnings from his invention, which had immediate practical applications in competition with daguerreotypy, and he secured patent protection for the calotype process, selling licenses in England, France and America. During the 1840s, he and his licensees sought to popularize the basic procedure under the name Talbotype. Amateurs paid £20 per year for the right to create photographs using a process that was already well publicized; professionals paid as much as £200 per year, depending on the marketing area. Ultimately, however, Talbot's efforts to maintain patent control of the negative-positive process failed, despite lengthy court proceedings.

Fox Talbot's process was ideally suited to the needs of portraiture because the paper fibers served to blur slightly the image transferred from the negative taken in the camera to the positive print, an inadvertent form of retouching that was especially pleasing to those with facial blemishes. Photographers even learned to place blank white sheets of paper between negative and positive (before exposure) to further soften the image through diffusion of the light rays passing through. The added effect was achieved at the cost of only slightly longer exposure times during the darkroom process.

MAKING THE CALOTYPE

1. **Readying the Sensitized Paper** • White paper of a thin, translucent nature was soaked in a sodium chloride solution, dried and then treated to a coating of silver nitrate solution in a darkened room. When dried again, it could be fitted to the plateholder of the camera on the day (or several days) before its planned use.

2. **Making the Exposure** • After the lens had been aimed and focused on a subject, the plateholder was placed in the camera. The lens cap was removed, and the exposure was made, usually for three minutes or longer. Then the lens cap was returned to cover the lens, and the plateholder was made light-tight once again with its own cover (dark slide).

3. **Processing the Negative** • In a darkroom (or a field tent specially made for this purpose) the photographer developed the negative in a tray of pyrogallic acid, usually for two to three minutes, prior to fixing the image in hyposulfite of soda. The fixed image was then taken out into ordinary room light for washing in water and air-drying.

4. **Making the Positive** • The transfer print (Talbot's term) or positive (Herschel's term) was made by facing the negative image to a fresh sheet of sensitized paper in a specially constructed picture frame. This was brought from the darkroom and the sheets were pressed together in the light for an exposure of many minutes. The transfer print was now processed exactly as the negative print had been processed. After drying, it was mounted for viewing.

5. **Improving the Negative** • The transparency of the negative, key to the clarity of the transfer, was enhanced by the introduction in the late 1840s of a waxing procedure that reduced paper opacity appreciably after the negative image was processed. Waxing consisted of dipping the paper in a hot-wax dip just long enough to saturate the fibers.)

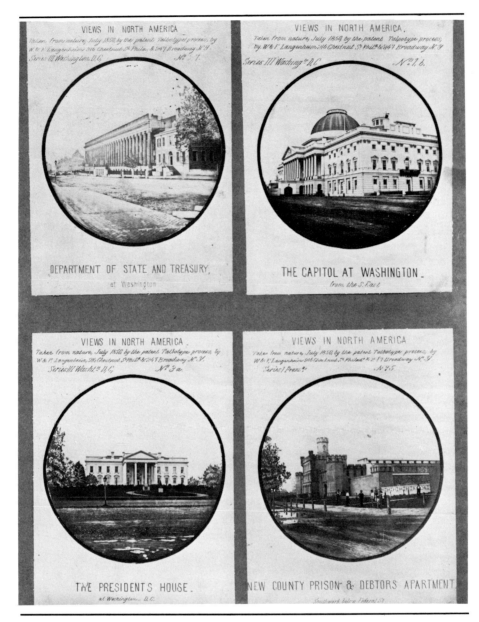

Langenheim calotypes from the series Views of North America are each
identified as taken from nature, July 1850, by the patent Talbotype process,
by W. and F. Langenheim, 246 Chestnut St., Phila., & 247 Broadway,
N.Y. (*Collection MoHS/LofC*)

Calotypes have survived as frameable prints in sizes up to 18 by 22 inches. Ca-
lotypists made numerous street scenes, landscapes and similar views, but there
were relatively few portraits, for exposures took from thirty seconds to five min-
utes and longer.

In America two brothers, Frederick and William Langenheim, who were part-
ners with a Philadephia photographer, saw in calotypy advantages over the popu-
lar daguerreotype. Calotypy was a simpler, lower-cost process that permitted the
photographer to make numerous duplicates at any time. The daguerreotype had
the advantage of a brilliant image, but it could not be duplicated, and it was prac-
tical only when attempted in small sizes. The daguerreotype could only be toned
and color-tinted a bit; the calotype, on paper, could be painted and altered in nu-
merous ways by a skilled artist.

Fox Talbot had patented his process in America in 1847. The Langenheims purchased the patent for $6,000 in 1849 with the expectation of profiting from their investment by the sale of licenses. The growing number of daguerrean practitioners, they reasoned, would see the inherent benefits of the more versatile calotype image. Their broadsides to the trade pointed out that paper portraits and views were "devoid of all metallic glare" and that they could be multiplied "to an unlimited extent with very little expense and labor."

"A thousand of these circulars have been distributed all over the union," they wrote Talbot, "but *horribile dictu*, up to this date, Novbr 18 [1849] not a single license has been sold."

Most photographers, it seemed, were loath to risk abandoning daguerreotypy, which had attracted to the galleries long lines of customers for portraits. No doubt many others simply resented the idea of having to pay for a license to create photographs by this process when they already had complete freedom to exploit Daguerre's process without fee. A few years later, the Langenheims achieved tremendous success by applying their skills as calotypists to a new photographic form, stereography (see Chapter 8).

▪▪ VICTOR PREVOST: AMERICA'S FOREMOST CALOTYPIST

It took a Frenchman, an immigrant to America, to capture the essence of the calotypist's art, using his camera like a poet's plume to express his love for the streets and monuments of early New York. The photographer and painter Victor Prevost (1820–1881) was a devotee of the calotype process. His images of the landmarks of New York and Philadelphia of the mid-1850s are the sole documents of many historic buildings of these communities. The Prevost photographs of Broadway facades, parks, churches and statuary are in many instances the only surviving depictions of these sites at that period.

Prevost began his career, as did many photographers of his time, as a painter. When he left France, he migrated almost immediately to California. There, in the pre-gold rush year of 1847, he did a number of paintings, one of which still hangs at the California Historical Society. In 1850 he took his art of the West to New York, and with these examples of his talent he started a career as a painter. He was successful to the degree that he married and was able to support his family by his art. It is believed that he learned of the calotype process of photography from one or another of his art world associates in 1851.

In 1853 Prevost visited France, and there he became a serious practitioner of the photographic art. He photographed the cobblestone streets of Soissons, a medieval cathedral town, and the ruins of a castle at Pierrefonds. In the dark groves of the forest at Compiègne he set up his tripod and camera for the necessary long exposures. Daguerreotypy, by that time, permitted exposures as brief as one to three seconds; the calotype, however, was made by a relatively insensitive plate that required ten, twenty, even one hundred times more exposure, especially in shaded conditions.

The long exposure times made it impossible for Prevost to include people in his street studies. The differences in brightness between light sky and worn dark stone meant that the darkroom effort invariably had to compensate for the overexposure of the sky and the relative underexposure of shadowed areas. No examples of his French photographs are known to survive.

Later that year Prevost returned to New York, taking with him knowledge of a modified calotype process that used a wax-saturated paper to make a less opaque

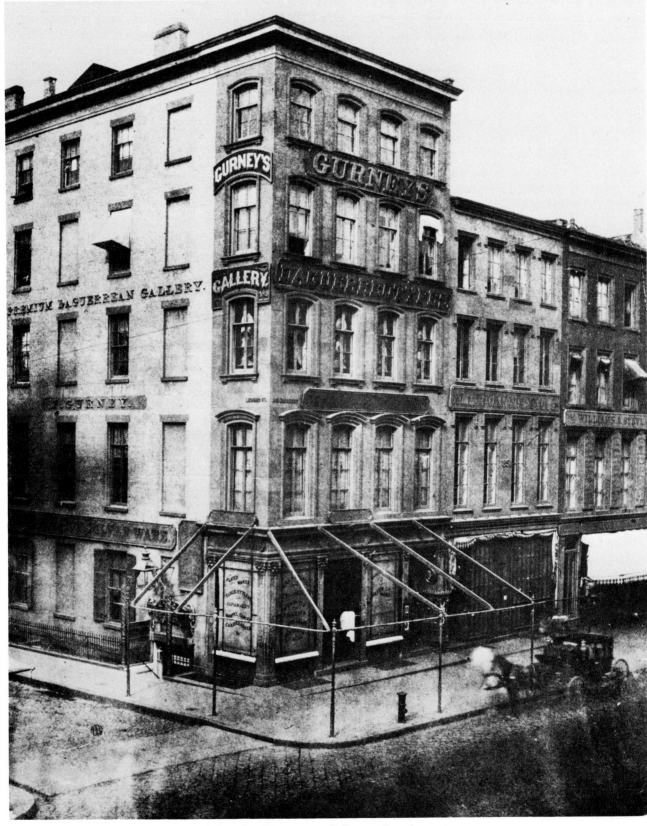

Prevost calotype of Gurney's Premium Daguerrean Gallery on Broadway at Leonard Street in New York's City Hall area, a center of commerce in the 1850s. (*Collection N-YHS*)

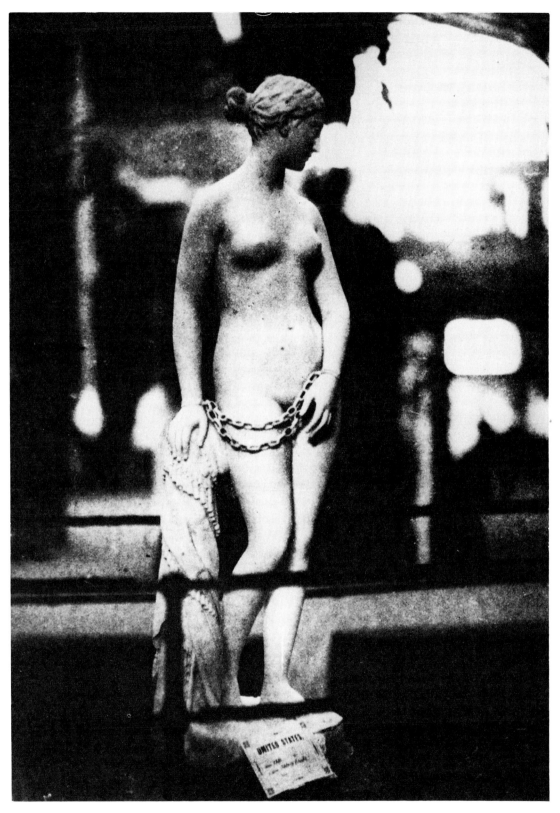

Victor Prevost's calotype of *The Greek Slave* by Hiram Powers was
made at the New York Crystal Palace Fair of 1853. The sole light
was from an overhead skylight. The lens was set at near maximum
aperture; a shallow field of focus aids in defining the statue against
the distant background. (*Collection N-YHS*)

negative. The waxing procedure had been introduced by photographer-inventor Gustave LeGray (1820–1862).

Yet even exposures by the wax-paper process required two to three minutes on brilliant days and up to fifteen minutes on the typical grey-sunshine days that one found in the large cities of the East. Talbotypes made without waxing showed people in studio sittings (one-minute exposures) and seated outdoors in full sunshine (exposure times of under one minute).

Confident of his skill, Prevost opened a photographic salon in New York City late in 1853 in partnership with a Paris friend, P. C. Duchochois. By this time, Fox Talbot had lost many of his patent rights, and the practice of Talbotypy in England, now license-free, enjoyed a brief vogue. As late as 1862 Talbotypes were submitted as photographic entries to the World Exposition in London.

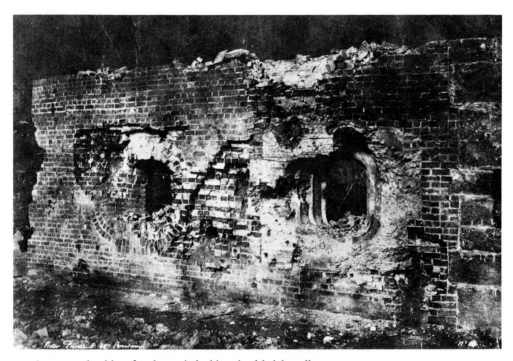

An unusual subject for the period, this ruined brick wall was captured in a calotype by Prevost. The fine detail counters the usual arguments against calotypy's limits of definition. (*Collection MusCNY*)

An enlargement of the signature, Victor Prevost 687 Broadway, provides positive identification of the origins of the study. (*Collection MusCNY*)

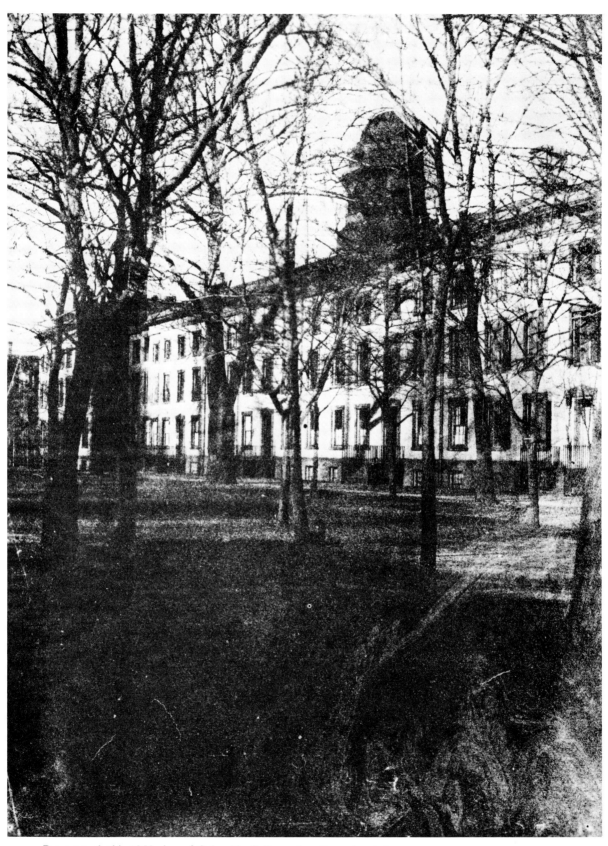

Prevost took this 1853 view of Columbia College when it was located near
Park Place in lower Manhattan. The uneven area at the lower right is the
result of poor emulsion coverage of the original negative or a later positive.
(*Collection N-YHS*)

Prevost and Duchochois located their studio in the fashionable "uptown" section of what is now Lower Manhattan, in the Houston and Bleecker Street area. At this time the commercial district of the city was ten blocks further south on Broadway, where Brady, Gurney, Fredericks and other established daguerreotypists maintained prestigious facilities. The calotypist had one advantage that contemporary daguerreans could envy: Once the paper sheets had been sensitized and dried, they could be stored for use for about two weeks; the daguerreotype had to be sensitized immediately prior to use.

To attract attention to his new enterprise and to capitalize on still another advantage of the calotype, Prevost undertook to create photographs in giant sizes that were far beyond the capability of the daguerreotypist, who was limited to the availability of polished silver-on-copper sheets. Accordingly, he made some calotypes as large as 18 by 22 inches at a time when the "large" daguerreotype was the so-called full plate, 6½ by 8½ inches. The Prevost samples were eight times that size!

The same year, 1853, was the year of New York's Crystal Palace Exhibition, showplace for the science and arts of the nation. The award of the first prize in photography at that event was surely as shocking to Prevost as it must have been to Brady, Gurney and the other daguerreans. The coveted prize was won by a well-known photographer of Boston fame, John Adams Whipple. His entry was done with the recently developed wet-plate system, which used the calotype idea: initial creation of a negative (on glass) and follow-up darkroom work to make one or more positives (on paper). Prevost prints by the wax-paper method won several honorable mentions.

Prevost soon found that although his portraits could be made in a number of copies, larger and at less expense to his clientele than the daguerreotype, the public simply did not like the softer, more gentle paper portrait as much as it did the brilliant and voguish miniature likeness of daguerreotypy.

From time to time Prevost sent his fine photographs to the magazines of the photographic industry. Unable to reproduce them for their readers, the publications could nevertheless praise the fine art of the maker. In the February 1854 issue of *The Photographic and Fine Art Journal* it was reported that "some very fine photographic views of scenes on the North River from Messrs. V. Prevost and C. Derchauchois" [sic] had been received.

In a later issue it was reported that "M. Prevost is about issuing a most remarkable and valuable work, one that will perhaps command more attention than anything that had been issued from the press for many years. We shall notice it further, on its appearance."

The forthcoming work never appeared. The photographs that Prevost was making in the streets and hills of New York, from the foot of Broadway to the tree-covered slopes of northern Manhattan, are known today only to those historians and scholars who have access to the prints at the New-York Historical Society and the Museum of the City of New York, from whose files publishers now draw material. Some few dozens of the original prints of this effort remain.

Unable to attract sufficient clients, Prevost's gallery closed its doors just three years after it had opened. Prevost was then only thirty-four. For a time thereafter he was an operator (photographer) in the gallery of Charles D. Fredericks, a successful daguerrean who wanted someone experienced in the paper print style of photography. A few years later Fredericks would pioneer the introduction of the carte-de-visite to Americans (see Chapter 5).

It was the beginning of the end of Prevost's photographic career. Shortly there-after we find him teaching art and physics at an institute for young ladies operat-ed in New York City by his wife's aunt. From the third-story window of the school, Prevost made calotypes of the Church of the Incarnation directly across the street. He left the institute for positions at two other schools in the New York area.

His negatives had an equally ignominious fate. They were given in 1898 to a photographer, W. I. Scandlin, after having lain for thirty years in the attic of a student. The photographic world is indebted to Scandlin, who recognized their unique nature, conducted the necessary research to identify their maker, and in 1901 lectured on Victor Prevost before the Photographic Association of America. Ultimately, thirty-six of the more than one hundred surviving paper negatives (along with Scandlin's notes on Prevost) came into the possession of the New-York Historical Society.

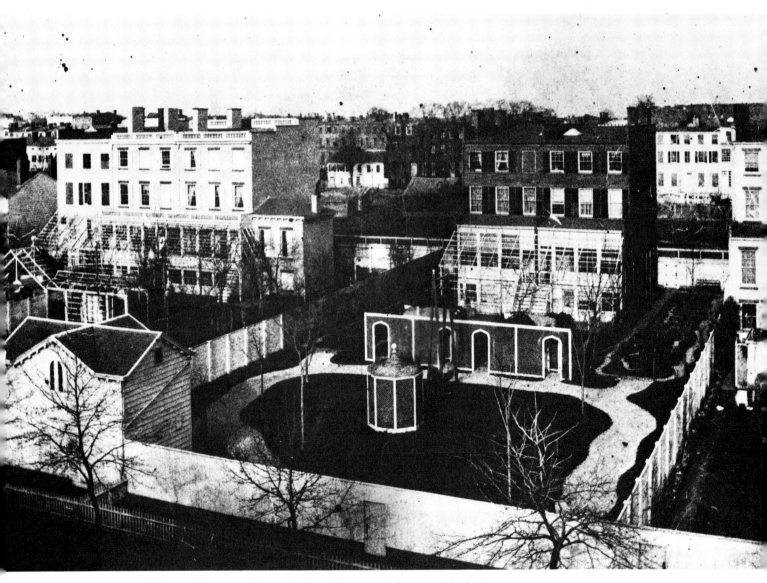

A Prevost cityscape, taken about 1853, was made in upper Manhattan.
Details of latticework within window frames are clearly visible in the original
print, which is approximately 10 by 12 inches. (*Collection MusCNY*)

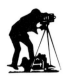

Prevost calotyped the New York harbor with steam and sailing ships at berth around 1853. Despite long exposures and the slight movement of the ships at anchor, the paddle-wheeler *Elm City* is easily identifiable (*center right*). (*Collection MusCNY*)

Victor Prevost (1820–1881) made this calotype negative and calotype process positive of the *Metropolis* at berth in the New York harbor about 1854. (*Collection MusCNY*)

R. Bruce Duncan, photo historian and print expert, points out in the Fall 1976 *Graphic Antiquarian* that "when you eagerly search for the earliest known photographs of New York City, you do not find the works of such successful daguerrean artists as Brady, Gurney or even Root. You will find only the single name of a photographer who lasted in business just three short years. A man who was but a glorious failure Victor Prevost, calotype artist."

THE AMBROTYPE
The Negative Viewed as a Positive

The rage for photography was overwhelming. In every major city photographic galleries, like exhibition rooms in the finest museums, made it possible for everyone to see and to acclaim photographic likenesses—and to consider a suitable time for arranging a sitting. In the earliest years some studio-galleries had from three hundred to a thousand sittings a day.

Few of the photographs made in the mass production centers were larger than a playing card, and most were only half that size. Encased in their protective leather, wood or molded housings with the delicate daguerrean image under glass, the miniatures were an endless source of amazement. Although at first they cost about $5 (more than a week's wages for a workingman), it was not long before studio competition brought prices down to a dollar, then fifty cents, and, finally, to the outrage of the leading photographers, twenty-five cents.

The daguerrean process had severe limitations that plagued photographers. The process required costly special silver sheets rolled onto a durable but expensive copper backing, and the plates were not factory-readied for immediate use. One could not simply place them in a camera, make an exposure, then complete development and delivery. Reinforcement of the silver surface with electroplating, followed by polishing and sensitizing, were time-consuming preludes to the operations of the studio, where subjects waited with apprehension more suitable to the nearby Painless Parker dental gallery, probably only screaming distance away.

Following its exposure, the daguerrean plate was taken to the darkroom for processing over the dangerous fumes of heated mercury. Then, before it could be marred by fingerprint, dust or grit, it had to be sealed with paper tape at its edges against a freshly cleaned pane of clear, thin glass. When the sealed sandwich had been given the protection of a leather or thermoplastic case, the portrait could at last be shown to a waiting client.

Thousands of people with a scientific bent, an artistic nature and an experimental personality learned the intricacies of this procedure, which made it possible at last to "fix" the image on the groundglass of the camera obscura. Experiments to improve and simplify calotypy continued, the adherents of its paper negative and

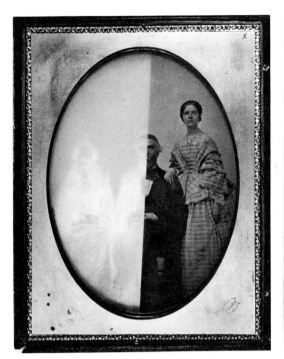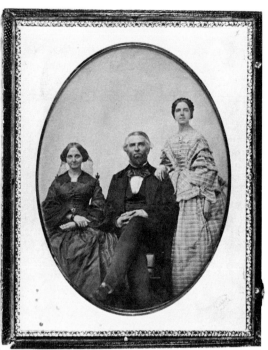

A Brady Gallery ambrotype rephotographed with a white card behind half of
the image-bearing plate reveals the weak negative (*left*). The same
photograph with the negative viewed against an all-black background gives
an ambrotype (positive) effect. (*Collection MusCNY*)

paper positive print procedure hoping to achieve the brilliance and detail charac-
teristic of the image created by daguerreotypy.

But calotypists, whose procedure involved the creation first of a negative on a
sheet of paper, then a positive in a separate darkroom process of contact printing,
were limited in their ability to obtain precise, sharp images. The granularity of
the paper interfered with the reproduction of detail when light passed through the
translucent paper.

Some photographers hoped to get a more satisfactory result from the creation
of the negative on a clear material such as glass. The problem was that no one
had had significant success in making light-sensitive materials such as silver ni-
trate adhere to the surface of glass. All of the liquid solutions ran like rain on the
pane.

In the 1840s experimenters had tried to use a variety of sticky matter that
would adhere evenly to a glass surface. In *The History of Photography* Beaumont
Newhall mentions experiments with "the gluey slime exuded by snails" among the
wide-ranging, trial-and-error efforts. Greater success was obtained with egg
white. In 1847 the pioneering French photographer Claude Félix Abel Niépce de
Saint-Victor (1805–1870), using the albumen of eggs mixed with silver salts,

●‖● THE PERIOD OF THE AMBROTYPE ●‖●

| 1800 | 1810 | 1820 | 1830 | 1840 | 1850 | 1860 | 1870 | 1880 | 1890 | 1900 |

achieved a sensitized glass plate. His experimental albumen negatives, brilliant and rich in detail, permitted positive prints that far surpassed Fox Talbot's paper-negative calotypes. While many photographers saw in calotypy's lightweight paper negative the possibility of field trips without the problems caused by the weight and fragility of glass, many more were impressed by the clarity of detail possible with an on-glass negative.

In 1851 a new development so revolutionized glass plate photography that it won over even the remaining enthusiasts of the on-paper system. In the late 1840s the medical world had learned about collodion, a tough, transparent membrane of fast-drying chemicals that could be used as a new "skin" to cover burns and bruises until the patient could generate a normal skin in the damaged area. This substance, a simple mixture of guncotton in alcohol with ether, found an even greater potential in photography. Readily and inexpensively manufactured, it made a superb emulsion.

Collodion was first used for a photographic purpose by Frederick Scott Archer (1813–1857), an English sculptor with an interest in photographic science. Archer saw in the tough skin a way to save glass photographic plates that had been broken following some of his albumen process experiments. The collodion skin was so strong that it kept segments of broken glass together. The procedure Archer recommended to his English contemporaries was already known to Gustave LeGray, who had conducted similar collodion experiments in France some years earlier. History has failed to honor LeGray for his collodion pioneering, but his later contribution to wax-paper calotypy was an achievement that he shared with no one.

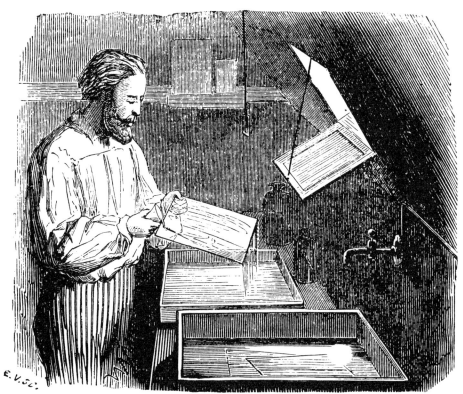

The heart of the ambrotype process was the coating of a clear glass plate with collodion, a syruplike, quick-hardening material which could absorb light-sensitive chemicals to become the so-called wet-plate.

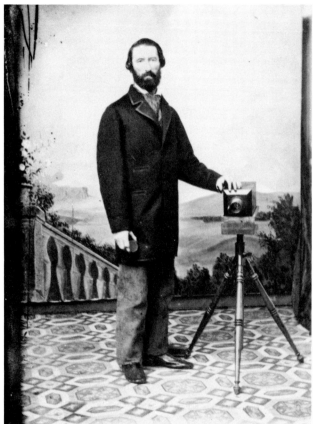

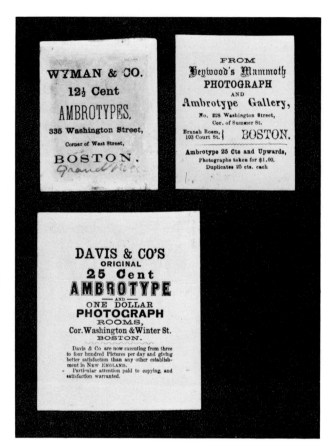

Left: A photographer of the ambrotype period, Peter Britt of Jacksonville, Oregon, is shown with his quarter-plate American chamfered front camera of daguerrean origin. (*Collection SOHS*) *Right:* Trade cards of the ambrotype studios were customarily sealed in the back of the ambrotype case. These Boston cards show ambrotype prices, ranging from 12½ cents to one dollar for "photographs" (albumen paper prints in larger sizes). (*Collection GG*)

Then, in *The Chemist* of March 1851, Archer suggested a new procedure, one in which the collodion skin would carry the exposed and developed image and could be peeled away from the glass plate (thereby enabling a single plate of glass to be used repeatedly in the field). Few photographers were interested in the idea; most were content to enjoy the benefits of a negative on glass based on a collodion emulsion and a follow-up paper print coated with a light-sensitive emulsion made from the egg white and silver salts.

But some noted that when the negative produced by Archer's process was placed before a dark cloth or other dark background, it could be viewed as a positive (thereby eliminating the need to make the positive paper print). The highlights were seen in the greyish-white tone of the developed collodion emulsion. The shadowed areas, being more or less transparent, revealed something of the black background. The tonal range was thus extended from grey-white to black.

This on-glass positive, readily made in the cameras of the daguerreotype process and on the glass already available in the studio to cover the daguerreotypes, also needed the protection of the daguerreotype-style cases.

Archer's collodion photography made possible a new system of photography, one that had been predicted by Herschel, who had reported the effect as early as 1840. Archer's invention, given freely to the scientific world, was patented in the

An 1856 trade circular from E. Anthony, the leading photographic supply
house until the twentieth century. Anthony manufactured cases and
chemicals for ambrotypes.

ambrotype variant by a Philadelphia daguerreotypist, James Ambrose Cutting
(1814–1867), in 1854. Cutting's contribution was to seal the image between two
sheets of glass with canada balsam, a gum then used by microscopists for sealing
specimens between glass slides. The ambrotype process has since been identified
with the patentee rather than with the inventor who showed how collodion could
be the carrier of light-sensitive chemicals.

The ambrotype took three major forms, each differing only in the way that the
black background, without which the positive viewing effect could not be seen,
was created. In the first and most popular form, the photographer created the

necessary black background under the image by painting the reverse side of the pane of glass bearing the image with a black varnish. Today many ambrotypes are found with parts of the black background flaking away, creating "holes" in the image. In the rare case where the emulsion remains, a touch-up job with black paint (such as auto body enamel) immediately restores the image.

The second form of ambrotype involved the replacement of the black varnish on the glass with a backing of a single sheet of black paper. The third variant came from the glassmakers, who made available glass of a deep purple hue that appears a nearly opaque black when set into the protective case without a black varnish coating or other black background.

Almost invariably the glass bearing the ambrotype image is found in a protective case. And nearly always there is a double layer of glass, as described in the Cutting patent of 1854, with the top pane serving to protect the underlying image from fingerprints and scratches. The underglass that bears the image is generally secured to the top glass by a thin metal gilt frame. In some instances the two panes were separated by a gilt mask that provided a formal setting for the portrait. The two panels of glass, the internal metal mask and the metal binding frame were then force-fit into the presentation case.

The system of outer case, edge and inner mask was made available in all the popular portrait sizes of the day, ranging from the tiny one-sixteenth plate (1⅝ by 2⅛ inches) to the maximum image size of cameras at that time, full plate (6½ by 8½ inches).

A New York (and later, Philadelphia) photographer, Marcus Aurelius Root (1808–1888), gave the process its name. He recounted the history in his memoir, *The Camera and the Pencil.*

The ambrotype on glass required a case for protection. One unusual dual-purpose case was created by J. F. Mascher, who patented stereo ambrotypes in cases with built-in viewing lenses. (*Rehn stereo ambrotype, Collection RAV*)

Ambrotypes by their nature cannot provide the brilliance of either the daguerreotype on silver or of later prints on paper. (*Collection GG*)

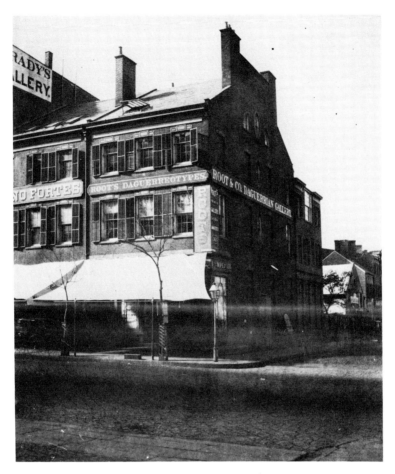

The New York gallery of Marcus Aurelius Root, a prominent
New York and, later, Philadelphia daguerreotypist who named
the ambrotype process from the Greek *ambrotos,* "imperishable
picture." (*Collection N-YHS*)

This process was first introduced, in 1854, into various Daguerrean estab-
lishments, in the Eastern and Western States, by Cutting and Rehn. In June of
the year [1854], Cutting procured patents for the process though Langdell had
already worked it from the printed formulas.

The process has since been introduced, as a legitimate business, into the
leading establishments of our country. The positive branch of it; i.e., a solar
impression upon one glass-plate, which is covered by a second hermetically
sealed thereto, is entitled the "Ambrotype" (or the "imperishable picture"), a
name devised in my gallery.

Although some believed that the process had been given Cutting's middle name,
Ambrose, Root had in fact taken the term from the Greek work *ambrotos* (im-
mortal, imperishable). While the "imperishable" ambrotype has in the main sur-
vived the years in admirable condition, those made on glass by the process that
used black paint or varnish as a background often show heavy flaking that has
materially diminished their photographic purity. The fragility of the glass itself
has meant the total loss of many more.

The studio gallery of (M. A.) Root & Co. at the corner of Franklin Street and
Broadway in New York City has been memorialized in an 1853 calotype by Vic-
tor Prevost (see photo at top of page).

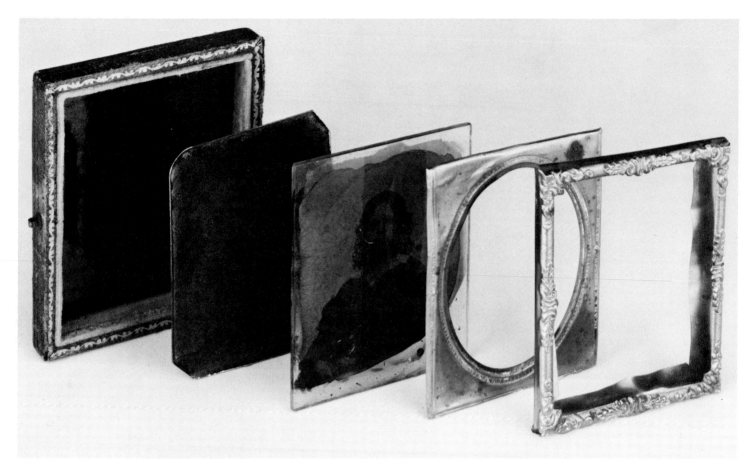

The assembly of the elements of the ambrotype was similar to that of the daguerreotype. First is an outer protective case of wood, thermoplastic or gutta-percha. Then comes a packet of a backing of black paper, cloth, or even metal; the on-glass image, emulsion to front and black varnish on the back; a brass die-cut frame; and finally, a gilt border of thin brass to edge-wrap the frame, glass, and backing.

The cases used for most ambrotypes were those of the daguerreotypists of the day and of the tintype makers who followed. This use has led many naive collectors to mistake ambrotypes for daguerreotypes or tintypes, a confusion compounded by the fact that images made by those processes were often enhanced by gilt frames and masks similar to those placed over ambrotypes. That the daguerreotype reveals itself to be a mirror at some angles of view immediately distinguishes it from the ambrotype; however, it is often necessary to open the case itself to determine whether the photograph is an ambrotype or a ferrotype (tintype). The ferrotype, a fourth form of the ambrotype, is made on a thin sheet of metal rather than on glass (see Chapter 4).

The ambrotype flourished during the final years of the daguerrean process, from 1854 to the end of the Civil War; few examples are to be found that precede or follow this period. By the end of the Civil War all studios had been converted to delivering positive prints on albumen paper from glass negatives made by the collodion wet-plate process or the low-cost tintype. While the daguerreotype image offered a superior brilliance and an unmatched wealth of detail, the trade price lists of the day show that the cost of materials to the photographer made it more profitable for him to promote ambrotypy than daguerreotypy. In addition,

colorists of the gallery could more easily add a suggestion of rouge to cheek or lips on the ambrotype. Golden earrings, buttons, watch chains, pendants and brooches were also painted on, the miniature portrait suggesting that the subject was a person of substance.

Ambrotypy was not without its disadvantages, the most important of which was the relatively slow speed of the collodion emulsion. Photographers reported that it took twenty seconds of exposure time in a gallery when the daguerrean system ordinarily required just two seconds. Part of the problem lay in the fact that the emulsion speed changed rapidly. When the emulsion was fresh, it could provide speeds equal or close to that of daguerreotypy; however, with posing and other delays the wet plate dried, becoming slower in its response to light and even completely insensitive.

A second disadvantage was the fragility of its glass. The metal-based daguerreotype could withstand the rigors of travel, and it could be cut to fit a locket or watch case.

However, the principal advantage of the ambrotype more than made up for its disadvantages: it cost less to produce and it could be sold profitably at a low price. Ambrotypes were offered to the public at half the price (and less) of daguerreotypes. When the Brady Gallery was making portraits by daguerreotypy for one dollar and complaining of competition from other daguerreotypists at fifty cents, some ambrotypists were already selling their product in cases for as little as ten cents, others for twenty cents. The costliest ambrotypes never reached the price of the most expensive daguerreotypes.

DIALOGUES NO. 8.

BEADLE AND ADAMS, 98 WILLIAM ST., NEW YORK.
General Dime Book Publishers.

• THE AMBROTYPIST RISKS HIS LIFE

"That's me! It can't be! Oh, no. Truly I am neither so weighty or so . . . frightened an individual. Sir, perhaps there are ways to make me (slimmer, taller, happier, more hirsute, etc.)."

A humorous playlet of the mid-nineteenth century, printed in *The American Miscellany and Beadle's Dime Dialogues,* is titled, "Getting a Photograph." The subject of the four-character sketch is the reaction of a country bumpkin who has been taken by two city cousins for his first visit to a gallery. The humor of the sketch depends on the mayhem threatencd by the initiate to photography when he is shown his likeness.

Joshua says, "If you say that's me, it's the biggest lie you ever told, and I'll fix ye for telling it. I'll——" The photographer saves himself from harm by retiring to a darkroom where he will be safe behind the locked door until the cousins persuade Joshua to leave the premises. [Curtain.]

(*Collection GG*)

Root wrote of the ambrotype:

> This species of picture had, at its very outset, an extraordinary popularity, which however, for reasons stated otherwise, has palpably and generally declined, so that, at present [1864], comparatively few are made. Positives taken upon enamelled or japanned iron plates [tintypes], instead of glass, are, at this date quite popular.

▞ JAMES CUTTING AND THE INTRODUCTION OF AMBROTYPY

Herschel's experiments in 1840 had shown that a thin negative could be made to appear to be positive by showing it against a black background. Cutting did not try to patent this essential technical basis of ambrotypy.

Though the patent that he obtained in 1854 in the United States and England protected only the image with a glass cover, he hoped it would make it possible for him to sell licenses. Photographers, he foresaw, would leap to the acceptance of ambrotypy. It was a shrewd plan, and for a time he enjoyed considerable prosperity as photographers rushed to change from on-metal to on-glass photography.

However, photographers soon began to use the process without paying for the Cutting license. Earlier they had successfully resisted efforts to sell them licenses to practice photography by a specific process when the Langenheims of Philadelphia sought to license calotypy in the United States in 1849. And many photographers had begun to use collodion wet-plate negatives instead of ambrotypes and to make albumen prints from glass plates (see Chapter 7).

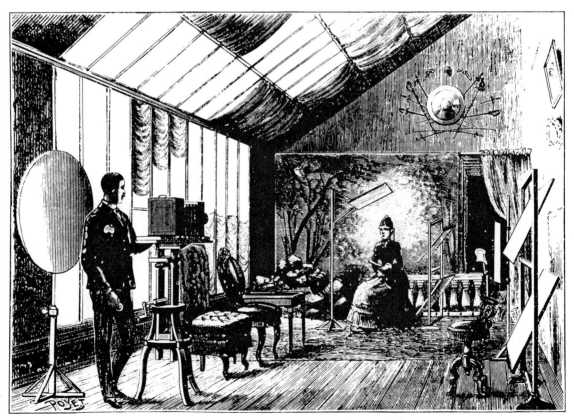

In the pre-electric era, studios used a combination of large windows, overhead skylights and a variety of bright reflectors and light-diffusing screens to create pleasing light and dark arrangements for quality portraiture. (*Collection IMP/GEH*)

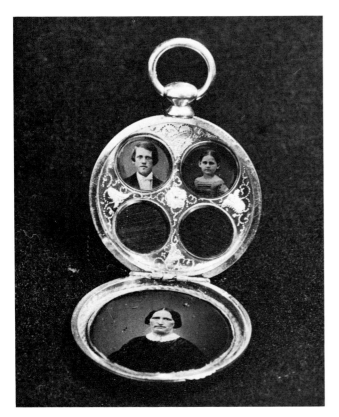

Although ambrotypes were made of glass, ambrotypists found ways to create miniature images that could be fitted into jewelry. (*Collection J/SS*)

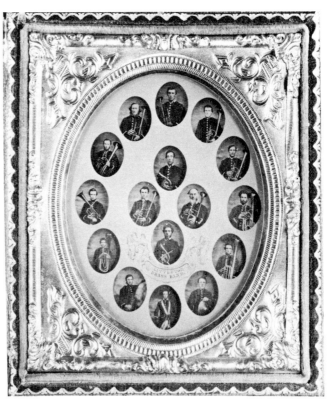

Multiple ambrotype in this group portrait of the Littleton Brass Band, shown here close to actual size, was a copy-photography feat. (*Collection HA*)

The patent that Cutting owned did not claim the invention of the ambrotype process. In fact, he was not even the first to make ambrotypes in the United States. That honor, according to Root, belonged to the photographer-experimenter Dr. Giles Langdell, who called his image the melanograph.

> In 1853, Dr. Giles Langdell . . . procured, while residing in Boston, a published account of Archer's process [collodion], and after several experiments succeeded in making very good collodion portraits on paper. My impression is that he was the first to operate successfully with this process in the United States.

It was Isaac Rehn, a painter-cum-daguerreotypist, who with Cutting became the ambrotype's principal promoter. His demonstrations of ambrotypy in numerous galleries and cities in 1854 and 1855 also included the making of glass stereographic pictures and "up to life-size [prints] by the solar camera enlargement," Root said, "executed, with remarkable excellence and beauty, by his artistic genius and skillful manipulation." Rehn's demonstration of the process to Root in 1854 had led to Root's suggesting the name *ambrotype*. Within a year the name had caught on, and the early designation, "daguerreotype on glass," which had been used to distinguish the new process from its precursor, soon disappeared from the galleries' advertising.

In *The Photographic and Fine Art Journal* for December 1854, a note from Philadelphia mentioned the advantages of ambrotypes: "They can be better protected from the influence of the atmosphere—much better—and are not marred by the double reflection so annoying in the daguerreotype."

AMBROTYPES;

--OR,--

Positive Collodion Pictures on Glass.

DEAR SIR,—Having been called upon by many Photographic Artists and others who have examined my POSITIVE COLLODION PICTURES (*Ambrotypes*), to sell my Process, I have at length concluded to do so, and give all an opportunity of practising it at as early a period as possible. The process I employ has never before been presented, but has remained in the hands of those whom I have personally instructed, and is known only to them and myself. The *New York Tribune,* in speaking of my specimens, says:—

"The Glass Process which Mr. HUMPHREY employs is certainly one which produces rare and beautiful results. The monotony and harshness of the old Daguerreotype is entirely obviated, and in its stead we see clear, well-defined impressions, perfectly distinct in every light. An art numbering among its warmest supporters a man of such scientific skill as Mr. Humphrey, must reach the highest point of perfection."

From the *Herald:*—

"The Ambrotypes produced by Mr. HUMPHREY are the most perfect specimens of art we have seen. They are rich, clear and brilliant."

From the *Painesville Telegraph:*—

"The glass pictures are far more beautiful than those taken upon metallic plates, and wherever introduced will occupy the entire ground. They possess a rotundity, a softness, a commingling of light and shade, a distinctness and delicacy of tone, which Daguerreotypes never attained. Somewhat different processes, we understand, are used by different artists in making this style of pictures; but the process adopted by Mr. HUMPHREY seems to *excel,* in its *finish and brilliancy.* Wonderfully beautiful is this whole business of making pictures by sunlight."

From the *Times:*—

"A new and important improvement in *Ambrotyping.* Mr. HUMPHREY has a process for producing in all the beauty of art, and with a faithfulness unrivaled by any we have heretofore seen. This gentleman's process is calculated to produce a great effect upon the Daguerreotype plate business."

The three following extracts are from papers speaking of my specimens, while with persons whom I was teaching, in their vicinity. From the *Cleveland Plaindealer:*—

"That it is a great stride towards perfection in this wonderful art, is evident to the most unscientific observer. The polished surface of the plate no longer casts glaring reflection into the eyes. A clear and well-delineated likeness stands out in relief, and is seen with ease, though held in any position."

From the *Portage Democrat:*—

"The Ambrotype likeness is produced on glass : the likeness is brought out in more full, round and life-like proportions than in the old process : it has not the glare of the old polished plate, but can be viewed with the ease and distinctness of an engraving : it is positively indestructible to the action of the atmosphere, or water, and cannot be tarnished or injured even by washing and rubbing. Likenesses by this process can be taken in all weather, and at a few seconds' sitting."

From the *Summit Beacon:*—

"We have just been invited to examine an entirely new class of pictures, called AMBROTYPES, taken on glass, instead of metal plate. There is a degree of perfection about these pictures, which renders them much more valuable than ordinary Daguerreotypes : they can be seen from any position, as distinctly as a lithograph, there being none of the glare observable on the plate. By a new chemical preparation, the likeness is so protected as to remain unchanged by atmospheric influences, and is unaffected even by the touch. The Ambrotype must, we think, in time, supersede the old process."

I now offer the following extracts from letters received from those whom I have instructed in the art :

"I wish you good success. I am perfectly delighted with the business. I would rather put up four Ambrotypes than one Daguerreotype. It all goes right. J. G. M."

"I meet with success. I have made some collodion from the cotton you prepared, and it works fine. W. B. M."

"I am highly pleased with the Ambrotype process, and am taking some very fine pictures,—as good as I have ever seen. S. J. M."

The full names have been omitted in the above, and the initials only given. They are persons well known in the photographic world, and I understand are doing a good profitable business. Many more extracts and quotations might be given, but enough has been already said to convince the most fastidious.

In presenting my process, I have been very careful to give minute directions, and I feel convinced that any person of ordinary understanding can take it up and proceed to practice with a good degree of success. I have introduced WOOD CUTS to *illustrate* some of the more difficult manipulations, and every precaution has been taken *to make this Work a perfect* TUTOR in every respect. Things that to an experienced person would appear useless, have here been mentioned. It is well known to every one, that in learning the Daguerreotype business, it was the *little* things that were so liable to be omitted, and that *great* troubles arose from such omissions.

THE AMBROTYPE PROCESS

is published in pamphlet form, of convenient size (duodecimo pages), and is accompanied by JAMES A. CUTTING'S specifications for his patents, now generally known as WHIPPLE, CUTTING & Co.'s Patents ; being CUTTING'S Process, as placed on file in the United States Patent Office. By these every one will see what is necessary to avoid infringing upon said patents, and can work accordingly.

Also, another and later patent, by JAMES A. CUTTING, giving his perfect process for cementing the glasses on Collodion Positives ;—a patent which has been sold for *thousands of dollars.*

Chemicals.—The most carefully-written formulæs for preparing chemicals are given, with comments upon their qualities and the best method of obtaining them, and of ascertaining their strength and purity.

The *Recipe for Making my Collodion* is alone worth, to any person engaged in the Art, several times the price charged for the entire process. In the treatise will be found the method for preparing

Soluble Cotton.

This plan I have of late tried many times, and in no instance has it failed. It produces a Collodion of fine film, clear and transparent. The formula for

Iodizing Collodion

is so plain and simple, that any one, no matter whether he be acquainted with chemistry or not, can by following the directions, succeed in producing good results. It is *the most durable article in existence.* I have kept it for six months unimpaired—giving, after that lapse of time, the *finest possible results.*

The formula herein presented, for preparing my

Developing Solution,

is one peculiarly adapted to meet the wants of every operator, and its effects upon the picture are unrivaled.

Fixing Solution,

the most approved in use.

Brightening and Finishing the Image.

The article used for this purpose is mentioned, and *has no equal.*

Backing the Image.

The method for doing this is with either a single or double glass. Also, the *Recipe for Making the Varnish.*

Nitrate of Silver Bath.

This *important* subject is given in full detail, and with great care. No one can succeed without a *good nitrate of silver solution,* and to prepare it and then produce a collodion adapted to it is a matter of *vast importance* to every Photographer. All the chemical changes are given, with full directions for their preparation. An *illustration* (wood cut) is given, representing the most approved bath for the solution.

MANIPULATION.

Under this head is given thorough and complete information upon the *mode of operating—illustrated* with wood cuts showing the various positions of holding the glass plate, &c. ; how to clean it, what with, &c. ; with *remarks* upon various points connected with the process, giving hints, cautions, &c., from the commencement of cleaning the glass to the completion of the picture.

There is a chapter devoted to the different freaks attendant upon working the collodion, such as *fogging, spotting, specking, waving,* &c. ; their probable cause is pointed out, and the means of obviating them.

NEGATIVES ON GLASS.

I have given a process for producing these pictures, which has proved very satisfactory for its uniformity of action, and the beauty of the results. With this will be found a formula for *iodizing collodion* adapted especially for negatives.

The Printing Process

is illustrated with wood cuts, &c. Everything has been done to make this as perfect as possible, and give a process which will produce good and PERMANENT impressions, together with the most approved methods of preparing the chemicals employed in my process.

Enough has been said to show that although the work is *small,* it contains *a vast amount of practical information,* and is UNEQUALED by any heretofore published in America. I feel confident that any one can take this *manual,* with all its *illustrations,* and, without any other instructor, produce good and satisfactory results.

☞ ORDERS will be attended to with dispatch, and answered by return mail, or as may be directed.

TERMS—FIVE DOLLARS PER COPY, in advance. *Postage Stamps taken at their value.*

*** All moneys may be sent by mail at my risk, provided the letter containing it is *registered* by the post-master. Address

(NEW YORK, JANUARY, 1856.) **S. D. HUMPHREY, New York.**

An 1856 trade circular from S. D. Humphrey, publisher of the photographic magazine *Humphrey's Journal,* offered his book, *Ambrotypes; or Positive Collodion Pictures on Glass,* for five dollars to teach the new technology to daguerrean establishments.

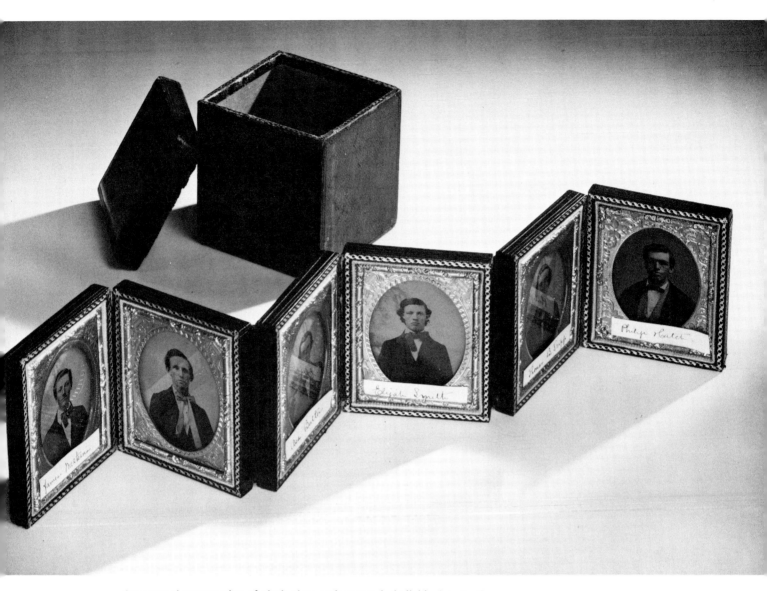

An unusual presentation of ninth-plate ambrotypes in individual protective cases arranged in an accordion-fold frame for shelf display. The leather case provides storage and additional protection. (*Collection HA*)

According to Robert Taft, a twentieth-century historian of American photography and the author of *Photography and the American Social Scene*, the first mention of the ambrotype by name occurs in Humphrey's *Daguerrean Journal* for February 1, 1855, as part of the description of Rehn's work at the fair of the Franklin Institute in Philadelphia.

With sample photographs and the materials necessary for their creation, Rehn and Cutting left Philadelphia to take ambrotypy to their contemporaries. As inventors of the use of the chemical bromine to speed up the collodion process (as it had assisted in the improvement of daguerreotype making), they had ready access to practitioners who sought to learn a proper new use for bromine. They sold rights and taught the ambrotype process along with the use of the bromine. Their sales efforts had only limited success; in a later court case relating to the patent, Rehn revealed that they had taken in only the costs of the trip—about $3,000—during their selling period.

3. Making the Exposure • The plateholder was placed at once in the camera, which had been aimed and focused on the subject. In sunlighted situations a five-second exposure was made by uncapping the lens after the dark slide had been removed from the plateholder. Indoors the exposure might be as long as twenty seconds. Following the exposure, the lens was recapped, the plateholder was again made light-tight by the replacement of the dark slide, and without delay it was taken back to the darkroom. (The plate would lose its sensitivity and usefulness once it began to dry.)

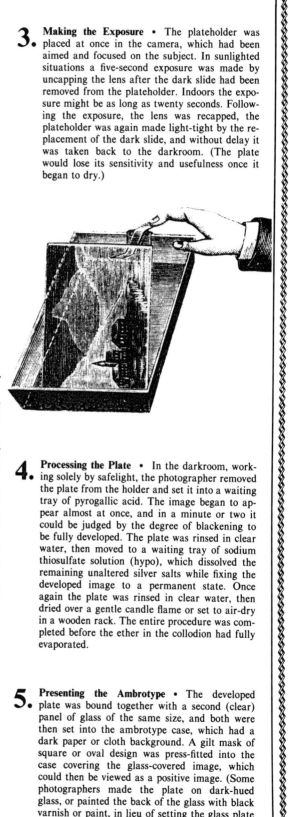

🔲 MAKING THE AMBROTYPE

1. **Readying the Plate** • After having washed or cleaned the glass to remove grit, fingerprints and other marks, the photographer, working in ordinary room light, poured a small pool of the viscous collodion onto the center of the surface of the glass. Holding the glass in both hands, he tilted and rotated it until the slow-running coating completely covered the plate almost to its edges. (The edges could not be part of the picture area because they secured the coated plate in the plateholder, in which the plate was taken to the camera in the gallery. The plateholder was essentially a shallow tray with a light-tight cover that was removed only after the plateholder had been fitted to the camera.) When the tip/tilt procedure had been completed, the excess of collodion was poured off the plate by tilting it at a high angle and aiming the lowest corner at the open mouth of the collodion storage bottle.

2. **Sensitizing the Plate** • The darkroom was made light-tight and the photographer, working by yellow safelight, placed the plate in a tray of the sensitizing agent, silver nitrate. When the plate had taken on a creamy-yellow appearance, usually in one to two minutes, it was removed from the tray and drained. While it was still wet and tacky, it was set into the open plateholder. The plateholder cover (or dark slide) was slid into place to protect the plate during its trip from the darkroom to the camera. The silver nitrate bath was returned to its light-tight storage bottle. At that point the photographer could once again function by ordinary room light.

4. **Processing the Plate** • In the darkroom, working solely by safelight, the photographer removed the plate from the holder and set it into a waiting tray of pyrogallic acid. The image began to appear almost at once, and in a minute or two it could be judged by the degree of blackening to be fully developed. The plate was rinsed in clear water, then moved to a waiting tray of sodium thiosulfate solution (hypo), which dissolved the remaining unaltered silver salts while fixing the developed image to a permanent state. Once again the plate was rinsed in clear water, then dried over a gentle candle flame or set to air-dry in a wooden rack. The entire procedure was completed before the ether in the collodion had fully evaporated.

5. **Presenting the Ambrotype** • The developed plate was bound together with a second (clear) panel of glass of the same size, and both were then set into the ambrotype case, which had a dark paper or cloth background. A gilt mask of square or oval design was press-fitted into the case covering the glass-covered image, which could then be viewed as a positive image. (Some photographers made the plate on dark-hued glass, or painted the back of the glass with black varnish or paint, in lieu of setting the glass plate against a dark background.)

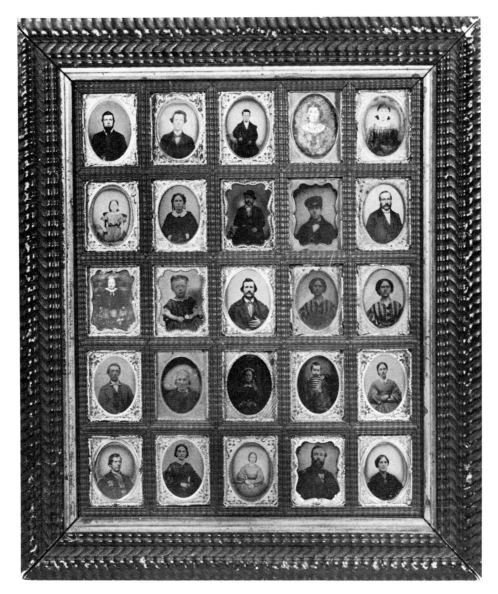

These ninth-plate ambrotypes are arranged in a family frame to be shown at
home. This assemblage made it possible to display cased images in an
organized manner. By 1863, with the appearance of the carte-de-visite,
album presentation became commonplace. (*Collection A/HW*)

The rise and fall of ambrotypy was swift. By 1855 ambrotypes had become
known to the public at large, and by 1856 they were the most fashionable form of
photography. In 1857 the process was already being challenged by newer and
more convenient methods of making photographs on paper. Yet another star was
rising with the emergence of the tintype, an adaptation of ambrotypy that pro-
duced images on metal.

In 1858 the ambrotype had proven itself to the extent that it had become a tool
of the New York Police Department. The Rogues' Gallery, a police exhibit of the
portraits of 450 known criminals, was described in the *American Journal of Pho-
tography* in 1859.

> The pictures are all ambrotypes of the medium size [quarter-pˡate?—*Edi-
> tor*] neatly put up, and displayed in large show frames, protected by glass
> doors. The photographer, Mr. Van Buren, is a regularly appointed policeman.

The interior of an Isaac Rehn case gives an explanation of the additional protection provided by the Cutting patent: varnishing the *second* glass cemented to the image-bearing glass. (*Collection GG*)

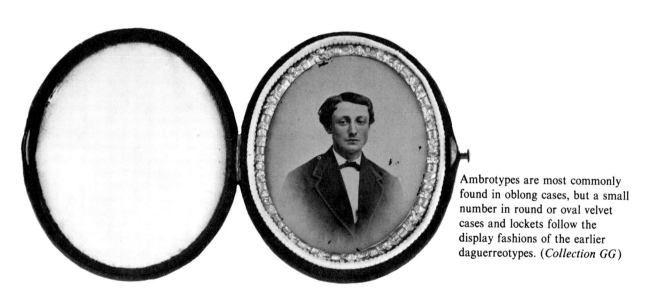

Ambrotypes are most commonly found in oblong cases, but a small number in round or oval velvet cases and lockets follow the display fashions of the earlier daguerreotypes. (*Collection GG*)

In 1862, with the Civil War in progress and portraiture never before so important in family life, photographers were enjoying a boom equal to that of the time of the original announcement of photography twenty years earlier. The news magazine of the industry, Humphrey's *Daguerrean Journal*, noted that such leading studios as Bogardus, Anson, Gurney and Williamson of New York had been making miniature portraits on metal (these were tintypes, not daguerreotypes) and that "the ambrotype is indeed in little demand now."

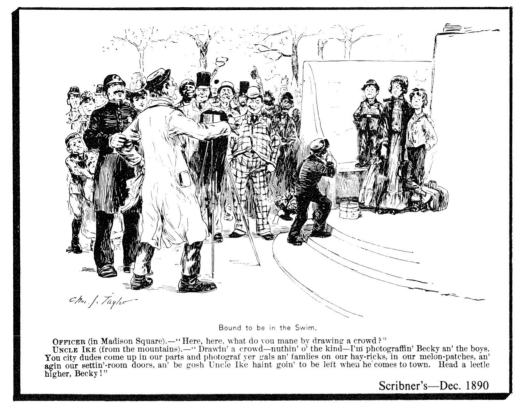

Bound to be in the Swim.

OFFICER (in Madison Square).—" Here, here, what do you mane by drawing a crowd?"
UNCLE IKE (from the mountains).—" Drawin' a crowd—nuthin' o' the kind—I'm photograffin' Becky an' the boys.
You city dudes come up in our parts and photograf yer gals an' famlies on our hay-ricks, in our melon-patches, an'
agin our settin'-room doors, an' be gosh Uncle Ike haint goin' to be left when he comes to town. Head a leetle
higher, Becky!"

Scribner's—Dec. 1890

Smaller cities were served by the traveling ambrotypist, who carried his darkroom and studio equipment in a wagon and created ambrotypes on hotel porches and in light public rooms. (*Collection GG*)

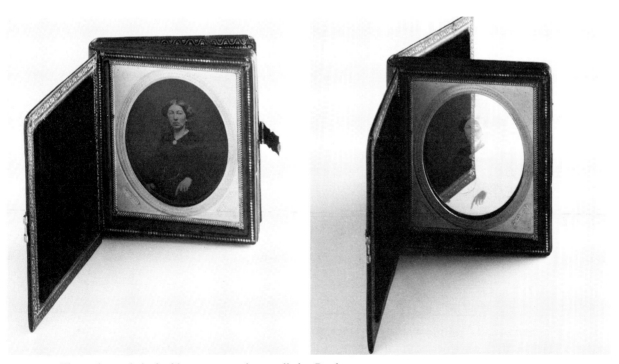

The ambrotypist's double-case, sometimes called a Brady two-way open case, permitted viewing of the image from either side. With the back open, the negative/positive of the image-bearing glass is clearly evident. (*Rehn ambrotype, Collection MRI*)

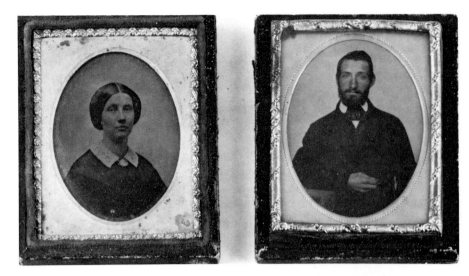

Traditional ambrotypes are posed against light backgrounds. By the end of the Civil War ambrotypes were no longer sought by the public or offered by the trade. (*Collection GG*)

The reign of the ambrotype had been brief, but it had brought substantial earnings to Cutting and heirs, both from the 1854 patent and from the extension of bromine with iodine as a speed-up for the collodion emulsion. This improvement in wet-plate processing eventually had benefits far beyond the immediacy of the ambrotype process. But Cutting sought without success to have the United States government pay for the right for government photographers to use bromine in connection with photography.

Cutting died in 1867 in an insane asylum where he had been confined for five years. His claims to the bromine process met an equally sad end when the Patent Office held in 1868 that they could not be renewed (to the benefit of heirs) because the patent should not have been granted in the first place.

Rehn left portraiture to become active in photographic applications in the printing field. In the 1870s there were numerous references to his various contracts, business activities and hobbies or side interests; a student of the occult, he held many peculiar ideas about spirits, ghosts and the afterlife.

In 1865, as the Civil War ended, the ambrotype had succumbed to the superior on-paper cartes-de-visite and the low-priced tintypes. There was no appropriate ceremony for ambrotypy at Appomattox.

THE TINTYPE
The Penny Picture That Elected a President

During its first twenty years photography had one major social role: it provided first the gentry and later farmers and working people with miniature likenesses. Until the 1840s only the wealthiest could hope to have a portrait suitable for a gold frame or a locket, and that was generally done by a miniaturist working in oil paints. The camera, like the pistol, was a great equalizer.

The first portrait photographers were artists who found in the new optical instrument and its interesting laboratory procedures a means to create large numbers of likenesses for an enlarged market. The more photographs in family hands, the more the family sought the gallery's services. The affluent could be sold the ornate frames they had always associated with fine permanent portraiture. The middle class could have their taste for oil miniatures satisfied with oil-on-photo combinations. Even the poor could even be given the suggestion of oil painting with a bit of tint on the image.

As each new process was introduced, the market for portraits expanded dramatically. The daguerreotype of 1840 to 1860 was initially marketed at $5, more than a week's pay for a workman at the time. The ambrotype that followed was launched at the lowest daguerreotype prices, in the smaller sizes costing only twenty-five or fifty cents each and in some instances a bit less than that.

The tintype, however, made photography universally available, with portraits selling for a penny or less. Within a dozen years of the introduction of the on-metal process of tintypery, galleries had sprung up specifically to offer postage-stamp-size likenesses. In the Gem Galleries portraits were made for as little as twelve for ten cents or thirty-six for twenty-five cents. The average price of tintypes, from the inception of the process in 1856 to its fade-out by World War II, was ten to twenty-five cents for an image about the size of a playing card.

A half brother to the ambrotype which it displaced, the tintype ranks first in its service to the American people as an instant photography system and first in earning power to the itinerant photographers who brought its advantages to every crossroads and hamlet. When at last the camera had become as familiar a house-

The Traveling Photographer by Jenkins, sketched about 1873, captures the
flavor of the moment, when the itinerant photographer established his
outdoor "gallery" at a fair or in the town square, where families were likely
to stroll and play.

hold item as the sewing machine and the electric light, the tintype became the
vacationer's keepsake, the Sunday stroller's memento and—for the sidewalk tin-
typist-entrepreneur—a good livelihood.

The tintype was an offshoot of the ambrotype, itself a by-product of the inven-
tion of collodion-based, light-sensitive emulsion. The ambrotype had two distinct
disadvantages that were to limit its popularity to a period of less than ten years.
An image made on glass, it was subject to inadvertent damage and must therefore
pass its guarded lifetime in a half-inch-thick case; and, being made on glass, it did
not lend itself to mass-production procedures as did photography on paper or on
"tin."

The tintype, created on the same sticky-wet emulsion but on lightweight metal
instead of glass, was light, less costly to manufacture, readily exposed in a multi-
lens camera and required no bulky case.

Tintypes were at first called *melainotypes* (from the Greek *melaino,* dark) by
Peter Neff (1827–1903), in the 1856 Hamilton L. Smith (1818–1903) patent and
on the earliest Neff-made plates. Another name was *ferrotype* (from the Latin

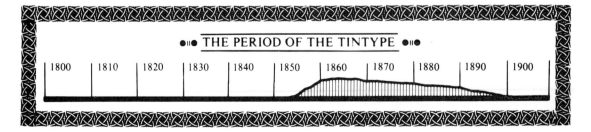

THE PERIOD OF THE TINTYPE

| 1800 | 1810 | 1820 | 1830 | 1840 | 1850 | 1860 | 1870 | 1880 | 1890 | 1900 |

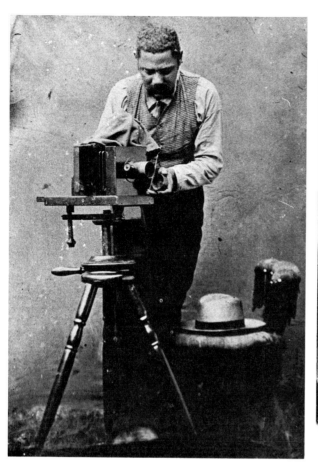

A tintypist working with a bellows-type ambrotype camera uncaps his lens to make his exposure. (*Collection GM*)

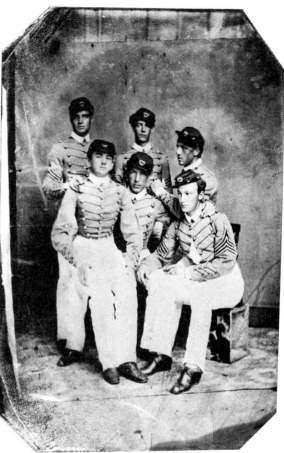

Civil War troops in a sixth-plate tintype, slightly enlarged from the original. (*Collection L/HJ*)

Photography at the Seat of War.

Decidedly one of the institutions of our army is the traveling portrait gallery. A camp is hardly pitched before one of the omnipresent artists in collodion and amber-bead varnish drives up his two-horse wagon, pitches his canvas gallery, and unpacks his chemicals. Our army here (Fredericksburg) is now so large that quite a company of these gentlemen have gathered about us. The amount of business they find is remarkable. Their tents are thronged from morning to night, and "while the day lasteth" their golden harvest runs on. Here, for instance near Gen. Burnside's headquarters, are the combined establishments of two brothers from Pennsylvania, who rejoice in the wonderful name Bergstresser. They have followed the army for more than a year, and taken, the Lord only knows, how many thousand portraits. In one day since they came here they took in one of the galleries, so I am told, 160 odd pictures at $1 (on which the net profit was probably ninety-five cents each). If anybody knows an easier and better way of making money than that, the public should know it. The style of portrait affected by these traveling army portrait makers is that known to the profession as the melainotype, which is made by the collodion process on a sheet-iron plate and afterward set with amber-bead varnish.—*Cor. Tribune.*

The ferrotype campaign button that helped elect a president was the first extensive use of tintypery as a propaganda vehicle; approximately twice actual size.

Advertisement for the Ferro-Photograph by the well-known New York City Estabrooke Gallery. (*Harper's Weekly,* August 17, 1867)

From the pages of *Scientific American* (October 18, 1862), a comment from *"Cor. Tribune,"* remarking on the war camp photos which assured a 95-cent profit on each dollar tintype.

A flaking quarter-plate ferrotype in a daguerrean case has begun to lose its image because the collodion base has shrunk, cracked and finally separated into segments. (*Collection GG*)

ferrum, iron), a usage attributed to Victor N. Griswold, an Ohio photographer turned manufacturer who made japanned (blackened) plates for use in the process. The name ferrotype has survived to this day in political button collecting circles to identify those tintypes made as campaign material. One of the most famous of the buttons was created for the Lincoln–Hamlin slate in the presidential election of 1860.

It was this button to which Lincoln had referred when he said, "Brady and the Cooper Union [speech] made me president of the United States." His campaign speech on February 21, 1860, the evening of the day when he posed in New York City for a Brady portrait, showed that Lincoln was a man of ability with a clear and forceful logic. But his popular image as a relatively uncouth, backwoods lawyer, according to Lincoln himself, appearing to many as "half-alligator and half-horse," was at that time still a disadvantage.

With the appearance of published reports of his Cooper Union speech, demand for his portrait rose. The tintype campaign button made from the Brady portrait and sold for a few pennies to campaign contributors helped satisfy that demand. An estimated three hundred thousand were distributed prior to the election. The photographic clarity helped dispel the image of the cartoonists which in the popular press had made Lincoln a buffoon and a backwoodsman.

The tintype could well withstand the rigors of travel during the Civil War. It also met the need of every soldier boy in blue or grey to send a photo home to the family—preferably one showing him in military regalia with pistol, rifle or sword proclaiming his dedication to the Cause. Mailed from the campgrounds, the tintype's safe arrival proved its advantage over the often-shattered glass ambrotype. Photographers in the camps near the battlegrounds took advantage of the monopoly they enjoyed in being far from cities and charged for their tent-made tintypes four times the going rate for ambrotypes in the big city galleries.

In 1862, the *New York Tribune* correspondent with the Army of the Potomac reported that, in one camp outside Fredericksburg, lines of soldiers were to be found standing outside the photographer's tent, each soldier paying a dollar to pose for a single portrait. The net profit, estimated by the reporter, was ninety-five cents on each photo (the plate used by the photographer cost about twenty-five cents, but it made possible four images).

At first, in the cities and in the camps, the photographers would "dress up" the tintypes in the same types of cases that had protected the ambrotypes, with gilt frames and leather covers to enhance the product. However, as the public sought lower prices, the cases—which cost more than the finished photograph—were

A cottage in the woods, a family portrait in a leafy setting, is framed in a pre–Civil War gilt mask. (*Collection PK*)

Preservers of law and order, the sheriff and the judge (or attorney), in a once-framed sixth-plate tintype; slightly enlarged. (*Collection KdeL*)

eliminated. In their place, paper holders of the size of the then popular card photographs (cartes) were used for protection. Instead of a glass cover, the photographer covered the tintype image with a quick-drying varnish to protect any tints or colors added to cheeks, lips, jewelry or buttons.

Unknown to the early American tintypists, a similar process on black paper produced an identical result. In 1853 Dr. Giles Langdell of Philadelphia introduced the *melanograph*, a photographic image produced on a sheet of black paper that had been coated with collodion, sensitized with silver nitrate and exposed in a camera. This print was also known as the *atrograph* (from the Latin *ater*, black). At the time, the achievement attracted little attention or interest.

While in Europe the tintype has been called "the American process," it was in fact first demonstrated (but never patented) in France, three years before an American patent covering the procedure was issued.

In 1853 an amateur photographer and teacher, Adolphe Alexandre Martin, presented to the Académie des Sciences a paper that described "the production of direct positives on tinned iron." In the same period, Martin described his experiments with the photographic coating of cloth. No one saw an advantage in the Martin photographs on metal, but a number of French clothmakers introduced photographs on cloth, or *pannographs*, which saw a brief vogue.

In America, in a series of experiments in 1854, Hamilton L. Smith, a professor of chemistry and natural philosophy at Kenyon College, Ohio, had been making ambrotypes. In one experiment he used preblackened sheets of thin iron instead of glass in order to eliminate the need to back up the glass with black material. In collaboration with one of his students, Peter Neff, Smith applied for and received a patent in February 1856. It specified iron but said that any solid or flexible material that could be blackened could also be used as a base for the wet emulsion. As a result, "tintypes" have been made on blackened leather, cardboard and other materials. Few of these have survived; nothing then or since has proved to be as practical and durable as thin sheet iron.

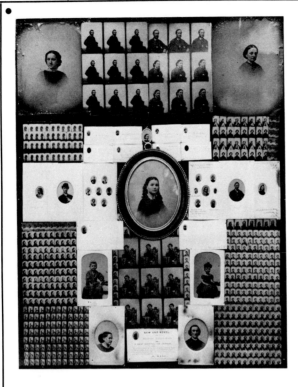

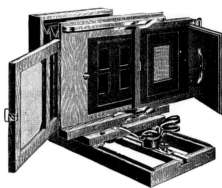

Above: Later, simpler studio version, about 1896, of a multiple-image studio camera.

Left: A Boston street-level window display of Simon Wing, father of the famed multiple-image cameras, showed the variety of sizes that could be taken by one camera. (*Collection JC*)

MAKING THE TINTYPE

1. Readying the Plate • The photographer took a black-painted plate of sheet iron from a storage box usually kept in the darkroom. To sensitize it for a photographic exposure, he poured a small quantity of collodion from its decanter onto the center of the plate. Tipping and tilting the plate slowly, he helped the syrupy collodion flow to all edges, then drip-drained the excess back into the collodion bottle for use on subsequent plates.

2. Sensitizing the Plate • Closing the darkroom door and working by a yellow safelight that was candle or whale-oil fired, the photographer filled a shallow tray with silver nitrate from a light-sealed bottle. He placed the coated plate into this bath and watched for the collodion to take on a creamy-yellow appearance, usually within one to two minutes, depending on room temperature and the condition of the silver nitrate. Then he tilted the plate to drain the excess silver nitrate from the now sensitized plate. Then he would put the plate into a waiting plateholder, a thin wood box that permitted the plate to be carried to the camera without its being exposed to light. Before leaving the darkroom, the photographer returned the silver nitrate to its light-tight storage bottle.

3. Exposing the Plate • With the camera's lens focused on the subject, the plateholder was fitted into the camera. The exposure time in the studio, then totally dependent on the amount of light available from windows and skylighting, was typically less than five seconds, usually at a setting equivalent to f 8 in a modern lens.

4. Developing the Exposed Plate • The photographer removed the plateholder from the camera and returned it to the darkroom. Again working by safelight, he removed the plate from the holder. The still tacky sheet of iron was plunged into a waiting bath of pyrogallic acid for one to two minutes, then fixed in a bath of sodium thiosulfate (hypo) for a further two to five minutes (often less if the customer was likely to be impatient). All chemicals were used at comfortable room temperatures, usually above 65°F. and below 90°F.

5. Finishing and Presentation • When the tintype was fixed, the photographer could take it from the darkroom into ordinary light. To protect the image from abuse, the plate was brush-coated with a rapidly drying varnish before it was secured in a paper frame for delivery to the client.

A LATER PROCEDURE • For most of the tintype era, photographers had the benefit of "modern" plates that were factory-coated, factory-sensitized and factory-cut. These dry plates were ready for use at any time in the gallery or afield. From about 1880 they replaced the wet plates almost completely. The photographer loaded all his plateholders each morning, then exposed the plates as each client arrived, developing each at once in the developing bath and fixing the plate in the waiting tray of hypo. When the portrait was made in a studio, varnish was added to protect the image; in the street, the waiting customer was handed the processed plate in a paper frame without the added protection.

The Kenyon Archives contain Neff's reminiscences of the discovery and his attempts to put it to commerical use.

When at Gambier, Ohio, in 1853–54, I was associated with Prof. Hamilton L. Smith in experiments to perfect his invention of taking pictures on iron plates, and I became enthusiastic with it—so much so that in 1855, at Yellow Springs, Ohio, I continued their development and the preparation of sheet iron, and persuaded Prof. Smith that if he would apply for a patent, I would prosecute it, and if granted, manufacture plates and introduce them, he being at no expense whatever. He consented, proposing that the patent should issue to William Neff and Peter Neff, Jr., which was accepted and agreed upon. I then

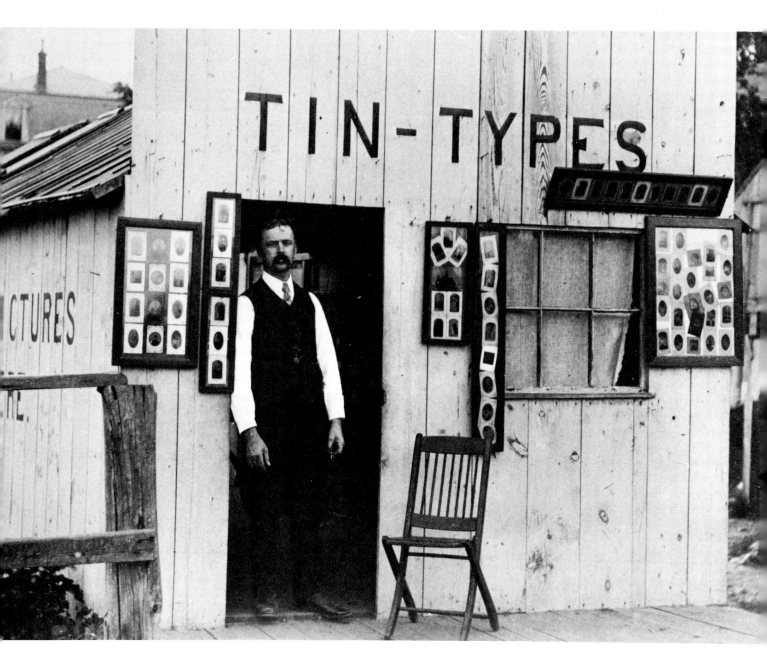

A village tintypist at his streetside gallery with numerous sixth-plate examples of his ferrotype art. Card mount styles suggest period from 1865 to 1875.

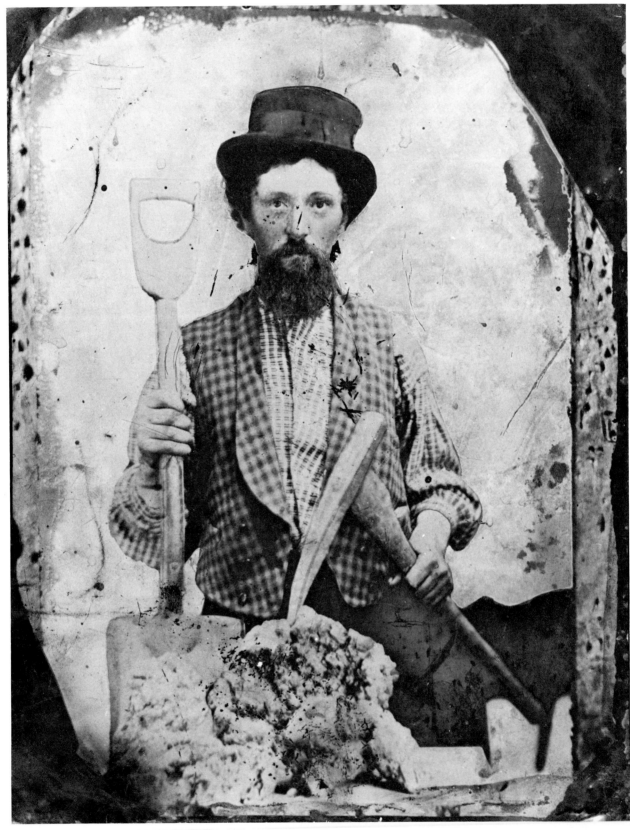

An enlarged sixth-plate comic ferrotype has a possible Western origin, from around 1860. It is likely that jacket, shovel, pick and ore-laden rock were studio props that made every gallery customer a booty-rich gold miner. (*Collection SHSC*)

prosecuted the application for a patent, before the Commissioner of Patents, in Washington, D.C., and obtained a patent issued the 19th Feb'y. 1856. Prof. H. L. Smith, Patentee, issued by assignment to William Neff and Peter Neff, Jr., Assignees, "For the Use of Japanned Metallic Plates in Photography." At the time of my Father's death, in November, 1856, he assigned his interests in the patent and its business to me. My first experiments towards making it of commercial value were made in the rooms over my Father's stable, on West Sixth Street, near Cutter Street, Cincinnati, Ohio. The many difficulties in obtaining sheet iron thin enough to suit for my plates were insurmountable, and plainishing them did not remove its roughness, but in summer of 1856, with my Father's security, Phelps, Dodge & Co. imported for me several tons of Tagers Iron. This was among the earliest, if not the first importation of these sheets. I built a factory for japanning plates at 239 West Third Street, Cincinnati, Ohio, with rooms for operating and teaching their manipulation and uses, and the preparation by compounding chemicals. It was slow and difficult work introducing this new process, being everywhere met with opposition from daguerreotype dealers, but succeeded by sending out teachers to instruct daguerreotype operators.

A

B

C

D

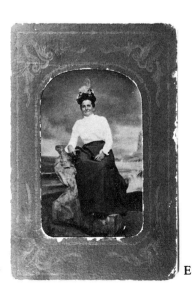
E

A. A lady and her chapeau in a formal ferrotype portrait in a quarter-plate portrait, shown slightly reduced. (*Collection PK*) B. A cadet in a ninth-plate portrait is shown near actual size. (*Collection NMG*) C. An unusual gallery study, almost a fashion plate, in a daguerrean gilt frame. (*Collection SG*) D. Few nineteenth-century personalities are found on ferrotype plates. An exception is this portrait of M. J. ("Calamity Jane") Conarray by an unknown tintypist. (*Collection GH*) E. A late tintype, taken around 1900, of a seaside nymph in a period cardboard frame. (*Collection GG*)

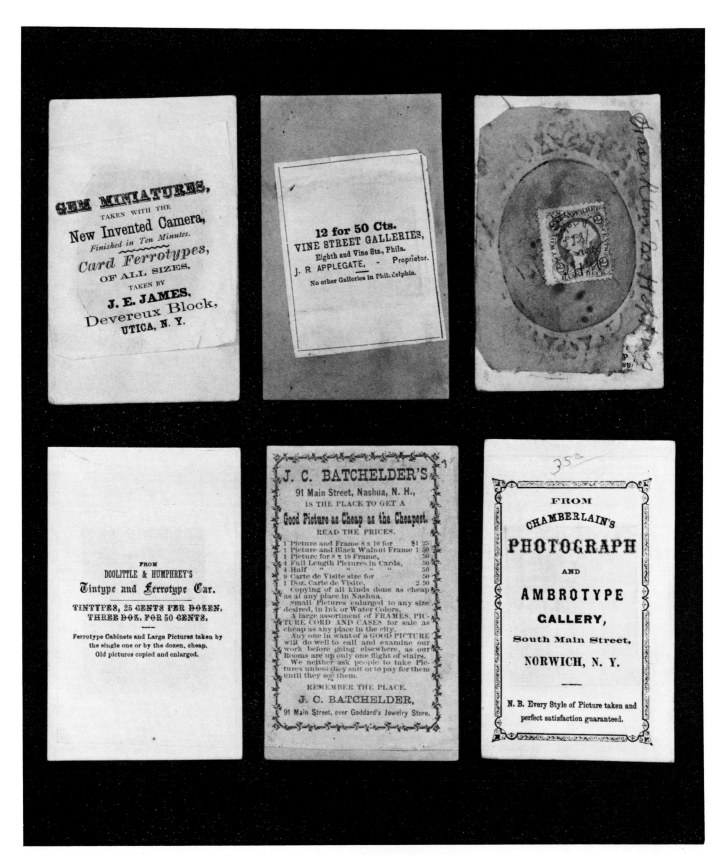

Advertising and promotion labels for tintype galleries provide guides to prices and origins of many tintypes. Internal Revenue stamp (top right) links period of sale to 1864–66. (See Appendix F.) (*Collection GG*)

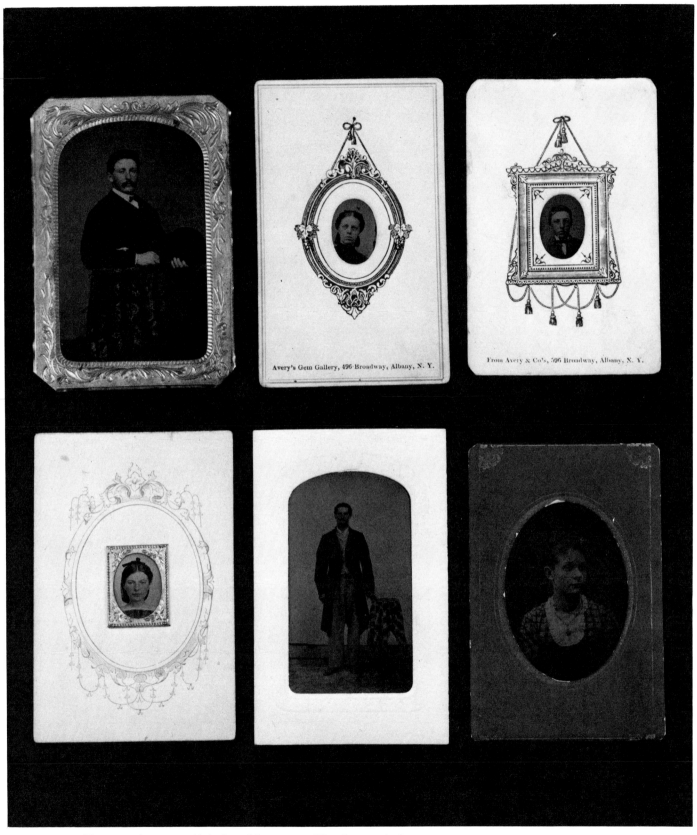

Frames and mounts aid dating of ferrotypes. Gilt edges rarely appear
after the Civil War; picture-frame printed borders date from the mid-
1860s to 1870s; dark card mounts indicate ferrotypes from the late 1800s.
Tiny Gem mount (*bottom left*) secured hand-tinted portrait in carte-de-
visite mount for album storage. (*Collection GG*)

My factory was destroyed by fire in the summer of 1857, and I then built at Middletown, Conn., and James O. Smith had charge of them and the work. My office was with James O. Smith, in Fulton Street, New York, N.Y.

It was in Cincinnati, Ohio, that I invented the "French Diamond Varnish"—a varnish for melainotypes and collodion pictures. It became the property of E. Anthony, New York, N.Y., 1858.

In 1856, at Cincinnati, Ohio, four thousand pamphlets, of 53 pages each, title, "The Melainotype Process, Complete, by Peter Neff, Jr.," were published for gratuitous distribution. In 1857 a booklet of 141 pages was published by Charles Waldack and Peter Neff, Jr., title, "Treatise of Photography on Collodion, embracing full directions for the compounding of chemicals and their theoretical and practical application to the art in all its relations." These publications at that time proved eminently useful.

My patent about to expire, I sold my factory buildings and business to James O. Smith.

The manufacture and sale of these plates (cut and boxed to suit the plate holders in use in the camera for the daguerreotype plates) was very large. My early agents were Peter Smith, Cincinnati, Ohio, who early bought the interests of Prof. H. L. Smith; E. Anthony, Scoville Manufacturing Co.; and Holmes, Booth & Hayden, of New York, N.Y.

Neff's agreement with Smith provided that Neff and his father would manufacture the japanned plates for the photographic world. His first manufacturing activity consisted simply of polishing and then blackening sheet iron imported from Europe.

Introduction of the new process was slow, for the daguerreotypists of the day still produced a far superior image on their silvered copper plates, and those making ambrotypes did not see the on-metal image as an improvement over the on-glass image they were selling profitably. Mathew B. Brady, for one, seeing the new all-metal photograph, gave orders to his galleries in New York and Washington not to make use of the process. It was the judgment of the time that not only was the quality poor, there was no negative to permit the profits to be made in duplicate prints, enlargements and framing. (Nevertheless, a full-plate street scene attributed to Brady, in the collection of the Museum of the City of New York, shows Broadway as it appeared in 1867. It is a tintype).

Abroad the tintype met with equal disinterest and even disdain for its relatively poor quality. Yet its economics made it acceptable at Brighton and other resorts, where European street photographers created button photos and similar mementos of a day at the seashore.

The one undeniable advantage of the tintype, which was to serve faithfully photographer and public alike for some eighty years, was its "instant" quality. The customer could be posed, photographed and delivered his likeness—not perfectly but acceptably dry—in a paper frame within six minutes.

Since there was no negative, the process of service was completed with delivery to the client. There was no negative to file, no proof print to deliver, no retouching and no consideration of reprint orders. Without the income from enlargements and expensive frames and the potential for reprints of particularly successful poses, the Main Street studio eschewed any interest in the process.

On the other hand, the process was ideal for the studio operator who sought the advantages of mass production and large-scale operation. If the studio used one of the patented inventions of a Boston photographer, Simon Wing, a camera with up to thirty-two lenses, it took but moments with tinsnips for any finishing room employe to cut the portraits apart and to insert each into its own paper holder. Prices

This outdoor quarter-plate family portrait was actually created in a studio with a real log and a painted backdrop. (*Collection GG*)

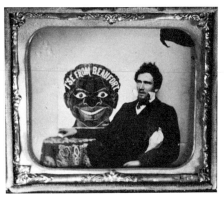

Comic portraits became standard attractions of the tintypist after the novelty of owning a likeness began to pall. (*Collection SG*)

• FAMILY TINTYPE CAMERAS

In 1900 a camera preloaded with twenty-six plates, each of the popular one-sixth plate size, was sold as an outfit suitable for family photography. Called the No-Dark, it was advertised as providing a "Finished Picture in a Minute." This all-wood camera, made in New York City, could be purchased complete, delivered postpaid, for $6. Its advertising stipulated:

> Takes the picture (2½ x 3½). Develops and finishes at the same time. A Finished Picture in a Minute. No muss. No darkroom. Clean, Complete, Convenient.

Perhaps only the last word of the advertisement was subject to closer scrutiny. To obtain the finished picture, it was necessary to use bottled liquids and a developing tank. However, a family in a picnic grove with a table, a stream and a healthy interest in things technical could certainly master the process.

The camera was made by the Popular Photograph Company, 114 Bleecker Street, New York City. It had built-in mirror finders for both vertical and horizontal format photographs and a shutter and lens typical of the box camera of the period.

"Picture in a Minute" photography was not a success back in 1900. Few No-Dark cameras were sold, and today collectors find them hard to locate. There is no way to identify readily the images attributable to this equipment, for the plates were the same size as those used in the professional cameras of the time.

Tintype jewelry was made in the last thirty years of the nineteenth century in the form of brooches, rings, cuff links, and even suspender clips. (*Collection GG*)

Cameras for the family such as this Mandel-ette loaded with ferrotype plates developed in a "darkroom within the camera" were sold for under $10 in 1929.

A German camera system used circular ferrotype plates, fitting brooches and medallions provided along with the camera and chemicals. It was offered as a family novelty as late as 1929 for only $4.95.

as low as "sixteen for a dollar" in the beginning and within a few years "twelve for ten cents" guaranteed an endless stream of customers as America came to sit for its portrait.

Some early twentieth-century street cameras were loaded with specially treated paper for a modern version of the Langdell melanograph, a "tintype on paper." For these direct positive prints, the emulsion was factory-coated onto black paper. After exposure, it could be developed in the street, within the camera body, using a silver solvent (generally ammonia or thiocyanate). In the processing, which took about three minutes while the customer waited expectantly, some of the silver from the emulsion would dissolve into the bath, to be redeposited by a silver-plating effect onto the image areas as a light-colored residue.

Direct positives on light cardboard imprinted with a postcard message area on the back were developed and fixed using a different chemistry. Such direct positives were developed and fixed in a simultaneous bath, which permitted a one-minute process similar to that of the early Polaroid photographs of the 1950s. Removed from the bath, the print needed only a simple rinse in the water in the pail at the photographer's feet. After a bit of blotting, the limp damp print was handed to the waiting customer.

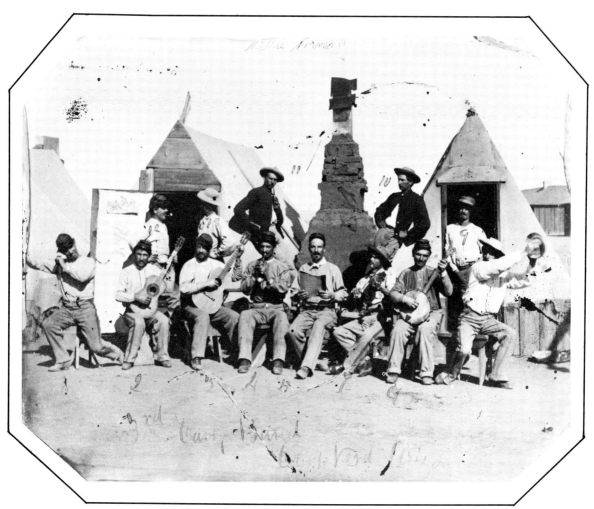

The 3rd Cavalry Band, Camp Verd, Arizona, posed before semi-permanent camp tents for the tintypist in this quarter-plate ferrotype (shown enlarged). (*Collection HA*)

■■ THE TINTYPIST AS COMMERCIAL PHOTOGRAPHER

The tintype was easily the longest lived of the nineteenth-century photographic processes, and millions upon millions of tintypes were made during its eighty-year popularity. In Edward M. Estabrooke's bible of the working tintypist, *The Ferrotype and How to Make It* (1872), the author reported that more tintypes were made in the sixteen years following its introduction than photographs by all other processes combined.

Most tintypes were portraits posed in the formal manner. Their size ranged from the tiny portraits that could be mounted on rings to the 8-by-10-inch, hand-colored portraits that one may still find framed in antique shops today.

The small number of tintypes that are not portraits fall into several different groups.

OUTDOOR SCENES

There are views of storefronts, street scenes, families on their front porches and an occasional large posed group, usually a church or school body. These photographs range in size from one-sixth plate to 8 by 10 inches; the most common sizes are 4 by 5 inches and 5 by 7 inches.

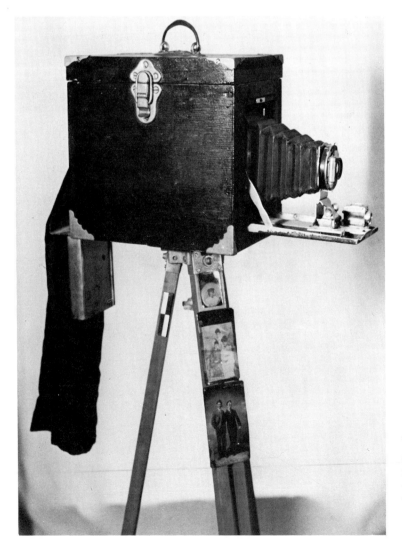

An advertisement from the Chicago Ferrotype Co. in *Today's Magazine,* 1911, offered the Wonder Cannon, which took photo buttons. Camera, tripod, plates, and buttons were sold for $25 to prospective street photographers.

The street photographer of the twentieth century carried his entire system in an improvised satchellike camera box. Legs of the tripod hold sixth-plate examples of the "while-U-wait" system. (*Collection SG*)

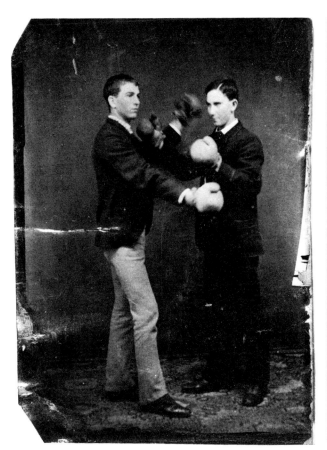

Boxing gloves, hats, canes, swords, pistols and gloves were instant props to enrich any novelty portrait at the Main Street gallery in the early twentieth century. (*Collection GG*)

Boardwalk photo galleries invariably offered beach, boat, and other novelty props for comic portraits. (*Collection GG*)

CARNIVAL AND BOARDWALK COMIC SCENES

Millions of souvenir photographs were taken of visitors to parks, beaches and other tourist sites by photographers who attracted attention with painted flats that depicted comic backgrounds, some with holes though which subjects could poke their heads so that hilarious new bodies could be photographically appended. Many of these comic photographs have survived in the folders in which they were originally mounted. Often they depict a spa or resort or provide some indication of the photographer, his address, prices and dating information.

ANIMAL PORTRAITS

Dogs, horses, chickens, goats, rabbits and other farm animals have been photographed on tintype plates. Most are found in the one-sixth plate size; some are larger, especially where the subject is a large animal such as a prize horse or bull posed with a trophy at a county fair.

POSTMORTEMS

In the nineteenth century it was common to request a photographer to make a deathbed portrait of a loved one. In such photographs, of men, women or children, the flowers on or near the prone body, the clasped hands and the closed eyes clearly establish that these are not candid "at sleep" photographs.

As late as 1979, Pennsylvanian John A. Coffer was traveling with his horse-drawn Photographic Van through the Midwest offering collodion-process tintypes to delighted sitters in public squares and parks.

• DATING THE TINTYPES

Introduction: 1856–1860 • The earliest tintypes were on heavy metal (.017 inches) that was never again used. They are stamped "Neff's Melainotype Pat 19 Feb 56" along one edge. Sizes range from one-sixth plate to full plate (see appendix E). Many are found in gilt frames or in the leather or plastic (thermomolded) cases of the earlier ambrotypes.

Civil War Period: 1861–1865 • Tintypes of this time are primarily one-sixth plate and one-fourth plate and are often datable by the Potter's Patent paper holders, adorned with patriotic stars and emblems, that were introduced during the period. After 1863 the paper holders are embossed rather than printed. Uncased tintypes have been found with cancelled tax stamps adhered to the backs. The stamps date these photographs to the period of the wartime retail tax, September 1, 1864, to August 1, 1866.

Brown Period: 1870–1885 • In 1870 the Phenix Plate Co. began making plates with a chocolate-tinted surface. They "created a sensation among the ferrotypists throughout the country, and the pictures made on the chocolate-tinted surface soon became all the rage," according to Edward M. Estabrooke. During this period "rustic" photography also made its debut with its pastoral backgrounds, fake stones, wood fences and rural props. Neither the chocolate tint nor the rustic look are to be found in pre-1870 tintypes.

"No Darkroom" was the primary appeal by a Worcester, Massachussetts, maker of dry plates for the tintype process in this 1916 advertisement directed to professional photographers.

Gem Period: 1863–1890 • Tiny portraits, ⅞ by 1 inch, or about the size of a small postage stamp, became available with the invention of the Wing multiplying cameras. They were popularized under the trade name Gem, and the Gem Galleries offered the tiny likenesses at what has proved to be the lowest prices in studio history. Gem Galleries flourished until about 1890, at which time the invention of roll film and family cameras made possible larger images at modest cost. It was no longer necessary to visit a studio that specialized in the tiny likenesses.

Gem portraits were commonly, stored in special albums with provision for a single portrait per page. Slightly larger versions also existed. Some Gems were cut to fit lockets, cufflinks, tiepins, rings and even garter clasps.

Carnival Period: 1875–1930 • Itinerant photographers frequently brought the tintype to public gatherings. New portable equipment, of size and weight that could easily be carried on a wagon, included skylight-paneled tents, roll-down backdrops and cases for supplies sufficient for a week or more at a fair or carnival. At such permanent locations as the Boardwalk at Asbury Park or Atlantic City, New Jersey, or in the streets leading to the views at Niagara Falls, tintypists established permanent galleries equipped with painted backgrounds suggestive of the locale.

STEREO VIEWS

The most common of the plate-loaded cameras with lenses mounted side by side for three-dimensional (stereo) photography (see Chapter 8) were occasionally loaded with tintype plates. Only a few stereo tintypes are known. William Culp Darrah, the leading historian of the stereograph phenomenon in America, writes that "the tintype stereo is not only the rarest form of tin-type, it is also the rarest form of stereograph. I have found three in more than thirty years collecting and know of four others in private collections."

A tiny Gem album containing postage-stamp-size tintype portraits photographed against albums for the cartes and cabinet cards.

The Post Office at Eminence (Kentucky?) in a reversed image outdoor study (letters in sign are backwards) in a sixth-plate ferrotype, unusual in its horizontal format. (*Collection AD*)

In the ferr(e)otype studio, a giant camera with a small back was often used to make carte size formal portraits. Note head-clamp to inhibit movement and photographer holding pocket watch for an exposure of five to ten seconds. (*Collection IMP/GEH*)

FERROTYPES (political campaign buttons)

In Abraham Lincoln's campaign for president in 1860, and in subsequent campaigns until the turn of the century, portrait buttons, identified by collectors today as ferrotypes, were mass-created by the tintype process. The Lincoln button, with its portrait by Mathew B. Brady, is among the most famous. It sold originally for five cents to twelve and one-half cents each, depending on the size and the elaborateness of the pinholder design, the accompanying ribbon and the market. Today the button, a collector's item, ranges in price from $125 to $250, depending on condition.

Campaigners used the low-cost tintype portrait for carte-de-visite size campaign portraits as well. Gem portraits bearing Lincoln and later figures were to be found edged with gilt frames and affixed to tiepins.

THE CARTE-DE-VISITE
America Sits for Its Portrait

French inventiveness thrilled the world with daguerreotypy; in the 1840s the superb fidelity of that process had set a worldwide standard for photographic perfection. In the 1850s another Frenchman was to popularize a system that would bring photography into the lives of millions yet unreached by the relatively costly daguerreotype.

This innovator was Adolphe-Eugène Disdéri (1819–1890), court photographer to Napoleon III. In 1854 Disdéri patented a simple idea, that of a photographic calling card made with a modified camera. The Disdéri camera, loaded with the wet plate of the Archer collodion process, allowed the photographer to create many images on the glass before it was developed, thereby giving the new on-glass system a mass-production procedure. It was an idea in step with the time, one which gave the camera the production capability of a printing press, a stamping machine or a thermoplastic mold. Why take one photograph at a time when multiple exposures could be made on a single plate at much lower cost?

In France, friends exchanged these photographs to the point where the practice became the rage. The word *cardomania* was invented to describe the phenomenon in Europe. The custom of visiting friends on a weekend afternoon and leaving one's card should that friend be away was revised to meet the delights of the new art form; one now left as calling card a small portrait as a modest token of remembrance and affection. Hence the name, *carte-de-visite*.

Disdéri was not alone in making carte-de-visite photographs. According to the early French photography magazine *La Lumière* of October 24, 1854, the photographer E. Delessert and one Count Aguado had also conceived a use for small portraits. Most calling cards, they pointed out, bore a name, address and sometimes a person's title; why not use a photographic portrait to represent the person? This novel calling card met with great favor, for the subject could pose in a manner suitable to the occasion of the visit: for ceremonial occasions, wearing gloves and standing with head bowed as in greeting; in inclement weather, holding an umbrella under the arm; when about to depart, as for a hunting trip, wearing an appropriate costume.

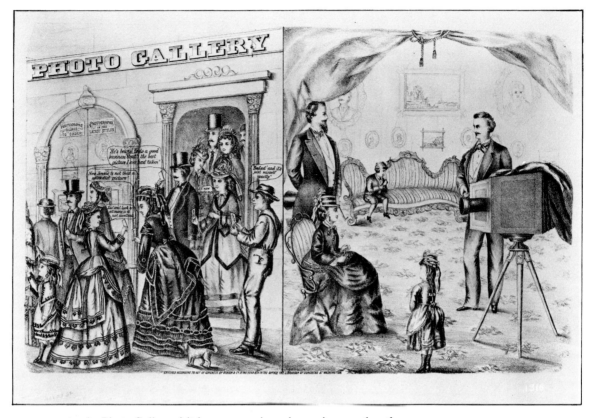

As the Photo Gallery visit became a universal experience rather than a special occasion, it became a suitable subject for the popular lithographs of the era, as in *Poster No. 7, Gibson & Co., 1873.* Nearly everyone is commenting on his new carte-de-visite. (*Collection LofC*)

Disdéri conducted his business in the cards on a grand scale. At a period when people customarily ordered but one or a few prints of a choice likeness, Disdéri sold his tiny calling card portraits only fifty at a time (later by the dozen, at twenty to twenty-five francs per dozen). His camera, using a single lens, took eight poses, each individually exposed on a single plate. The preferred image or images were then mass printed on the albumen paper (so called because egg white was used to make its coating adhere to the paper surface). Sometimes Disdéri photographed three or four persons on a single plate, changing the sitter between exposures. His innovation reduced darkroom preparation for the sittings to one-fourth of what it had been.

By 1862 he had added another innovation to speed production: a four-lens camera that made four simultaneous exposures. By 1865 he was using a camera with twelve lenses, each of which created a portrait of postage-stamp size. By then similar cameras were in use in England, America and elsewhere.

With all these cameras the mass-production principle prevailed: the wet plate was coated with collodion and sensitized with silver nitrate in the normal manner. After exposure and processing, a paper print was made. When dry, this could be cut into six, eight or more portraits, depending on the number of lenses on the camera. The paper prints, each about the size of a playing card, were then affixed to card mounts to become what the world has ever since called cartes-de-visite. Beginning in about 1860, the portraits of this unique size could be stored conveniently in specially designed albums that displayed prints in a tidy, organized manner.

According to the photographer and historian Marcus Aurelius Root, the first American cartes-de-visite were produced in 1860 in the New York gallery of

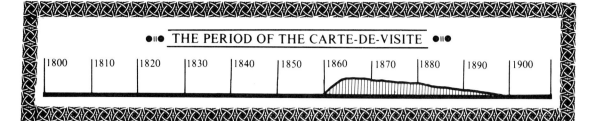

●‖● THE PERIOD OF THE CARTE-DE-VISITE ●‖●

|1800 |1810 |1820 |1830 |1840 |1850 |1860 |1870 |1880 |1890 |1900

Charles D. Fredericks & Co., originally a daguerrean competitor of Root. Their acceptance by the public led to the spread of this form of photography across the country, and their low cost permitted the development of a new activity, the collecting of photographs of subjects other than friends and family. Printing technology did not yet permit the reproduction of photographs, so one who wanted a likeness of a popular hero, a political figure or a great work of art of the Louvre, the Vatican or another cultural center had to purchase that day's equivalent of the picture postcard. Such cartes were produced in the size 2½ by 4½ inches that would fit the albums sold by photographers.

The sale of stock photos in the carte size became a giant business; millions were sold by photography sales agents of E. & H. T. Anthony & Company, the largest photo supplies distributor of the period, and local photographic galleries. The subject matter of the cartes broadened to include theatrical personalities, street scenes, landmark buildings and historic sites. Cartes were used for the promotion of P. T. Barnum's exhibitions of his freaks and circus wonders.

The multiple-exposure single plate of the carte-de-visite camera made possible economies which lowered the costs of picture taking considerably. This light-streaked plate carries the image of Mathew B. Brady (about 1863). (*Collection NatA*)

Until the late 1860s, most subjects were posed against neutral backgrounds, which often resulted in drab, dull imagery. And because the photographer generally suggested full-length images, the subjects' faces in the final carte were invariably of collar-button size. Then photographers began to experiment with their product. Some added simple props: books, fans, parasols or other small items in the hands or lap of the posed lady; a hat, a cane or gloves in the hands of the gentleman sitter. Later, larger props were introduced: imitation marble columns, chairbacks and large plants were set against backdrops painted with Italian lake scenes, rural meadows or manorial entryways.

To enlarge the small, barely visible faces, lenses were developed that achieved the close-up effect of head-and-shoulders. Subsequent equipment permitted the vignette, a portrait in which the head floated against a white background, and this convention became widely popular for its ethereal quality.

After a time some photographers became still bolder. Moving the camera nearer the subject, they created a larger head-and-shoulders for the "imperial carte," a borderless, edge-to-edge photograph made for a mount of 2½ by 4½ inches. The Brady gallery in New York had used "imperial" to designate its near life-size enlargement, but the "imperial carte" offered only a larger-size face on the small card mount.

Before 1861 some prominent American photographers were skeptical when it was suggested that they offer the new French-style carte. *Anthony's Photography Bulletin* reported that Abraham Bogardus, a leading New York photographer, laughed when he was first shown the earliest French imports: "It was a little thing; a man standing by a fluted column, full length, the head about the size of a pin." Within a year, however, Bogardus' studio was turning out the profitable cartes at the rate of a thousand a day.

E. & H. T. Anthony & Company, American distributor of the first art subject cartes and then of the carte-size albums, set the basic dimensions of the card: 10.17 by 6.35 cm, with a paper print 8.9 by 5.4 cm mounted on it. Mounts of this size were available to the photographic trade for many years; in 1891 the E. & H. T. Anthony catalogue still listed them, although by that time the size was no longer popular.

⠿ MATHEW BRADY, AMERICA'S FOREMOST PHOTOGRAPHER

The photographer who as much as anyone benefited from the new carte system, and whose own cartes featured some of the most famous personalities of his era, was himself a near-legendary figure. Mathew B. Brady (1823–1896) came from a remote upstate New York area that included Lake George and the historic battleground of the French and Indian Wars. When he was fifteen a painter took an interest in him, and in 1841 he enrolled young Brady at the Academy of Design in New York. His teacher was one of America's greatest inventors, then also a fine artist and teacher, Samuel F. B. Morse.

Brady supported himself as a clerk in a mercantile establishment, then as a workman in a leather case factory. In the Morse loft at the corner of Nassau and Beekman Streets Brady was introduced to the fine art of painting and to the painter's allied art, the daguerreotype. Morse had learned the process directly from its inventor in Paris in 1839.

In 1844 Brady left both his regular job and his training with Morse to open his own first studio, on the top floor of a building in the bustling downtown commer-

cial district, at the corner of Broadway and Fulton Street, directly across from Barnum's Museum. The corner of the building, high above the street, proclaimed the studio name; from New York rooftops one could see the masts of sailing vessels and the cornice of Brady's building with the sign, "Brady's Daguerrian Miniature Gallery."

To attract attention to his newly opened business at a time when others had established reputations of their own, Brady conceived his studio as the creative center for the publication of an artistic Who's Who, the Gallery of Illustrious Americans. It was his plan to photograph and then place on display, in a handsome museumlike parlor of his gallery, portraits of the famous and near-famous of the time.

His strategy succeeded. His success as an entrepreneur offering excellent photographic work by skilled operators (photographers) led to the opening of a second, and then a third, Manhattan location. Brady not only photographed the leading personalities, he acquired from other galleries their best efforts at portraying the great.

In time the Brady gallery became a major source of the photographs used by the etchers and woodcut artists who worked for magazine publishers. The published lithograph may or may not have appeared with the name of the etcher, but the credit line "Photography by Brady" was common. By this route Brady became a household name, carried into millions of homes in issue after issue of *Harper's Weekly, Frank Leslie's Illustrated Newspaper* and other journals.

In the years that followed, Brady continued to photograph leading artistic and political figures: Daniel Webster, John C. Calhoun, Edgar Allen Poe, Henry Clay, James Fenimore Cooper and the "Swedish nightingale," Jenny Lind.

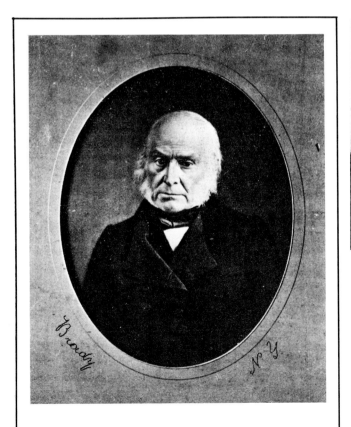

M. B. BRADY'S
NATIONAL MINIATURE GALLERY,
Nos. 205 & 207 Broadway, corner of Fulton St.,
NEW YORK.

This Establishment, believed to be the largest of the kind in the world, is open at all times for public examination. Both citizens and strangers are invited to inspect these Magnificent Pictures, for which a

PRIZE MEDAL WAS AWARDED
AT
THE WORLD'S FAIR,

And which have generally been regarded as the best pictures ever exhibited. In addition to these, the Gallery contains the portraits of the most distinguished men of our country, interesting for being exact likenesses, as well as beautiful and artistic pictures. Great attention is paid to copying

PORTRAITS, ENGRAVINGS, &c.,

and every kind of Daguerreotypes can here be obtained, at the shortest notice, and in the highest style of the Art.

Brady capitalized on being one of the three American medal winners at the 1851 World's Fair in London in his widespread advertising for his display of "the best pictures ever exhibited."

A Brady daguerreotype of the nation's sixth president, John Quincy Adams, taken about 1847 *(left)*, one of many American political, artistic and social celebrities on display at Brady's Daguerrian Miniature Gallery. (*Collection LofC*)

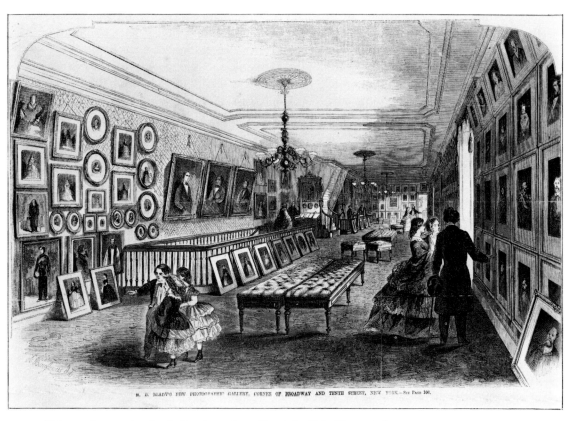

M. B. BRADY'S NEW PHOTOGRAPHIC GALLERY, CORNER OF BROADWAY AND TENTH STREET, NEW YORK.—See Page 106.

This wood engraving by A. Berghaus from *Frank Leslie's Illustrated Newspaper* (January 5, 1861) heralded the opening of Brady's "uptown" gallery, shimmering with elegance: costly carpets, luxurious couches, artistic gas fixtures, and even a private, or "ladies'," entrance. (*Collection LofC*)

A Broadway view of Brady's building in 1853 between White and Franklin streets, from a wood engraving by Leslie Cooper in the *Illustrated News* (November 12, 1853) depicting the Firemen's Celebration. (*Collection LofC*)

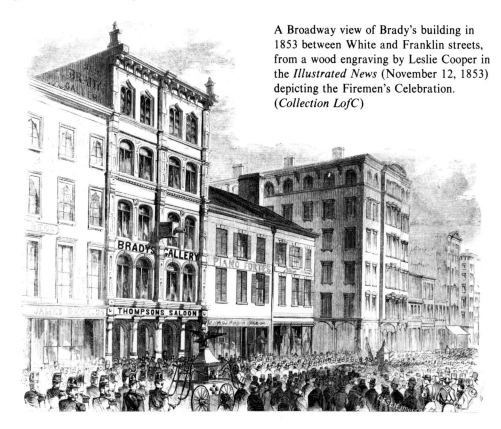

Brady also put his background in art to work and announced "Daguerreotypes in color," which were actually tinted photographs. He realized early the value of publicity and noticed the attention that was given to the prizes awarded by the then prestigious art world leaders of the American Institute. Scarcely a year after he had opened his studio, he was awarded a premium and an honorable mention. The following year he won first prize in two categories, and in 1846 he was awarded the institute's highest prize. He was just twenty-three and had been a photographer only three years, and the worlds of art and photography were already acknowledging his talent.

Brady opened his first Washington, D.C., gallery in 1849, a simply equipped photographic center designed to be operated primarily while Congress was in session. There Brady met and married Julia Handy, daughter of a prominent family.

Shortly after their marriage in 1851, the couple took a belated honeymoon, an ocean voyage to England to permit Brady to participate in the London World's Fair, which had scheduled the largest photography exhibition up to that time. For his entries, Brady selected forty-eight of his best portraits and the newly published Gallery of Illustrious Americans, which featured seventy-five etchings. He won first prize for all entries and one of three medals awarded for the best daguerreotypes. His fellow American contestants, M. M. Lawrence, a New York daguerreotypist and John M. Whipple of Boston, won the other two, Whipple for a startling daguerreotype of the moon. *The Illustrated London News* acknowledged the sweeping technical and artistic success of the American team, which had demonstrated an achievement far above that shown by the entries from other nations.

A typical Brady Gallery carte portrait from the Washington studio shows Mrs. McVickers, modishly long-haired wife of General McVickers. (*Collection LofC*)

The "imperial carte" by Brady permitted a portrait to the very edges of the carte blank for maximum visual impact. (*Collection MusCNY*)

THE PHOTOGRAPHIC ART A BLESSING TO THE WORLD---CARTES DE VISITES.

Of all the arts the one that seems most miraculous is photography. That the rays of the sun, darting through space with a velocity of a hundred and ninety-two thousand miles in a second, should, after bounding and rebounding from the walls of a room millions of times, till they cross each other in every conceivable direction, be directed upon a bit of paper and made to print a likeness accurate in all its microscopic details, would certainly have been deemed impossible before it was done, and yet there are large numbers of persons who by the daily performance of this miracle obtain bread and meat for themselves and little shoes and bibs for their children.

The most valuable feature in this wonderful art is the cheapness and facility with which it is performed. Heretofore, a few individuals in the community have been able to have their portraits painted by artists who, after devoting years to study and training, have been able to produce a picture bearing some resemblance to the person for whom it was designed, but the pictures of the photographer, though possessing a fidelity unapproachable by any painter that ever lived, are produced with a rapidity and ease that places them literally within reach of all classes in the community. This art contributes a thousand fold more to the sum of human happiness than the art of painting.

The ease with which photographs are taken, and the cheapness at which they are sold, has reached its highest development in the carte de visite. A man can now have his likeness taken for a dime, and for three cents more he can send it across plains, mountains, and rivers, over thousands of miles to his distant friends.

One of the most interesting results of the ease and cheapness with which photographs are produced is the prompting which it will give many persons to have their likenesses taken frequently during their lives. What would a man value more highly late in life than this accurate record of the gradual change in his features from childhood to old age? What a splendid illustration would such a series of photographs make in every household. First, the new-born babe in his mother's arms; then, the infant creeping on the floor; next the child tottering by the mother's apron; then the various phases of boyhood, till the sprouting beard tells of the time when the plans and hopes of life began to take form and purpose; another portrait with softer locks and eyes is now coupled with the series, and the stern warfare with the world begins; the features henceforward grow harder and more severe; lines slowly come into the forehead and grey hairs mingle with the locks; the lines grow deeper and the head whiter, till the babe is changed into the wrinkled and grey old man, so different but still the same! Even when life is closed the power of the photographer has not ceased. The fixed features that return no answering glance to the last fond look of surviving love are caught and indelibly preserved to its memory.

The Marriage of Gen'l Tom Thumb, one of the most widely distributed novelty cartes attributed to Brady. Posed before a single painted curtain, it may have been made by a Brady assistant.

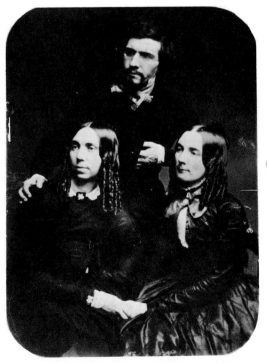

A daguerreotype of Brady and his bride, Julia (*left*), about 1851. Mrs. Haggarty (*right*) is believed to be a relative. (*Collection LofC*)

The *Scientific American* (August 9, 1862) calls cartes "a blessing to the world."

At a time when the prices of daguerreotypes had sunk to lows of twenty-five and fifty cents in the mass-production establishments of downtown New York, Brady was charging from $1 to $30 for his portraits. By 1853, according to a census, ten thousand daguerreotypists were employed as operators or had opened their own galleries. Mathew Brady's work was the guide to their posing and lighting styles.

Brady opened his most lavish studio establishment at Tenth Street and Broadway in 1860. Special gas fixtures, custom heating, costly carpeting in a soft, velvety green pile sprinkled with spots of gold, gold-painted furniture and a glass ceiling over all made it the showplace of the city. The walls were covered with examples of all the styles of photography as well as oil paintings and crayon drawings. The great glass skylight above the "operating rooms" was of an emerald color, said by Brady to have an advantage in "certain effects" (possibly an allusion to an effort to work within a range of the spectrum that favored the responsiveness of the plates). Looking down from the walls on the opening day gala were the Brady portraits of presidents Buchanan, Van Buren, Polk, Tyler, Pierce and Fillmore.

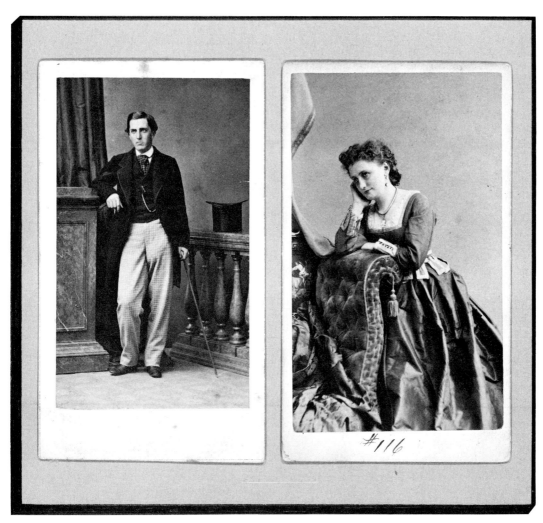

Left: A classic example of the carte photography style by French photographer Disdéri who popularized the format.
Right: An alluring portrait by American photographer Sarony whose carte experience led to a brilliant career as a theatrical photographer.

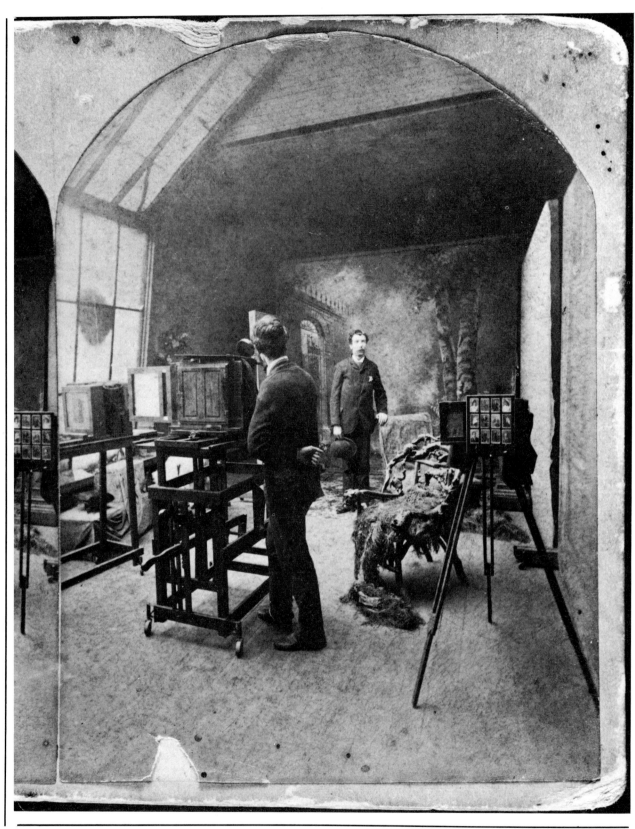

A carte-de-visite gallery reproduced from a post–Civil War stereograph reveals a skylight, painted background and props suggestive of the 1870s "rustic" period, along with examples of carte art. (*Collection IMP/GEH*)

When Abraham Lincoln went to New York City for his famous Cooper Union antislavery address in late February 1860, it was just one month after the Tenth Street gallery had become the talk of the town. Lincoln went to the Brady gallery with three members of the Young Men's Republican Committee. It was Brady's first meeting with Lincoln.

> I had great trouble in making a natural picture. When I got him before the camera, I asked him if I might not arrange his collar and with that he began to pull it up.
>
> "Ah," said Lincoln, "I see you want to shorten my neck."
>
> "That's just it," I answered, and we both laughed.

When Lincoln stepped before the camera, another problem presented itself. The "immobilizer," or head-clamp, extended to its full height, did not reach Lincoln's head, and a small taborette had to be placed under the stand. Brady took the pictures, and after Lincoln's speech the following day, they accompanied the press coverage, appearing as woodcuts prepared by such publishers as Currier and Ives and *Frank Leslie's Illustrated Newspaper*.

The camera used to photograph Lincoln, with its wet-plate process, at last enabled Brady to meet the prices set by his competitors. Brady charged twenty-five cents for a carte-de-visite portrait, a new low sitting fee for his galleries. The sitter was offered a choice of six to eight poses on the single glass plate. One of these plates, a portrait set of Brady himself, belongs to the National Archives in Washington, D.C.

The famed soldier-named "Whatizzit" wagons in the field during the Civil War carried the cameras and wet-plate equipment of photography teams. (*Collection NatA*)

Advertisment for "card photographs" of the nation's military and political leaders, along with the albums for their display, from *Frank Leslie's Illustrated Newspaper* (November 31, 1863). The reverse of a carte-de-visite describes the photographic variety available at Batchelder's in Nashua, New Hampshire, around 1870. (*Collection GG*)

On April 12, 1861, the first Confederate gun fired on Fort Sumter and the Civil War was on. Brady, like every other photographer, did a land-office business. It was a mass-production opportunity, and the carte-de-visite, which could be mass produced, gained even greater popularity. The Brady gallery filled with soldiers of every rank who wanted their pictures in the new, low-cost, card style that was easy to mail and easy to carry. In the camps, where cartes were not available, the tintype was the rage, but in the cities the studios promoted the carte system with its potential for added sales of multiple prints.

With their swords and rifles, pistols and forage caps, and smelling of strong cigars and smoky whiskey, the military elite sat for Brady in Washington. It is believed that almost every general officer in the Union Army had his picture taken at one time or another by Brady or one of his operators.

Between the Civil War and 1880, cartes of Lincoln and his contemporaries bearing the imprimatur of the Brady galleries were sold by the hundreds of thousands to American families at prices of twenty-five cents or less.

MORE PORTRAITS.—Mr. Brady has a new and fine collection of battle scenes fresh from Petersburg. They are not of battle-fields (for no battles have been fought about there yet), but of generals and their staffs, batteries, hospitals, and many other interesting features of camp life. The portraits are capital, presenting the subjects in the "undress," easy posture and careless style of out-door existence, and conveying an accurate idea of how the men look, much better than statuesque parlor views of the same personages in their best clothes could do. Grant, Meade, Wright, Burnside, Hancock, Baldy Smith, Gibbon, Barlow, Wilcox, Griffen, Neill, Potter, Crawford, Warren, Martindale, Russell and others, singly or with their staffs, are hung up in his gallery. General Grant is shown in a number of positions, sitting, standing, leaning against a tree, about to mount a horse, &c. The variety of faces in these pictures is hardly more remarkable than the variety of hats—or, rather, the variety of shapes which are imparted to the huge, plastic, full dress regulation "slouch." One general wears it pulled fiercely over his eyes; another with the front brim turned up; another with the crown stretched out into the shape of a sugar loaf; another with the body violently punched in, as though a cannon-ball had caromed on it; another with the hat cocked over one ear; another with it thrown back on the head like a sailor's tarpaulin. It is the most versatile and expressive military hat ever invented; and for artistic purposes is indispensable. It is a hat that betrays the wearer's character with wonderful accuracy.

There are two other portraits in Brady's gallery, not taken recently, nor before Petersburg, which may have escaped the attention and comparison which they should receive. One is of Abraham Lincoln, the other of Jefferson Davis. The resemblance between these portraits is the point to be noticed. The men are, apparently, of the same height, the same build, the same breadth of shoulders, the same large heads and strong faces, protuberant foreheads and sunken cheeks; the same wrinkles and crowsfeet deeply marked; the same air of resolution or obstinacy pervading every lineament. They stand in precisely the same attitude. The left hand of each rests upon a book (supposed to be the Constitution and laws of the U. S.), and the right hangs idly by the side. Both are dressed in precisely the same fashion of complete black. The only substantial difference in the "getting up" of the two is that Mr. Lincoln shows a full face and a turn-down collar, and Mr. Davis a three quarter view and a standing dickey. The coincident resemblances between the two men are certainly very curious and interesting.

From *The Journal of Commerce* (July 27, 1864), news of Brady battle scenes "fresh from Petersburg." The portraits, in the casual attire of camp life, were studies before the battle. The reporter compares Brady portraits of Abraham Lincoln and Jefferson Davis: "resemblances between the two men are certainly very curious and interesting." (*Collection GG*)

While the Brady studios became carte-de-visite factories, Brady himself worked as the nation's first "pictorial war correspondent." He began by moving his equipment to the camps, where he made the now famous scenes of camp life, photography being seen by the military of the time as an apparently harmless novelty. Brady thought the camera useful, however, and in due course he expected it to be of service to military topographers.

Two years later Brady's vision of military intelligence through photography was assisting in planning attacks, setting cannon positions and establishing ambushes. Brady took to the field with various Union armies aboard his horse-drawn "whatizzit wagon," which carried camera models ranging from 16 by 20 inches to the small stereo, 4 by 4 inches. Brady and teams of his operators were to be found at the major arenas, eating with the troops and setting up their portable darkrooms behind the logs and in the trenches that shielded the men from shellfire. The carte-de-visite camera was not suitable for such photography; the only war scene cartes were copies of larger photographs.

The Brady galleries and the leading bookstores offered battlefield photographs to the news-starved public at prices of seventy-five cents and one dollar. Many of them were stereographs made for the three-dimensional viewers that were rapidly gaining in popularity.

One newspaper commented:

> Mr. Brady has done something to bring home to us the terrible reality and earnestness of war. If he has not brought bodies and laid them in our door-yards and along the streets, he has done something very much like it. . . . Crowds of people are constantly going up the stairs; follow them and you will find them bending over photographic views of the fearful battle field taken immediately after the action.

• THE LINCOLN–BRADY CHAIR

In February 1857 new chairs were installed for members in the House of Representatives. The only one of the old chairs known to have survived that change was Lincoln's, which dated from the time of his service in the Thirtieth Congress as a representative from Illinois. "Brady and the Cooper Union speech made me president," Lincoln said, and as a token of his friendship and admiration, the chair he had saved from the 1857 changeover was his gift to Brady in 1860.

Lincoln's cabinet members and the jobseekers who hoped for positions in the administration posed in the Lincoln chair, which became a fixture in Brady's Washington gallery. It was one of three "properties" commonly used in thousands of sittings before the Brady camera into the 1880s. Lincoln's chair, a marble-topped table and a massive, filigreed gold-leafed clock with the words "M. B. Brady" on its face were to become in this manner the "signature" of the Brady photograph. Where these props are not visible, the interlocked hexagons of the carpet pattern still identify many Brady gallery portraits.

The arms of the Lincoln chair, of mahogany with leather arm rests, made it look uncomfortable. The chair was in fact comfortable; Lincoln himself was first photographed in it at the famed sitting of May 1861. The pensive portrait, hand near face of the troubled president in the comfortable chair, is the classic photograph of the Great Emancipator.

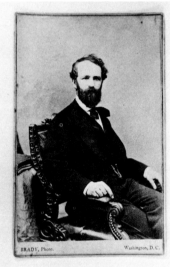

Mathew Brady's famous Lincoln chair, and Congressman Samuel Sullivan Cox of Ohio seated in the chair for the Brady portrait that was almost *de rigueur* for budding statesmen. (*Collection MusCNY*)

Brady teams followed the Union armies everywhere; at one time he had photographic stations at thirty-five locations. When General Robert E. Lee surrendered in 1865, Brady alone was permitted to photograph him a few days after the ceremonies at Appomattox. His Lee portrait is considered one of his most successful.

Brady's scenes of death were not ended. He photographed the hanging of the four men who, with John Wilkes Booth, were judged to have conspired to murder Abraham Lincoln. Brady personally set up two large cameras in the courtyard of the Washington Penitentiary and made exposures before and after the hangings. With an assistant, he developed the plates on the scene before leaving the prison yard.

The war concluded, it was time for Brady to give more attention to his studios. Certain that the government would want to own his thousands of glass plates for its official records, he proposed the payment of a modest $100,000 and completed the often begun, often delayed job of cataloguing the *War Views* plates.

Mathew B. Brady after his return from the Battle of Bull Run in a carte-de-visite taken July 22, 1861. His duster covers a sword presented to him by the New York Zouaves. (*Collection LofC*) Advertisements in 1865 for carte albums priced 20 carte albums for one dollar; 200 view albums sold for $12.50. (*Collection GG*)

There was little interest on the part of the United States government. The French government, however, offered to acquire the catalogued collection of eight thousand negatives, but the idea of their being owned by a foreign government troubled Brady, and he refused the offer.

To awaken interest in the war plates and to call attention to his portrait center at its new location in Washington, Brady announced the National Historical Museum and Portrait Gallery and opened it with an exhibition of the famed *War Views.* The show was well received and the event considered a success, but private groups were still unable to raise the funds for the purchase.

In 1869, the negatives unsold and his galleries in difficult straits, Brady began to sell properties he held in New York to liquidate his debts of over $100,000. Much of the debt was related to the four-year photographic effort in the battlefields and the cost of dozens of employees, materials, transportation and supplies.

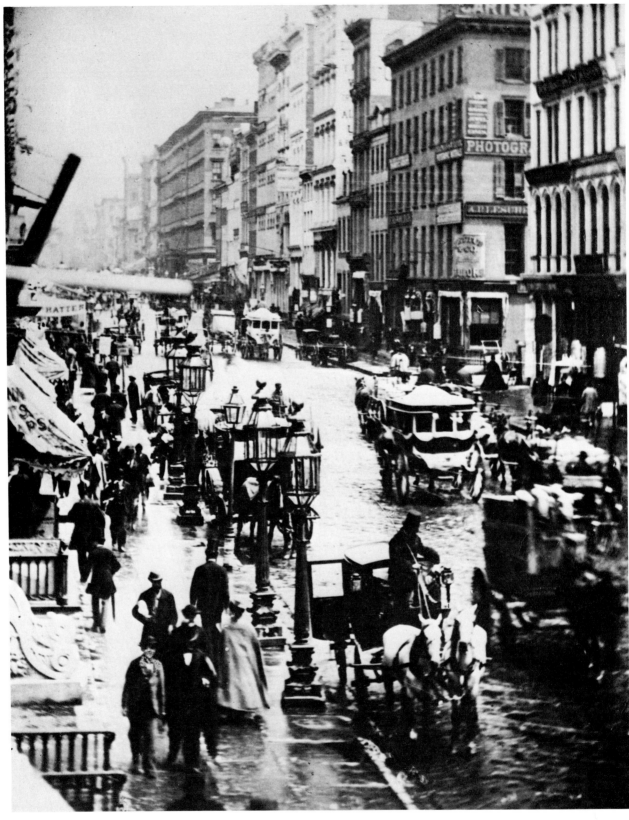

This photograph of Broadway looking north from Spring Street in New York
City in 1867 is attributed to Brady or one of his assistants. (*Collection N-YHS*)

It was then proposed to Congress that the government's library acquire two thousand Brady portraits of the leading figures of the period. At the time the storage bill alone for the portrait negatives was $2,840, and Brady could not raise the money. Thus the U.S. government acquired the negatives by meeting the storage bill.

In 1875 Congress finally authorized $25,000 to purchase the *War Views* negatives. It was too little and too late for Brady; his principal creditor, E. & H. T. Anthony & Company, his supplier, had attached one of the three sets of *War Views* plates that Brady had stored in New York. The American corporation GAF, successor to the Anthony Company, today owns the publication, resale and exploitation rights to the plates obtained as a debt settlement.

Brady, still based in Washington, continued to meet the great and near-great from behind his camera, primarily making cartes. He photographed Ulysses S. Grant and, once again, Robert E. Lee. He continued the production of cartes-de-visite with a set of three photographs of the fourteen electoral commissioners appointed to resolve the disputed election of Rutherford B. Hayes.

In 1882 the Brady portraits acquired when the U.S. government paid the storage bill were shown to be deteriorating. A proposal to reproduce them at a total cost of $75 per thousand was deemed to be prohibitively costly!

In 1892 Brady was struck down by a runaway horsecar at Fourteenth Street and Broadway, not far from his Tenth Street Gallery, itself long gone. He was never to work as a photographer again; the last of the Brady galleries was sold in July 1895.

Brady still owned one set of the *War Views,* and he continued to hope that the government would acquire the prints. To draw attention to the set, Brady agreed to deliver a Carnegie Hall magic lantern lecture at the end of January 1896, intending to illustrate his talk with glass slides made from the plates. Brady died on January 16, two weeks before the event.

• DATING CARTES-DE-VISITE

From the thousands of cartes to be found today in albums, many of which were dated by the first owner or the photographer, from the presence or absence of tax stamps on the cartes and from similar sources, it has been possible to catalogue variations among the cartes in order to establish guides to dating. Borders, card thicknesses, the presence of a machine-cut (rounded) corner and similar construction and printing details are further guides to dating.

The earliest cartes (from 1860 on) are those with a gold border of two lines. Thin double-line cartes-de-visite most commonly feature a thin inner hairline and a somewhat thicker outer line, with right-angle corners on both borders. Such borders are known to be found on cards readily datable to 1864–1866 because they sometimes bear revenue stamps on their backs (sales of photographs were taxed during the period September 1, 1864, to August 1, 1866).

Where the revenue stamps are of the blue two-cent playing card type, the carte is datable to the summer of 1866, when stocks of available stamps were to be exhausted in anticipation of the end of the tax.

Another guide to the dating of the earliest cartes is the corner finish. Cards with square corners were available only from 1860 to 1881; cards with rounded corners were available only from 1870 to 1891.

The thickness of the cards also assists in dating them. Those whose thickness is .4 mm of less are thought to date from 1864 to 1870; a .5 mm thickness is datable to the years 1870 to 1875; .6 mm cards were produced from 1873 to 1884; and the heaviest, .7 mm, are from the period October 1879 to at least 1888.

The World in Miniature.

As familiar to our *eyes* as "household words" is the photographic album with its well-selected gallery of household friends and distinguished public characters. It is astonishing to what an extent the business of producing *cartes de visite* (or small-sized photographs) has risen within the past two years. It has superseded the daguerreotype and ambrotype entirely, and now constitutes the chief adornment to thousands of parlor center-tables. You cannot do your friend a kinder service than to present him or her with one of these tasty albums. Among the leading artists in this city, who can supply all the wants of the public in this novel art, are Messrs. J. Gurney & Son, No. 707 Broadway. They have recently added to their collection of cards, a series of pictures of all the leading editors of the New York press; and so far as we can judge, we think they add another testimonial to the skill of those well-known artists. Their recently-issued catalogue contains a list of the most eminent personages in the world, whose pictures can be had for insertion in albums for a trifling sum.

From *Scientific American* (November 29, 1862), a commentary on the rise of cartes which "superseded the daguerreotype and ambrotype entirely." (*Collection GG*)

A Brady carte novelty, one of a series of cartes which included trained birds, was a total departure from the Brady catalogue of personalities. (*Collection NYPL*)

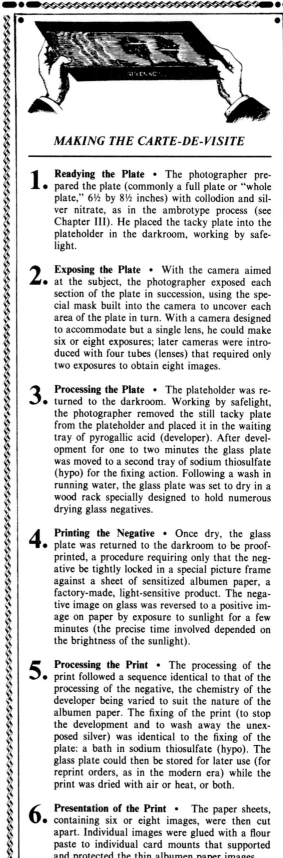

MAKING THE CARTE-DE-VISITE

1. **Readying the Plate** • The photographer prepared the plate (commonly a full plate or "whole plate," 6½ by 8½ inches) with collodion and silver nitrate, as in the ambrotype process (see Chapter III). He placed the tacky plate into the plateholder in the darkroom, working by safelight.

2. **Exposing the Plate** • With the camera aimed at the subject, the photographer exposed each section of the plate in succession, using the special mask built into the camera to uncover each area of the plate in turn. With a camera designed to accommodate but a single lens, he could make six or eight exposures; later cameras were introduced with four tubes (lenses) that required only two exposures to obtain eight images.

3. **Processing the Plate** • The plateholder was returned to the darkroom. Working by safelight, the photographer removed the still tacky plate from the plateholder and placed it in the waiting tray of pyrogallic acid (developer). After development for one to two minutes the glass plate was moved to a second tray of sodium thiosulfate (hypo) for the fixing action. Following a wash in running water, the glass plate was set to dry in a wood rack specially designed to hold numerous drying glass negatives.

4. **Printing the Negative** • Once dry, the glass plate was returned to the darkroom to be proof-printed, a procedure requiring only that the negative be tightly locked in a special picture frame against a sheet of sensitized albumen paper, a factory-made, light-sensitive product. The negative image on glass was reversed to a positive image on paper by exposure to sunlight for a few minutes (the precise time involved depended on the brightness of the sunlight).

5. **Processing the Print** • The processing of the print followed a sequence identical to that of the processing of the negative, the chemistry of the developer being varied to suit the nature of the albumen paper. The fixing of the print (to stop the development and to wash away the unexposed silver) was identical to the fixing of the plate: a bath in sodium thiosulfate (hypo). The glass plate could then be stored for later use (for reprint orders, as in the modern era) while the print was dried with air or heat, or both.

6. **Presentation of the Print** • The paper sheets, containing six or eight images, were then cut apart. Individual images were glued with a flour paste to individual card mounts that supported and protected the thin albumen paper images.

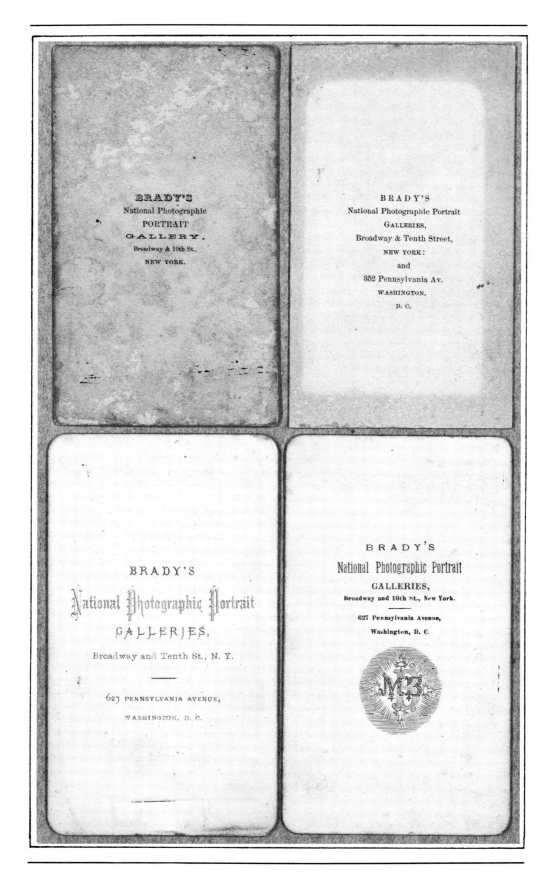

Brady's earliest cartes show the Tenth Street address in New York; then came the first Washington, D.C., location, at 352 Pennsylvania Avenue, 1862. The address, 627 Pennsylvania Avenue dates cartes from 1862 on.

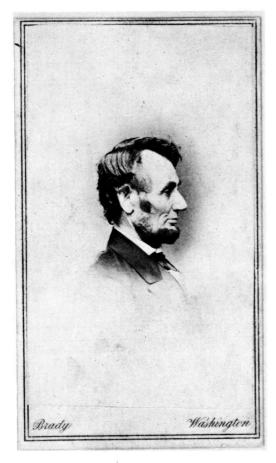

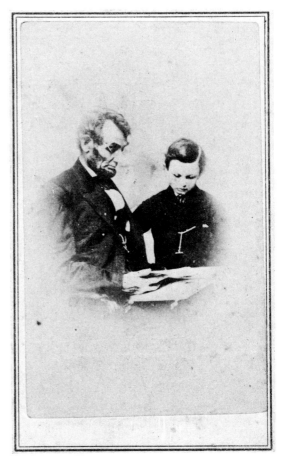

Top left: Lincoln was photographed on numerous occasions by Brady. This profile, taken on February 9, 1864, was the basis of the 1909 sculpture by Victor D. Brenner for the Lincoln penny, making this Brady photograph the most widely reproduced photography-based art in history. Lincoln and his son, Tad, in another memorable pose from the February sitting (*top right*). (*Collection LofC; GG*)

"Photography by Brady," the slogan and credit line that appeared on millions of published etchings, lives on in the millions of Brady cartes-de-visite that took his talent into every home. His *War Views* were finally donated to the Library of Congress; much else relating to Brady and the Americans he photographed is on file at the National Archives.

No American today can escape the impact of Brady on the American scene. It is his portrait of Lincoln, made on February 9, 1864, that appears on the face of the $5 bill, and another photograph from that same sitting, the famed Lincoln profile, is the basis for Victor D. Brenner's sculpted Lincoln on the penny.

THE CABINET CARD
Photographs on the Mantelpiece

T he years 1860–1865 were the gestation period in America for the French-inspired carte-de-visite. Its petite size, a boon to the customer, proved to be a mixed blessing for the photographer. Although the cards could be readily mass produced, the size of the head in the tiny photograph made it next to impossible to attempt the kind of retouching that would flatter the subject and lead to larger, more profitable print orders.

Brady's galleries and other major studios had earlier pioneered the large-size "imperial" portraits, but their cost was too high for the majority of gallery clients. These customers could be tempted to consider the preparation of larger, costlier photographs, but few could actually afford the luxury. One alternative was the "imperial carte," a larger portrait on the small carte, in which the picture area was limited to the face alone and the image was brought to the edges of the card. A happy compromise for the client, it brought no added income to the gallery.

English photographers resolved the problem by introducing a print that was four times the size of the carte. In 1863 a London gallery, Windsor and Bridge, began to advertise a new dual-purpose photograph for the home, one that was small enough to be accommodated in an album yet large enough to frame for display. It is believed today that the designation *cabinet card* arose from the first unframed showings of these card-mounted prints behind the glass of the cabinets in which middle-class English families displayed fine china, objects d'art and small statuary.

The new larger-size card was one that English photographers of the day found relatively easy to create. The standard glass plate for cartes-de-visite bore eight individual images, four across in two rows. The same plate was used to create two side-by-side portraits, each to a maximum size of 4¼ by 6½ inches. Since the edges of the plates were invariably unevenly coated and ofttimes finger-marred, the safe working area could be held on average to 4 by 5½ inches for each of the two albumen prints made from the glass plate. These prints were mounted on the new cards which were standardized at the photographer's familiar half-plate size (4½ by 6½ inches).

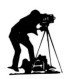

The mounting board, sturdy enough to stand without framing, was first as simple as the cartes which they superseded. Soon the border space below the photograph was used by the photographer to sign his work, then to advertise his studio. Versions of the mount were made available in pastel colors and later, in dark colors. Studio emblems were often embossed in gold and card edges were similarly adorned with gilt. In some cases, mounts were deckle-edged with a scalloped effect. Any darkroom worker with carte-making experience could also make the new cabinet cards since there was no change in any of the procedures; if anything, the process was simpler in that all elements were larger and easier to handle.

The new format had immediate appeal to photographers because most of them owned professional cameras of the full-plate size (6½ by 8½ inches). The two side-by-side exposures on the single sheet of glass could be made either simultaneously or consecutively, and each of the two negatives was large enough to permit pencil retouching.

The cabinet size was introduced in America late in 1866. Edward L. Wilson, publisher of the authoritative *Philadelphia Photographer,* wrote of the trade's dilemma at the time.

> Something must be done to create new and greater demand for photographs. The carte-de-visite, once so popular and in so great demand, seems to have grown out of fashion. Everyone is surfeited with them. All the albums are full of them and every body has exchanged with every body. Since their introduction in 1861, they have had an immense run.
>
> The adoption of a new size is what is wanted. Some discussion as to new size has taken place, and there have already been two or three suggestions.
>
> From Mr. G. Wharton Simpson we have received a specimen picture made by Mssrs. Window [sic] and Bridge of London—they call it the cabinet size. It is something like a carte-de-visite enlarged. The mounting card measures 4¼ x 6½″, the print 4 x 5½″, and the opening in the album 3⅞ x 5¼″.
>
> Mssrs. E. and H. T. Anthony & Company inform us they are manufacturing albums for the new size.

With samples displayed in the street-level gallery showcases where they could be viewed by passersby, and with the appearance of albums that held both the new picture size and the smaller cartes, photographers soon saw ample evidence of customer interest in the new picture format. If photographers had hoped that the new size would supplant the low-cost cartes, they were mistaken, but their hope that it would add to studio profit was more than satisfied.

Robert Taft described the reception of the cabinet card in his *Photography and the American Scene.*

> Within a year after its introduction it became a brilliant success as far as photographers were concerned, and its popularity continued for many years. The card photograph [carte-de-visite] was still made after the introduction of the cabinet photograph, and probably in total volume of business even passed the cabinet photograph when at the height of its favor.

The larger photograph size created a new problem of photograph quality. Flaws that were not particularly obvious in the smaller carte now became unacceptably visible. A misplaced strand of hair in the carte was hardly noticeable; in the cabinet photo it became a virtual rope across the brow or face. Therefore much greater care had to be taken in posing the subject and preparing the prints.

In response to the problem, the studios developed a new technology of retouching. Pencil and opaquing material came to be used liberally on the negative to

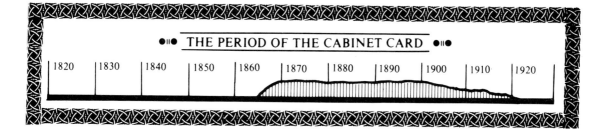

●ıı● THE PERIOD OF THE CABINET CARD ●ıı●

| 1820 | 1830 | 1840 | 1850 | 1860 | 1870 | 1880 | 1890 | 1900 | 1910 | 1920 |

eliminate pinholes, to alter backgrounds and even to modify the personality of the sitter. Wrinkles could be hidden, moles could be softened or removed entirely. backgrounds could be enhanced and a blank area replaced with sky and cloud effects behind subjects seated indoors. By 1868 the advanced retouching skills of French and German photographers became known in America, and at a major convention of photographers in Boston in 1869 an exhibit of the retouching skills of a German specialist created a sensation. Before-and-after prints showed how pencil work on the negatives peeled years off aging faces and added lustre to dull eyes. Decorative effects were introduced into backgrounds.

One major proponent of retouching was a Cleveland photographer, James F. Ryder. Ryder's skillfully retouched prints were of such influence that the photographers' convention was held in Cleveland in 1870. There photographers could see Ryder in his hometown, visit his studio, study his wares and learn his techniques at first hand.

The cabinet card, nearly four times the size of the popular carte-de-visite, made larger albums necessary, but the new size also permitted shelf and wall display in frames. (*Collection GG*)

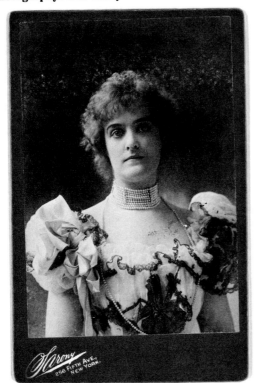

The larger image revealed defects and blemishes, calling for greater skill in posing, lighting and a new art, negative retouching, to create the perfect skin and flesh tones. (*Sarony photo, unidentified subject; collection GG*) The backs of the cabinet cards became permanent advertising billboards for "artist photographers."

Successes in retouching led to innovations both in the darkroom and at the camera. Diffusion of the image (to reduce the need for retouching) could be effected with new soft-focus lenses or with special handling of the negative in the darkroom. The new results led to verbal skirmishes and finally to a new Civil War in which photographers and artists were the infantry and cannoneers. The issue, of course, was Truth in Photography. One opponent of retouching called it "a degenerating, demoralizing and untruthful practice." Another claimed that retouching had been suggested "by some miserable photographic tyro who, satisfied with his inability to produce a passable photograph, was obliged to call in an 'artist' to cover up his malpractice."

Retouching, instituted with the appearance of larger photographic images, continues to this day as standard practice in the formal portrait studios. Proponents of twentieth-century miniature camera photography, making portrait negatives with heads of the size to be found on early (1860–1870) cartes-de-visite, rely on soft-focus lenses or darkroom diffusion devices to achieve the softening of blemishes and wrinkles.

By the period of the cabinet card (1866–1906) the basic studio camera suitable for such photography had evolved considerably. It was no longer the cumbersome, boxlike camera obscura of the daguerrean era, yet it dwarfed the lightweight folding field camera of the Civil War. It had the ponderous look of the furniture of the Victorian age, especially in the late 1870s. The new camera for the gallery, along with its massive support, was so large that a small photographer might be lost to view behind it. And the tripod of the early camera had now become a table with wheels, a vehicle more akin to a teacart for the parlor than to the traditional three-legged foldaway setup.

A retouching stand with shadowing pencils. At left is a unique cabinet card, assembled as an advertisement for the Hunt & Fisher gallery in Plainfield, New Jersey, about 1880. A dozen cabinet cards were $3.50; cards (cartes), $2. (*Collection PK*)

Since careful portraiture required perspective that could be achieved only with the camera at a distance greater than ten feet from the subject, the photographer used a kind of lens known as a long focal length optic. Such a lens was large, and it required a camera with a bellows that could expand to three or four feet (between the lens at the front and the plate at the back). Giant cameras and heavy glass lenses required stable supports, so complex tablelike camera rests on wheels were developed, featuring gears and cranks for raising and lowering the camera or tipping or tilting it during the aiming and focusing. They also had drawers for storing plateholders and other conveniences for the operator. The early flexible lightweight camera could still be found in any studio, but it was reserved for the occasional sitting outside the gallery.

The size and weight of the camera and limitations on the height to which the support table could be adjusted created rigidly defined fields of view. These factors in turn played a strong part in defining concepts of posing. For example, such a camera made it impossible to photograph a child playing with toys on a floor; the camera simply could not be pointed down at such an angle. The limits of the long focal length lenses made it difficult to hold sharp focus at short distances, and this kept the photographer from making close-up portraits as often as he might have wished.

While photography had originated with portrait painters, the new portraitists found themselves severely limited by the nature of their equipment. The painter who had yearned to "fix" an image on his camera obscura was now a technician who envied the painter his freedom. The photographer by and large was able to offer only standing and seated poses; the nature of skylighting and the limited range of backdrops and studio props (imitation rocks, gates, garden benches,

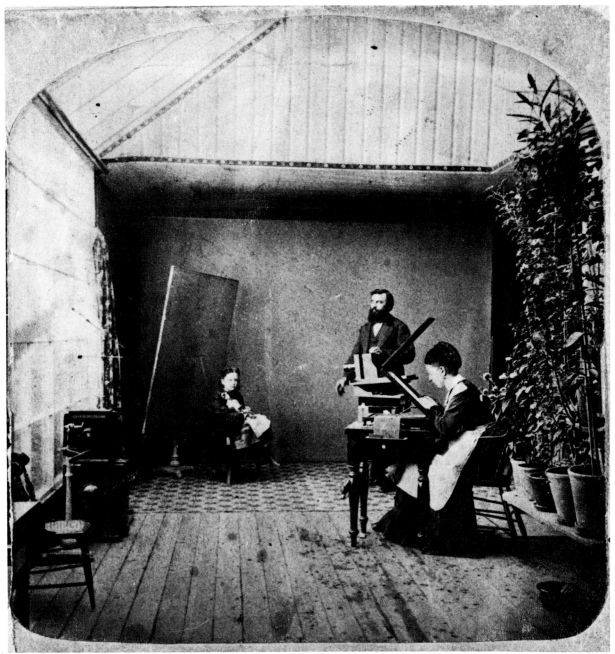

The cabinet card photographer in his gallery, from a stereograph. A negative
retoucher is seated at the foreground work table (about 1875). (*Collection
IMP/GEH*)

stuffed animals) were constants. It was only at the beginning of the age of elec-
tricity that arc lighting permitted an alternative to the soft, grey drift light from
skylights and veiled gallery windows.

The photographer's gallery was literally built around the giant camera. To
make a larger or a smaller plate, he replaced not the camera but the back ele-
ment, a wood frame interchangeable with a number of others, each with a
groundglass and an arrangement for the fitting of one or another size of plate-
holder. The backs ranged in size from 5 by 7 inches to 11 by 14 inches and larger.
As the subject was settling into the posing chair, the operator could swiftly re-
place the camera's back to meet the request for a carte (the studio's smallest pho-

tograph), a cabinet card or the costly larger portraits. Each change of plate size necessitated a change of lens. The optical characteristic of a lens suitable for portraits of cabinet card size would not properly serve the magnification range necessary for a portrait on a plate two or three times that size.

Until the 1900s most formal portraits were made on plates appropriate to the cabinet card print order: 5 by 7 inches or 6½ by 8½ inches. Variations in photographic style such as vignetting (the effect that isolated the head and shoulders against a white background) could be achieved at the instant of exposure with a device before the lens or later, in the darkroom, with optical trickery. Plain backgrounds could be altered with brushwork on the negative to incorporate cloud effects or they could be lightened to white or darkened to near-black by diminishing or increasing the amount of light falling on the background area during darkroom print exposures. All of these effects were learned during the cabinet card's forty-year lifetime.

The advances of the cabinet card portrait over the cartes were not lost on an increasingly sophisticated public. People learned to ask for the effects they saw on samples in the gallery showcases. The common cabinet card, with slight retouching, was inexpensive, usually $3.50 per dozen (from one negative) or four for $2 in small-town studios. The unretouched cartes-de-visite, at twenty-five cents each or $2 per dozen, outsold the cabinet cards only until the 1880s, then faded away to leave the cabinet card the most popular photographic format.

The larger negatives provided room for a variety of experimental effects in the darkroom. Portraits could not only be vignetted, they could also be positioned within new borders and shapes of a second negative (*left*). Even traditional static poses from daguerrean days took on greater impact and a sense of presence. (*Collection GG*)

Inspiration Point, Clear Creek Canyon (*Colorado*), by the Western photographer W. H. Jackson, was one of the many standard cabinet card offerings that brought Rocky Mountain grandeur to Eastern families (*left*). (*Collection PK*) An unknown documentary photographer made this poignant cityscape about 1880. (*Collection GG*)

Temple d'Hathor at Danderah, a French cabinet card, was one of many art, travel and historic subjects available to the American family before the era of photographically illustrated newspapers and magazines. (*Collection GG*)

President Grover Cleveland (*left*) and poet William Cullen Bryant were
among the well-known figures shown on cabinet cards that were available in
stationery stores as part of continued sales of stock photographs which
started with cartes in the 1860s. (*Collection GG*)

A few minutes of retouching was part of the gallery's effort in readying the
proofs from which a client would select and order finished prints. Further re-
touching, coloring and framing were invariably recommended at the print selec-
tion visit in order to increase the gallery's profit. The studio's investment in a staff
retoucher was more than repaid by the larger orders obtained from clients who
appreciated a flattering photograph. In the major cities and the finer studios, the
cabinet card sitting generally required a minimum order of twelve cards for $12, a
price that included the making and showing of proofs and the retouching of blem-
ishes on the negative selected. Few customers realized that all the negatives they
were shown had already been retouched slightly to diminish the worst wrinkles
and the most offending skin blemishes or errant strands of hair.

The cabinet print won wide acceptance within a few years after the Civil War,
but its heyday appears to have been in the years between 1875 and 1906. By the
end of that period a more sophisticated consumer, seeking greater variety in pho-
tograph size, style, mount and frame, was no longer satisfied with the cabinet card
that produced millions of images of the face of America in forty years of service.

Once the American home had acquired the albums with spaces for both the
cabinet card and the carte-de-visite, photographers and photography houses began
to create additional stock photographs in album-size images. Photographs of the
Great West, early American Indian scenes, portraits of local ball clubs, choirs and
political figures were made available in the conventional size, 4¼ by 6½ inches.

Toward the end of the century, the Soule Photograph Company replaced E. & H. T. Anthony & Company as the major stock photograph supplier. Soule limited its offerings to the cabinet-size photograph, mounted on cards for family albums or unmounted for framing. By 1894 Soule's catalogue offered more than 14,000 "ancient and modern works of art, art reproductions of famous paintings, sculpture and architecture." The cards were priced at twelve for $1.50, unmounted.

In the 1880s newspapers and other publications were finally provided with halftone printing, a system that made it possible to publish photographs in a quality approaching that of the original. By the turn of the century, rotogravure sections of newspapers—special papers printed with special inks on special presses—further improved photographic reproduction quality. The sale of cabinet photographs of celebrities, scenes of wars and disasters, travel and art views was profoundly affected by these developments, and by the end of the Spanish-American War, stock photographs for the family album were no longer being collected. Family scrapbooks, made up of photographs clipped from a number of publications, were a low-cost replacement.

At first cabinet cards were stiff, posed in the fashion of the daguerrean era. With the arrival of the dry plates of the 1880s and even with the slightly slower early plates, posing took on a more natural look, as shown in this parent and child study (*left*) and the character study of "Mrs. Gilbert" by Sarony. (*Collection GG*)

MAX ALVARY.

87 UNION SQR., N. Y.

Napoleon Sarony (1821–1896) gaudy in his Turkish fez, was one of the most acclaimed cabinet card era photographers. A man of great wit and talent, he was first an artist, then a photographer. His presentation of the theatrical scene lifted cabinet card photography to unmatched heights of photographic grandeur. (*Collection PKap*) Max Alvary, a New York character actor in a costume portrait by Sarony (*right*). (*Collection GG*)

◫ NAPOLEON SARONY AND GLAMOUR PHOTOGRAPHY

One of the most colorful photographers of the nineteenth century was Napoleon Sarony (1821–1896), chronicler of the American theatre and publicist for some of its loveliest ladies. Sarony's cabinet cards reached into every American home as had the work of no photographer except perhaps the incomparable Mathew B. Brady.

At Sarony's death, the *New York Times* on November 10, 1896, noted that during his career, first in England and then in America, he had posed and photographed 40,000 actors and actresses and another 200,000 of the general public— and astonishing volume of photography for one studio, and all of it accomplished between the late 1860s and 1896.

Sarony's cabinet card and carte-de-visite portraits of the giants of the stage and his sensitive studies of every president of the United States from Ulysses Grant to Theodore Roosevelt and generals William Sherman, Philip Sheridan and Winfield Hancock were to make these faces familiar to Americans everywhere at a period when printed portraits were only drawings, etchings or cartoons. In the concluding paragraphs of its page-one obituary notice, the *Times* pointed out that his clientele included "practically every man and woman who has come before the public since he started his business, and every prominent visitor from abroad."

Sarony, born in Quebec, Canada, was named after Napoleon Bonaparte by his father, an English lithographer who unreservedly admired the Little Corporal and had served with Wellington at Waterloo. In 1838 Napoleon Sarony went to New York City, where his natural talent for art and the interest he had shown in the lithographic accomplishments of his father led him in time to a position with Nathaniel Currier of Currier & Ives fame.

The cabinet card gallery was a drawing room of extreme elegance, featuring high-quality furnishings, draped skylights and tasteful props. Very young children were posed in the broken egg cradle. (*Collection HS*)

•QUICK DATING GUIDE TO CABINET CARDS

The earliest American-made cabinet cards have been dated only to the post–Civil War period, beginning in 1866. Designs and colors of these cards followed those of the cartes of that time. Cabinet cards are rarely found after 1906.

Card colors

1866–1880:	white card stock of a light weight.
1880–1890:	different colors for face and back of mounts.
1882–1888:	face of buff, matte-finished, with a back of creamy-yellow, glossy.

Borders

1866–1880:	red or gold rules, singles and double lines.
1884–1885:	wide gold borders.
1885–1892:	gold beveled edges.
1889–1896:	rounded corner rule of single line.
1890–1892:	metallic green or gold impressed border.
1896:	impressed outer border (without color).

Corners:

1866–1880:	square, lightweight mount.
1880–1890:	square, heavy board with scalloped sides.

In the years when photography was making its impact on the world, Sarony was helping to found his first business venture, Sarony, Major & Knapp, specialists in etchinglike reproductions of daguerreotypes. The business prospered. Sarony made a name for himself as a draftsman, and as the firm branched into the theatrical field, he helped to produce posters for advertising. By 1857–1858 he was also a daguerreotypist in Yonkers, New York.

Sarony's first wife was the daughter of one of his partners; her death, leaving four Sarony children, was a turning point in his life. He left America for the Continent, seeking a new identity and a career as a fine artist while living on earnings from his New York business. When Civil War–related changes wrecked what had been a profitable enterprise, he was forced to suspend his art studies in Paris.

Sarony had a brother, a photographer who lived in Scarborough, England, then a fashionable resort for the English gentry. He joined his brother there and learned the technology of wet-plate processing and the studio procedures that made gallery operation a lucrative enterprise. In less than a year he had a studio of his own in Birmingham, his father's early home. With his background in painting and his daguerrean skills, he had an advantage over his less artistically accomplished contemporaries.

Sarony's portraits had a vitality quite different from the staid Victorian likenesses that his competitors created. Using his skill as a lithographer and seeing

One of *Sarony & Company's Stereo Celebrities,* this stereograph gives the illusion of three-dimensional viewing of theatrical personalities. The paired photograph was viewed through a stereoscope found in most Victorian homes. (*Collection GG*)

the picture area as a total environment rather than as a field in which one set an isolated head or a standing figure, Sarony improvised backgrounds. He is credited with inventing new effects, probably subtle shadings, with lighting and with darkroom processing. Sarony is said to have been one of the first photographers in England to replace the blank background with painted scenic effects.

In 1864 Sarony returned to New York and established himself as a photographer on lower Broadway, where daguerreotypy had been launched. Later he moved the studio uptown to the more fashionable Union Square, a park then surrounded by fine homes and leading restaurants and hotels.

According to Marvin Kreisman, a biographer of Sarony, "his camera studies were much in demand by the dramatic profession. At that time he was still working with the wet-plate process, making only the carte de visite size. He usually made eight poses on one 10x12-inch plate, using a single-lens camera and moving the plate after each exposure." This was essentially the same method used ten years earlier by Disdéri in France. It forced the photographer to work with painstaking exactness, and its slow operation was in keeping with the careful posing and lighting effort that marked the Sarony portraits.

From 1870 until his death in 1896, Sarony's famous carved oak posing chair was used by even more celebrities than the Lincoln chair in the Brady gallery in Washington. There was strong reason for stage celebrities to frequent the bizarre studio owned by the odd little man: he paid them for the privilege of marketing their costume portraits—if they did not pay him to create a portrait role that might catch the public fancy. Sarony portraits of state figures were sold in theatres, at midtown hotels and at all stationers where picture postcards were to be found. He secured exclusive rights to the portraits by the one-time model's fee he paid each personality. Newer stage figures, seeking a reputation, often paid Sarony to add their image to the collections of portraits of established stage figures that he distributed to an adoring public.

It was highly profitable to sell these portraits to the millions of Americans who were no longer filling photo albums with Civil War heroes. And the family that did not collect popular theatrical luminaries could usually be enticed to acquire heroic portraits of figures in the arts or politics, among them Henry Wadsworth Longfellow, Walt Whitman and William Cullen Bryant.

Sarony himself was as colorful a figure as anyone who posed before his lens. He was often seen on Broadway, Kreisman says, sporting a rakish moustache and beard and wearing a calfskin jacket, his trousers tucked into highly polished cavalry boots. Atop all, a Turkish fez. He had the ego to match his talent and a drive and ambition that honored his namesake.

Sarony frequently attended the opera and the theatre, but his closest friends were artists. He was part of the circle of gifted people who shared the life at the Salmagundi and Lotos clubs, and his quick crayon sketches were well known in the art world. He was bold with nude drawings, which he showed in his studio and

Adah Menker as Mazeppa. (*Collection IMP/GEH*)

• SARONY BUILDS HIS REPUTATION

Sarony's new style of photography lent itself especially to the theatrical poses of actors and actresses, and his studio became a center for such portraiture. It was his photograph of Adah Menker as Mazeppa that, according to the *New York Times*, set him up before all England as a master.

Adah Isaac Menker was a famous actress whose portrayal of Mazeppa had created a furore.

"Adah Menker," Sarony used to say, "came to me in Birmingham. 'Mr. Sarony,' she said, 'all attempts to photograph me as Mazeppa have been failures. Now I want you

to take me in eight poses on condition that you allow me to pose myself.' I agreed to this on condition that she would allow me afterward to pose her in eight different attitudes. She said that was only fair and we went to work.

"When the photographs were ready, I hunted her up in her dressing room in the theatre. I gave her those of her own posing first. Her exclamation was: 'They are perfectly horrible. I shall never have another photograph taken of me as Mazeppa as long as I live.' Then I presented the photographs of my own posing. She threw her arms around me and exclaimed, 'Oh, you dear, delightful little man, I am going to kiss you for that,' and she did."

presented to friends, finding his models among stage aspirants who came to his studio hoping that a photograph by Sarony would be a publicity key to future success. Some agreed to pose unclad for a drawing, if not for a camera study.

With the development of the retoucher's skills in the 1870s, Sarony realized that his theatrical photography would be enhanced dramatically by the substitution of the larger cabinet card for the cartes he was then making. The cabinet cards were large enough, according to Philip Kaplan, a theatrical photography historian, to be displayed and sold as souvenirs both in the theatres and in prestigious hotels. At the height of the season, Kaplan says, the price of the cards was usually $12 per dozen, a very handsome price for the time.

Sarony also made his share of photographs of ladies in tights worn for their chorus roles. These photographs, risqué for the time, joined their counterparts in a "special" album kept in some Victorian homes by photo fanciers who had great visions for the future of photography.

As the sales of theatrical portraits grew, a royalty system was devised to compensate top performers. Sarony had a monopoly in this area because of the large sums he advanced against royalties for exclusive rights. Within ten years he had assembled a stock of 40,000 photos of actors, actresses, lecturers, wrestlers, prizefighters, politicians, midgets, and people who had figured in stories featured in the period's scandal papers.

"Why do they buy the photos?" asked Olive Logan, actress and author of *Woman and Theatres*.

> They buy them because they like us, because they dislike us, because they know us, because they don't know us, because they want to see how we look and for no reason whatever. The photograph market has many fluctuations; let us be maligned or lauded, scathed or flattered, and cabinet photo stock goes up forthwith. Ah! If we were only considerate enough to die, that is a different matter! Then everybody wants a photograph. The photographer would be in luck if he could only get hold of a negative of the gentle genius who died yesterday in solitude and poverty. What a demand there would be for photographs of that dead young poet. While he lived, no photographer could have sold a hundred copies of his picture.

Lillie Langtry, a leading actress and a familiar visitor to the Sarony studio, explained the phenomenon of photograph collecting in another way:

> The photograph craze, like every other fashionable rage, has its comic side. After the shopkeepers had exhibited my pictures in the windows alongside royalty and distinguished statesmen, all the pretty women rushed pell-mell to be photographed that they too might be placed on view. Some smothered themselves in furs to brave photographic snowstorms, some sat in swings, some lolled dreamily in hammocks, others carried huge bunches of flowers indigenous to the dusty studio and looking painfully artificial, and one was actually reproduced gazing at a dead fish!

The description may well have been drawn from life in the Sarony studio, for the flamboyant owner knew no limit in collecting bizarre properties such as a stuffed crocodile, Egyptian mummies, Russian sleighs, statues of Chinese gods and examples of the taxidermist's art from the far corners of the world. Following his death in 1896, an auction of his studio effects at the American Art Galleries was the hit of the season.

The Sarony legend remained for a time with his studio, which became a New York landmark, a theatrical photography center on Broadway in the Tin Pan Al-

ley area above Times Square until 1925. But with the death of its founder, it lost the bulk of the publicity that had brought it a continuous flow of clients. The widespread publication of photographs in newspapers and the special high-quality reproduction of photography in the gravure sections of various publications ended the profitable sale of Sarony's stock photographs for the albums in American homes.

Technical advances in photography brought enlargements, prints made by gravure and the rich-looking prints of the platinum process. The cabinet card limped into obscurity at about the time of World War I, as larger, framed photographs on shelves and walls reflected the growing affluence of the American family. Napoleon Sarony had died in 1896; Otto, his personally trained successor, succumbed in 1903; and both the Gibson Girls and the cabinet cards faded into obscurity shortly thereafter. Finally, even the glamour of the Sarony label on a photograph stirred few memories; America's photographic Napoleon had also lost his battle to remain always in the public eye.

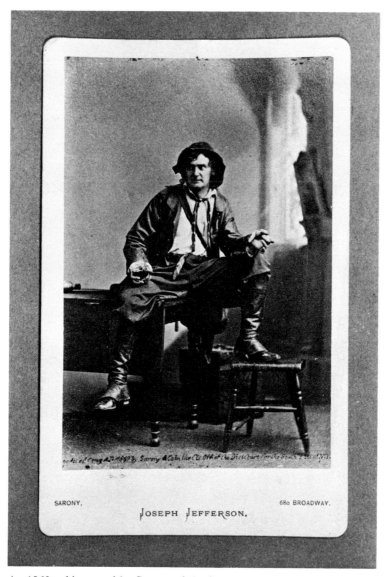

SARONY, 68o BROADWAY.

JOSEPH JEFFERSON.

An 1869 cabinet card by Sarony of the famous actor Joseph Jefferson was made in the first New York gallery of the theatrical photographer. It captured the spirit of the actor's role in a striking departure from the formal portraits by Sarony's contemporaries. (*Collection PK*)

• DATING THE CABINET CARD

The earliest cabinet cards, those of the late 1860s and the 1870s, like the first cartes-de-visite, were of simple design. The basic card stock on which the photograph was mounted was a lightweight cardboard not used in later years. A thin red line with square corners, less than one-eighth of an inch from the edge, was the sole decorative motif.

In later years the red line became a complete border and a space below the mounted photograph allowed the photographer to give the name and often the address of his studio. When mass printings were made of cards depicting public figures, this area also included the name of the personage. If the subject was an actor, the role in which he was posed would be included. Sometimes this information was printed on a small gummed label that could be affixed in the area below the photograph.

Buff or maroon cards, often with the imprint of the photographer in gold, date from the 1880s. Gold beveled edges and deckle-edges with gold illumination in the edge-carved notchings are offered in trade catalogues of the early 1890s. Dark green mounts are occasionally seen; these date from the late 1880s.

Square corners and rounded corners on cards of heavy mounting stock are found through all years of the cabinet card era, but the earliest cards, those of the late 1860s and 1870s, were made only with square corners.

As with the carte-de-visite, impressed gold borders, usually single or double ruled lines that appear about one-eighth of an inch from the edge, were offered to enhance the photographic presentation. These commonly date from the 1870s to the 1880s and are almost always earlier than the cards found with solid color backgrounds and with the ornate borders, illuminations, line artwork and scroll effects of the photographer's own advertising on card backs. Such heavily imprinted cards date from the final years of the cabinet card era, generally from the 1890s to about 1910.

The 1888 E. & H. T. Anthony catalogue, a prime source of supplies, reveals that the studios paid thirty cents per package of twenty-five cabinet cards in primrose or maroon color in a "plain" design (evidently this meant either no ruled border or a single or double ruled gold border). Gold beveled-edge cards cost $1.45 per hundred on primrose stock, $1.55 per hundred on black, chocolate or maroon.

By 1895 the photographer had a wider choice of style and color. There were grey, amber, bottle green, maroon and chocolate cards in enameled finishes as well as rose tints and other "assorted colors" in unenameled finishes. Card prices ranged from thirty to sixty cents for twenty-four cards, without imprint. Photographers who offered cards imprinted with the studio name paid more for the personalization.

Some cards have been found with heavy embossing of a texture that gives them an art-board surface, often with an unembossed area left clear as the mounting surface for the print. Cards of this type have been dated from 1891 to 1906.

James Greenleaf Whittier. (*Collection MRI*)

Indian Scouts. (*Collection PK*)

WHIPPED AT POST

Henry Wadsworth Longfellow by Jeremiah Gurney (*top left*). (*Collection PK*) *Whipped at Post*, a documentary card (*bottom left*). (*Collection PK*) An erotic cabinet card (*top right*).(*Collection GG*) Soule Photograph Co. advertised in the 1890s that it had 14,000 cabinet photographs available (*above*).

▣ *MAKING THE CABINET CARD*

The cabinet was essentially two elements: an albumen print made from a collodion process on-glass negative and a supporting mount of lightweight card stock. During the first fifteen years of cabinet card making, all photographers followed the essential steps of the collodion process, which was then in wide use in the making of cartes and other prints. The glass plate of the cabinet card operation was identical to that used by the carte photographer, who divided the area into six carte-size photographs; the cabinet card photographer made two side-by-side exposures on the plate. •

1. **Readying the Plate** • The photographer prepared the plate in ordinary room light in the darkroom. When the glass had been cleaned, he spread the collodion on one face of the glass, then dripped the excess collodion back into its bottle. The safelight was the sole light permitted during the sensitization of the plate in a bath of silver nitrate for approximately one minute. The newly sensitized plate was removed when it had a creamy yellow appearance and was immediately fitted into a waiting plateholder.

2. **Exposing the Plate** • With the subject posed, the first of two exposures was made on one half of the plate while a divider within the camera protected the other half from light. Shifting the divider and aiming the camera again, the photographer exposed the second half of the plate. Exposure times ranged from five to ten seconds.

3. **Processing the Plate** • The photographer returned to the darkroom with the plate. Working by safelight, he immersed the plate, image side up, in a waiting tray of pyrogallic acid. Developing was usually complete in one to two minutes; then the image was fixed in a tray of sodium thiosulfate (hypo). Following a wash in running water, the developed glass plate was set to dry in a wooden rack.

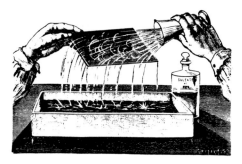

4. **Printing the Negative** • Once dried, usually in less than an hour, the glass plate was ready for proof-printing, a procedure requiring that the negative be locked tightly in a picture frame against a sheet of factory-made light-sensitive photographic paper. The sunlight exposure of this picture frame created a positive image on the paper within a few minutes. The precise exposure time was determined by the brightness of the sunlight; usually only a few minutes was required. Sun-made proofs required no further chemical processing.

5. **Presenting the Proof** • By the 1870s the proof print had come to serve two purposes. It guided the work of the retoucher, who would use a pencil on the negative to eliminate defects and to soften some facial detail, and it would be shown to the client to entice an order.

6. **Making the Final Prints** • The retouched negative would be locked into the special picture frame against a sheet of factory-sensitized albumen paper. The time of this sunlight exposure was brief, less than that necessary for the proof print. The processing of the paper followed the processing sequence for the negative: developer, hypo, washing, drying. The dried print was trimmed and affixed with flour paste to the stock mount.

After 1880, with the introduction of the dry plate, there were modifications in some of the procedure that the photographer followed. With the factory-made sensitized plate, it was no longer necessary for the photographer to sensitize his glass plates or to process a plate immediately after making an exposure. He loaded his plateholders each morning in the darkroom and processed all plates each night after completing all sittings. All steps following the near-instantaneous exposure (proof-printing and final print preparation) were identical to those of the wet-plate era.

THE WET-PLATE PRINT
The Photograph That Opened the West

<p>he number of photographers practicing "sun-limning" (an early term for photography by sunlight) in 1860, according to Marcus Aurelius Root, exceeded ten thousand. But, Root wrote, "a great proportion of this number were not qualified to achieve even a high mechanical success therein, being ignorant alike of its theory and practice."</p>

By the standards of Root, one of America's great daguerreans, most indeed may have been barely qualified. It is possible that every one of his professional contemporaries was experienced in at least two of the major processes then available. Most photographers then learned their craft as apprentices or as students of gallery photographers whose own careers spanned the period of photography's first technological developments. Thus Mathew B. Brady learned from Samuel F. B. Morse, who had been introduced to daguerreotypy by Daguerre early in 1839. Since up to 1860 the daguerreotype and the ambrotype were the major offerings of the gallery, knowledge of these vastly different systems was shared by all who emerged from gallery training. And, through reading the literature of the time, Humphrey's *Daguerreian Journal, The Photographic Art Journal* of H. H. Snelling and *The Photograph and Ambrotype Manual* of N. G. Burgess, many operators were introduced to alternative and experimental processes. Further, through the sales efforts of the Langenheim brothers of Philadelphia they learned of the on-paper calotype process (see Chapter 2). But Root was distressed that despite training under proficient masters and the widespread availability of definitive technical literature the average professional was still "not qualified."

Fortunately for the less talented photographer, the new processes demanded less proficiency. It was a time when daguerreotypy, a highly demanding procedure, was in decline, rapidly being superseded by ambrotypy. This procedure in turn set the stage for the transparent negative, and from that negative it was but one step to paper prints of high quality. For a number of years before the Civil War, prints on paper and on sensitized canvas were being created in big-city galleries.

In 1854 in Cincinnati, Ohio, a giant photographic print—a life-size, full-length portrait—was made from a standard studio negative on a specially prepared sheet of paper measuring 5½ by 7 feet. The darkroom of photographer Charles Fon-

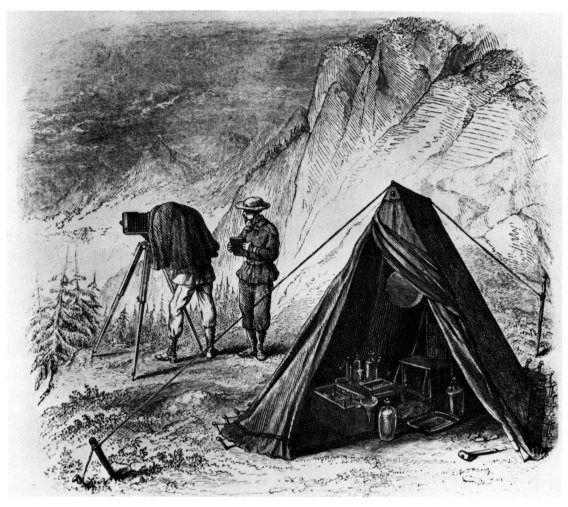

When the wet-plate photographer went into the wilderness he brought with
him sheets of glass, collodion, sensitizing and fixing agents and a darkroom
tent in which each plate was individually readied and then processed.

tayne, which produced this noteworthy print, was equipped with a solar (sun-powered) enlarger, an optical system that extended from the darkroom to where it could be reached by the sun's rays outside the building.

The giant prints were rarities; until then only the Brady gallery in New York and a few others had been able to make life-size enlargements with the solar enlarger—and even these were limited to enlargements of the head and shoulders, generally made to serve as a base for a portrait in oils.

Few Americans, of course, could afford the cost of such photographs, so there was plenty of work for the poorly trained or less skilled photographer whose abilities were equal only to the new and simple processes. He could always make a living from the carte-de-visite and, after 1866, the cabinet card. Neither of these sizes required the use of an enlarger; the dry negative need only be exposed in sunlight to a light-sensitized sheet of paper and then taken into the darkroom for processing. Much of the demand for larger photographs could be satisfied by making larger negatives; few photographers undertook to construct the very large cameras that could provide sharply detailed prints without enlarging. Thus, by the late 1860s, few Americans had yet seen a photograph much larger than a book page.

At this time a new type of camera artisan appeared, one who rejected the sedentary character of gallery life. Far more skilled than his contemporaries, he had a far broader vision; he eschewed the making of likenesses and sought instead to capture no less than the glory of America. His breathtakingly precise large photographs competed for an audience with oil paintings and Currier & Ives prints. The body of work that he and his associates left behind consists of photographs loosely classified as "wet-plate prints" because all were made by the collodion-albumen process that succeeded the ambrotype and the daguerreotype.

Photographers seeking new frontiers for themselves and their camera talents following the Civil War found a wide variety of assignment and employment: with survey teams of the U.S. government and the railroads in the Far West, with geological expeditions of various universities and museums studying newly uncovered prehistoric Indian sites and with Army expeditions moving into the unmapped wildernesses beyond the Rocky Mountains.

Some of the pioneer photographers who helped open the West were Andrew Joseph Russell, Charles R. Savage, Alfred A. Hart, T. H. O'Sullivan (the Brady team photographer of Civil War fame), William Henry Jackson and Carlton E. Watkins. Through their cameras Americans in the East saw for the first time the mountains, prairies, canyons, gorges and deserts of the West. Their wet-plates helped shape a national consciousness along the lines of those who had earlier spoken of a Manifest Destiny, of an America that would extend from coast to coast.

It was their photographic conquests that gave romantic allure to the words "wet-plate photography." The giant cameras they carried became the symbols of their courage and their determination to bring back detail from canyon deeps and mountain peaks. Their introduction of the mammoth plate, 18 by 22 inches, assured full appreciation of the most intricate shore edge or glacial ledge.

The giant spaces they discovered demanded giant cameras. While the flexible folding camera of the city photographer was of the full-plate size (6½ by 8½ inches), few of the special expedition cameras were as small as that. The camera that documented the famous meeting at Promontory Point, Utah, of the tracks of the Central Pacific and Union Pacific railroads on May 10, 1869, was built to accommodate plates 10 by 13 inches. The camera boated down the Colorado River during the Powell Expedition into the Grand Canyon was 11 by 14 inches. In 1875 William Henry Jackson packed a camera 20 by 24 inches for his work as a member of the survey of the Rocky Mountains and the Southwest led by explorer-scientist Ferdinand Vandiveer Hayden.

The work of these heroic photographers, shown in major exhibitions in Washington, D.C., is generally acknowledged to have been instrumental in convincing Congress to enact legislation establishing many of the major national parks, monuments and preserves. The maps of the surveys showed where everything was; the wet-plate photographs showed precisely what was there.

Yet those who were enthralled with the drama of the Western visas could hardly comprehend the unique circumstances that accompanied the creation of these documentary masterpieces. On the Powell Expedition in 1871, two of the photographers who struggled their way into the Kanab canyon returned without a single negative. "The silver bath had got out of order, and the horse bearing the camera fell off a cliff and landed on top of the camera, which had been tied on the outside of the pack, with a result that need not be described," F. S. Dellenbaugh explained in *A Canyon Voyage,* a memoir and account of the Powell Expedition that described in nonscientific terms the hazardous venture into the wilderness within the Grand Canyon.

To obtain a single exposure of Lake San Cristobal, Colorado, in 1875, William Henry Jackson climbed the mountain three times. On the first day the winds were too strong to allow the camera to be kept steady for the long exposure. On the second day the silver bath leaked. On the third day, according to Jackson's memoirs, "Everything worked lovely and secured a fine negative on first attempt."

Twelve of Jackson's huge negatives are listed in the government catalogue of the Hayden Survey: "These are the largest plates ever used in field photography in this country. They convey an impression of the real grandeur and the magnitude of the mountain scenery that the smaller views cannot possibly impart."

Since the typical Eastern gallery-trained photographer was capable of making only "smaller views" at a time when the populace was being entertained and edu-

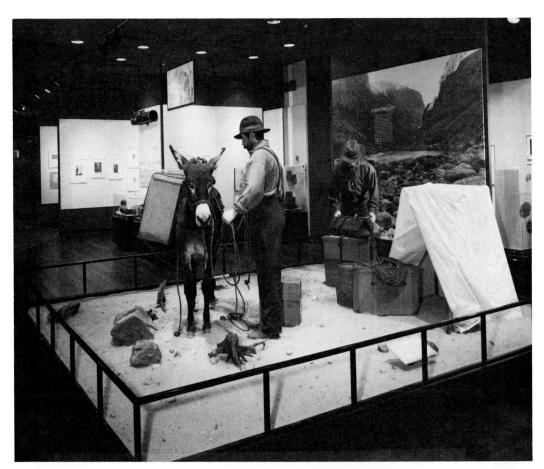

A display at the Smithsonian Institution depicts the travails of the explorer photographer, who as early as 1853 accompanied expeditions into the unknown Far West. (*Collection SI*)

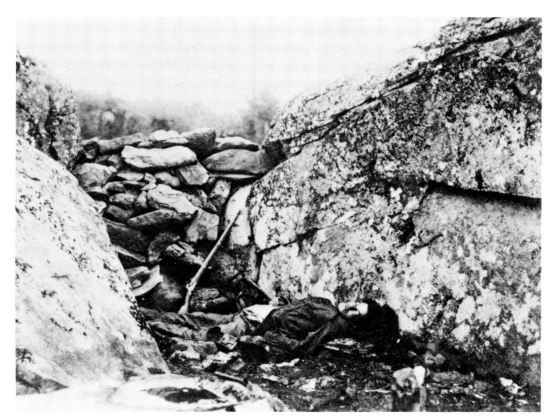

Documenters of the Civil War like Timothy H. O'Sullivan were totally
dependent on the wet-plate process for battleground coverage. (*Collection
LofC*)

cated by the mammoth views, Jackson's city-centered contemporary was awe-
struck at the capabilities of the wet-plate system, which was then the bread-and-
butter procedure of the Main Street gallery. Gallery operators limited for years to
the making of cartes-de-visite and cabinet cards saw in the giant albumen prints
made from window-size negatives a glorious technical achievement that far out-
shone their humble efforts in convenience-filled darkrooms.

As Jackson returned from his Colorado River journey, news reached America
of a different kind of exploration. Reports from England and France spoke of en-
couraging results with a new kind of photographic plate, one that was manufac-
tured in a factory and shipped to photographers to replace the wet-plate created
in the tent. The new dry plates were less sensitive than those on which the field
photographer created fresh emulsions each day, and which, as they aged became
undependable. In the beginning they were known as "dry collodion" plates. An
English firm, the Liverpool Dry Plate and Printing Company, in 1867, is believed
to have been the first to market them. Those who put the plates to use paid the
price—a tripling of the usual exposure time to about thirty seconds at $f/24$, ac-
cording to one report of the time.

The new dry plates were not perfected in time to expand photographic frontiers
for the survey and expedition photographers of the 1860s and 1870s. It was not
until the early 1880s that a dependable factory-coated plate technology evolved in
the United States, and even then the new plates required longer exposure times
than the collodion and silver nitrate plates upon which the photographers of the
frontier depended.

▟▟ CARLETON E. WATKINS AND THE YOSEMITE VIEWS

One of the leading photographic artists of the thirty-year wet-plate era was a former gold rush adventurer. In 1851, lured by the promise of wealth to be panned from the mountain streams of California, Carleton E. Watkins (1829–1916) left the upstate farmland of New York, ultimately to find treasure in the redwoods and mountain peaks of the gold country.

As with nearly all young men who sought fortunes in panning and placer mining, Watkins soon exhausted his small capital and had to abandon his dreams of riches and settle for the regular salary of a store clerk in a booming San Francisco. When an operator in a photographic establishment in San Jose left his job, the gallery owner asked young Watkins to become studio caretaker for a few days until an experienced photographer could be employed. He gave Watkins a brief explanation of the daguerreotype process and suggested that he attempt portraits should the expected Sunday crowd materialize. The first efforts of the enthusiastic new photographer proved entirely successful, and a new operator was never hired.

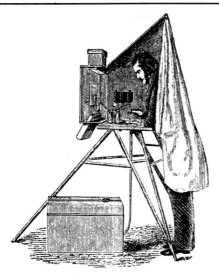

MAKING THE MAMMOTH WET-PLATE PRINT

1. **Readying the Plate** • The sheet of glass was first cleaned carefully to remove all grease and grit. By daylight, a small quantity of collodion was poured onto the center of the glass plate and the plate tipped and tilted until the syrupy collodion had run to all edges and corners. The excess collodion was then drained off into the collodion bottle. Next, in the light-tight tent or photographic wagon, working by safelight, the photographer immersed the coated glass plate in a bath of silver nitrate for approximately one minute; the plate was sensitized when its overall appearance was creamy yellow. The silver nitrate was then returned to its light-tight container and the plate was placed in the waiting plateholder.

2. **Making the Exposure** • The plateholder was fitted into the camera that had been aimed and focused on the landscape view. The lens was uncovered for a period ranging from one to twenty seconds or more, depending on the brightness of the light, the darkness of the subject and the aperture of the lens. Photographers outdoors obtained greater fields of overall sharpness by setting lenses at the smaller openings. (Studio photographers, seeking the shortest possible exposure time to reduce the chance of the subject's moving, used the largest possible lens apertures.)

3. **Processing the Plate** • The plateholder was removed from the camera and returned to the darkroom tent. A waiting tray of pyrogallic acid was the bath for developing the image; fixing was done in a tray of sodium thiosulfate (hypo); washing in clear water completed the process. The glass plate was dried inside the tent or wagon to reduce the likelihood of airborne dust or grit settling into the emulsion (such matter would produce defects in the final print).

4. **Printing the Negative** • In the laboratory of the gallery, following the field trip, each negative was numbered in ink along one edge. Under safelight the plate was secured in a special picture frame against a sheet of factory-sensitized albumen paper. The frame and its plate-printing paper sandwich were then taken into a sunlit area for exposure for fifteen to thirty minutes. The exposed print was then immersed in a waiting tray of developer in the darkroom, processed until all tones were satisfactory, fixed in hypo, washed in clear water and dried.

5. **Presenting the Print** • The dried albumen print was edge-trimmed, then pasted onto a large heavyweight card or mounting board, ready for inclusion in a portfolio or for framing behind glass.

Carleton E. Watkins (1829–1916) panning for gold in northern California, only feet away from his darkroom wagon (about 1867). (*Collection SCP*)

In 1857 Watkins, now an experienced operator, returned to San Francisco to open his own studio. However, his personality was totally unsuited to running a portrait gallery. His youth and young manhood had been spent in the fields of his family's farm and then in the rugged mountains of northern California; now he was spending all of his daylight hours in the confining quarters of the darkroom or in the unstimulating surroundings of the portrait gallery.

Watkins saw in the mountains the gold of photographic adventure. While his contemporaries reaped their riches with portraits of the San Francisco citizenry, he spent his earnings grubstaking a totally new venture: mountain photography. Leaving the operation of his gallery to an apprentice, he made the Far West his vast outdoor studio. His earlier experiences as a placer miner had readied him for the lonely and difficult life of the mountainside wanderer; he had no fear of the wilderness and understood completely the demands that Nature makes of the explorer.

Watkins conceived and undertook a series of mule-pack trips to the Sierra Nevadas, the Mariposa Grove and the Yosemite wilderness north of the populated areas of California. He was probably the first to photograph such historic redwoods as the Grizzly Giant.

After a time Watkins realized that a camera suitable for gallery portraiture was of limited value in dramatizing the scale and grandeur of the vistas he wanted to capture on his wet-plates. So he created his own camera, its size limited only by

the largest photo paper he could obtain in that period, 18 by 22 inches. This enormous camera was almost double the size of the camera then used by the environmental photographers, which was 11 by 14 inches. Watkins solved the problem of the weight and bulk of his new camera and its glass plates by doubling his pack from six mules to twelve. He also created a photographic wagon that would serve as a darkroom in those areas where a wagon could be pulled.

Watkins showed his giant prints in San Francisco to enthusiastic audiences that included other photographers who were in awe of his expertise under the challenging conditions of the mountaintop, local artists who appreciated his discerning eye, and local politicos who saw in the images an opportunity to dramatize their California to the Eastern establishment.

Watkins' powerful mountain views were shown to President Lincoln and the Congress, and the interest and excitement they created led to legislation that established Yosemite and Mariposa Grove as California State Parks. From that time, Watkins' identification with Yosemite was widely publicized. Capitalizing on his newfound reputation, he named his business the Yosemite Art Gallery.

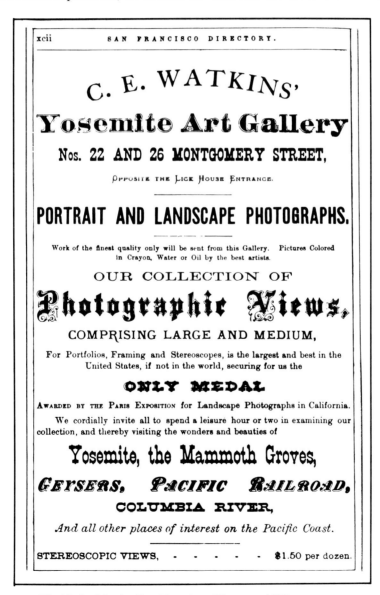

Watkins' ad in the *San Francisco Directory*, 1873.

◀ A typical Watkins Yosemite view taken about 1866: Mt. Starr King. (*Collection MG*)

By 1866 the Watkins Yosemite views had become a set of 114 mammoth wet-plates. They depicted a walking tour of Yosemite, including a valley entrance, visits to various falls and ascents to remote sites on the rim, Sentinel Dome and Glacier Point. At the time complete sets were sold to individual customers. No complete set is known to exist today; individual prints now sell for over $1,000 at auction.

Millions of Americans learned from their newspapers of the creation of the California State Parks, but few had seen the prints that were circulated in Washington. Publishers saw in these dramatic Western scenes a new kind of book on a giant scale, one whose pages would be individually made albumen prints, bound in sequence together with introductory notes. The most spectacularly conceived such book was *The Yosemite Book* of 1868, attributed to Josiah D. Whitney, surveyor for the government of the Yosemite Valley. Watkins provided fifty original photographs from the Yosemite views set, four additional plates were contributed by one W. Harris, and the volume, published in an edition of 250, was among the earliest books in America to be devoted entirely to landscape photography.

The Watkins contribution to the finished work was Herculean. Each print, 18 by 21 inches, required an hour to print, fix, tone and wash. The exposure time alone of the negative in contact with the albumen paper was fifteen to thirty minutes. (Only forty years later this exposure time would be reduced to fifteen to thirty seconds.) The Watkins laboratory produced 12,500 prints for the venture.

Even as the book was being readied, Watkins was being acknowledged the leading landscapist of California; his contributions had been cited by critic Oliver Wendell Holmes, and his achievements had been the subject of extensive reviews in *The Philadelphia Photographer,* then the leading journal of photography.

In 1867 the noted wet-platist C. R. Savage said that "among the most advanced in the photographic art, none stands higher than . . . Mr. C. E. Watkins, who has produced with his camera, results second to none in either the eastern or western hemisphere."

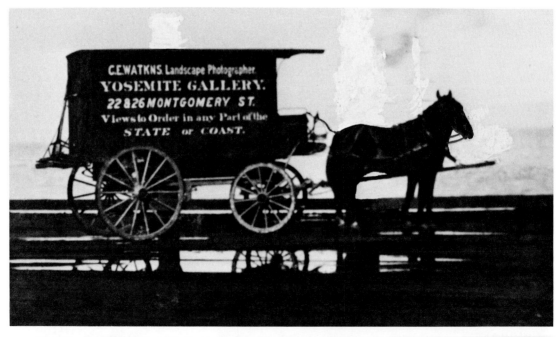

Watkins enlarged his camera for mammoth views from 11 by 14 inches to 18 by 22 inches using his wagon as a darkroom to first sensitize and later to develop each exposure. (*Collection BLUofC*)

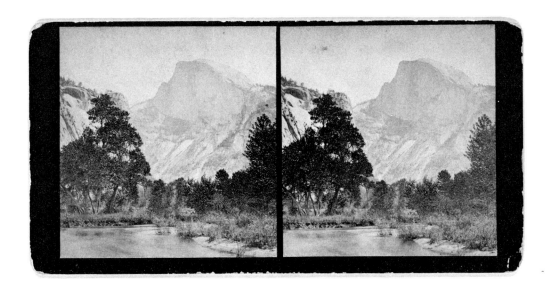

From Watkins' Pacific Coast stereograph card series, No. 1127, *Tasayac, or the Half Dome, 5000 Feet. (Collection GG) Bottom:* A river view toward North Dome, Yosemite, about 1866. (*Collection LofC*)

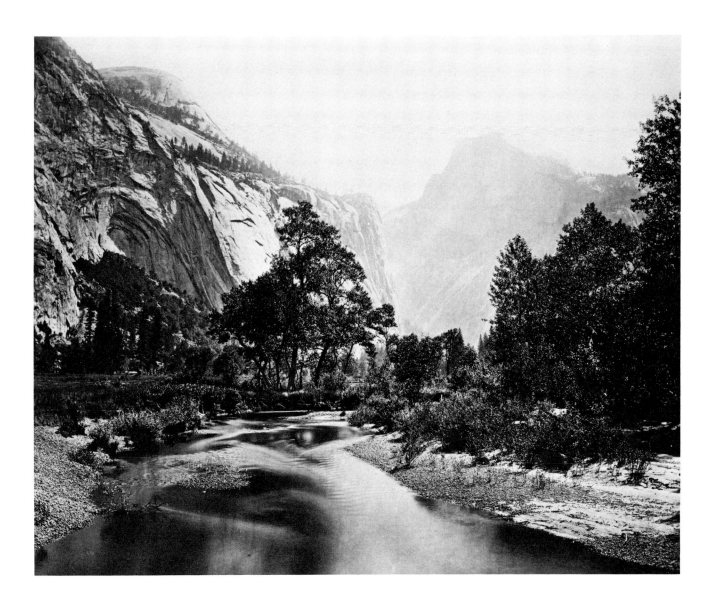

From Watkins' New Series (after 1874) No. 3133, *Lieut. Wheeler's Party in Yosemite.* (*Collection MRI*)

In 1867 Watkins relocated his Yosemite Art Gallery to 429 Montgomery Street, San Francisco, and continued his documentation of city life. The following year he took to the woods again, traveling up the Pacific Coast to Oregon to make the extensive Pacific Coast series: logging camps, rural villages and the famed Oregon views, work that many considered the zenith of his landscape undertakings with his mammoth-size camera.

Watkins pictured life in the redwoods and in the placer mining camps; a friend has recounted how on one occasion in a dark glade it took an hour-long exposure to capture the breathtaking spectacle of the hearty woods. With the same care, he made some of the most significant views of San Francisco.

By 1873 Watkins had expanded his coverage to more distant territories. His offerings now included the route of the Union Pacific Railroad, the mining cities of Comstock and Virginia City in Nevada and subjects as far east as Utah and as far south as Tombstone, Arizona. His mule pack and photographic wagon had become as familiar to some as the mail stage.

By this time he had been joined in scenic wet-plate adventuring by new talents in Western photography: Clarence King, Eadweard Muybridge and others. Between the new competition and the fact that the novelty of his pioneering efforts had begun to wear thin, Watkins' photographic business faltered. The financial panic of 1873 aggravated the situation, and Watkins' gallery failed. His giant negatives and his smaller three-dimensional stereographic views were acquired at auction by a photographer, I. W. Taber, who shared the building with Watkins' gallery.

This low tide in the Watkins fortunes marks the historical division of his work. In the subsequent cataloguing by historians and collectors of the Watkins oeuvre, those photographs attributed to the period 1861–1874 are codified as "old series"; the "new series" photography was that created by Watkins during the balance of his career.

The dominant section of the "old series" is the group of 2,000 stereographs (see Chapter 8) and the 114 numbered mammoth plates of Yosemite. Little else survived, many of his early photographs having been destroyed (perhaps because the value of the reusable glass overshadowed the probable future use of the plates).

Some plates may have been shattered during their cartage to new studio locations; others may have been discarded because Watkins disapproved of the quality of his earliest efforts.

Photography at the base camp with wagon and camera of O. G. Allen, Pendleton, Oregon. (*Collection MCUofO*)

• WATKINS PRINTS AVAILABLE TODAY

Mammoth-size Watkins albumen prints are regularly offered at the major photography auctions. Prices are invariably over $1,000, depending on subject matter and print condition. Smaller Watkins photographs are found at auction at prices from $250 to $500.

Thousands of Watkins stereographs of the "old series," clearly imprinted "C.E. Watkins" or "Yosemite Art Gallery" (before 1874) and the clearly marked "Watkins New Series" (after 1874) are still to be found in antique shops and flea markets at prices ranging from a few cents each to $25. Watkins material, along with the contemporary work of Savage, Jackson and other pioneers, may be located at the photographic print specialty centers in most large American cities.

Print collectors have found gold in early Watkins prints. (*Collection DPLWC*)

Three Brothers, 4,480 Feet, Yosemite No. 28, a Watkins view about 1861.
(*Collection LofC*)

Despite his business failure, Watkins managed to relaunch his photographic career, confining his field trips to California. His landscape style changed as he undertook commissioned studies from owners of ranches, farms and estates, work that came to him because of his reputation as a sensitive, skilled artist. The fruit orchards and meadowlands that were his new subjects were a far cry from the towering waterfalls and the majestic High Sierras; the photographer of the Grizzly Giant had become the documentarist of much tamer stuff.

At the age of seventy-six, in financial difficulties and in poor health, Watkins lived with his family in his San Francisco studio on the top floor of a building at Ninth and Market Streets. It was an unfortunate location; on April 18, 1906, California's most disastrous earthquake struck, totally destroying the plates and

A Watkins' Yosemite river view. (*Collection MG*)

photographs he was then attempting to sell to Stanford University. The shock broke his spirit and his mind; he was committed to an institution, where he died ten years later.

America's appreciation of the dedication of the wet-plate pioneers who wrestled with Nature on windswept mountaintops to obtain photographic treasure has long since faded. Few photographers today would know how to make a wet-plate negative; none use or own the giant cameras that Watkins and his contemporaries toted up canyon walls. Even collodion, the base for the emulsion, is rarely available in photographic centers. Saddest of all, many photographers today, looking at a contact print made from the 18-by-22-inch negative, believe themselves to be studying an unusually excellent enlargement.

William Henry Jackson, another of the pioneer Yosemite photographers, on a lofty perch. (*Collection DPLWC*)

• IDENTIFYING THE WET-PLATE NEGATIVE

It is almost instantly apparent if a glass plate is a wet-plate. Wet-plates almost always reveal an uneven coating where the collodion syrup did not flow quite to the edges. Many of the plate edges reveal torn or rippled emulsion and even the fingerprints of the darkroom technician who handled it in the developing bath with fingers wet from the fixing bath.

Collodion wet-plates in the studio sizes (up to 11 by 14 inches) may be found dating to the late nineteenth century and into the twentieth century. Collodion processing was still commonly associated with platemaking for the printing industry up to World War II. Mammoth-size negatives (18 by 22 inches) can invariably be dated to the nineteenth century, though by the 1880s few photographers owned the giant cameras, the tools and techniques for enlarging photographs having been considerably advanced by that time.

Only occasionally is it possible to determine whether an albumen print was made from a wet-plate negative, especially if the outer edge of the print has been trimmed away. Such an edge would immediately reveal the irregularities of the collodion coating prepared in the field. Only print experts can determine whether a print is authentic or a copy and whether it is of albumen origin or from the later chloride and chloro-bromide periods.

Typical damaged wet-plate negative edge.

THE STEREOGRAPH
The Paired Photographs
of Parlor Travel

Three kinds of photography won the hearts of the American public in the time between the Civil War and the introduction of the family camera in the late 1880s. All had begun in the mid-1850s with a base in the collodion wet-plate negative, and each introduced to the general public a new aspect of the photographic experience. The carte-de-visite made available low-cost portrait miniatures without the need for elaborate protective devices; the tintype introduced durable, readily produced photographs at extremely low cost to even the poorest families; and the stereograph brought to a wide audience the magic of in-depth illusion, which to this day startles the first-time observer.

Stereographs are almost identical side-by-side images of a single scene, viewed simultaneously throught an optical device held to the eyes like a pair of binoculars. The viewer directs each eye to a slightly different image, and the fusion of the two images in the mind creates the illusion of depth perception.

Oliver Wendell Holmes called stereo cards "leaves torn from the book of God's recording angel." Victorian families that owned dozens of cartes-de-visite, and perhaps again as many tintypes, owned hundreds, sometimes thousands of the seven-inch stereo cards. The first millions of the cards, made between the 1850s and the 1870s, depicted travel, the Civil War and a wide variety of art subjects.

The stereograph and the special optical instrument that made it an easy matter for anyone to enjoy the depth illusion stemmed from the experiments of two English gentleman scientists, Sir Charles Wheatstone (1802–1875) and Sir David Brewster (1781–1868). Using specially made artists' drawings and an elaborate system of mirrors, Wheatstone established that the brain combined slightly different left and right views of a subject to provide a sensation of depth. The differing views are, of course, the result of the fact that a person's two eyes, being some distance apart, see a subject at slightly different angles. In human beings the average distance between the eyes is 3½ inches. Brewster modified Wheatstone's theory, applied it to photography and suggested a simple handheld viewing box, the so-called fully enclosed Brewster viewer. This device simplified the viewing of the near-twin images produced by a camera with two lenses fitted approximately 3½ inches apart.

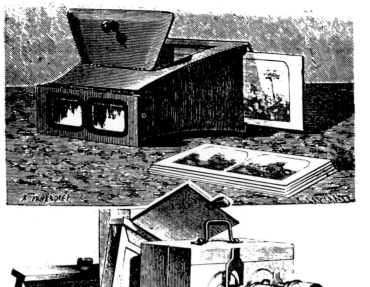

Brewster-type stereo viewer for stereograph prints and hyalotypes (glass), about 1852.

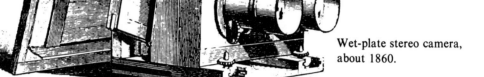

Wet-plate stereo camera, about 1860.

The invention produced a stereo age in which stereography was adapted to all of the forms of early photography. There were stereo-daguerreotypes, stereo-ambrotypes and stereo-tintypes; there were stereo-calotypes (they made possible the first stereo cards) and there were stereo-diapositives, a variety of stereo card on glass.

At first the two images were created in sequence, using the widely available quarter-plate (3¼ by 4¼ inches) cameras. These were single-lens cameras; after the first exposure, the camera was moved laterally about 3½ inches and a second exposure made. When the two images were aligned for simultaneous but separate viewing by the left and right eyes of the observer, there was an illusion of depth in startling detail. The effectiveness of this primitive early system was limited to stationary subjects: distant mountains or nearby sculpture. The long exposures of the time (from four to twenty seconds, even in sunlight) limited the choice of subject matter, for water moved, boats rocked, clouds floated, birds flew. When the two-lens cameras were introduced in 1854, limitations on subject matter were ended.

Sir David Brewster had suggested the concept of such a camera in 1849, and the first one was made in England five years later. For most photographers it was necessary only to modify a standard field camera to provide for two side-by-side lenses on a board that was interchangeable with one that supported the regular single lens. The plate at the back would accept either two small images when the dual lens was in use or one large image when the larger single lens was in place.

●ıı● THE PERIOD OF THE STEREOGRAPH ●ıı●

|1820 |1830 |1840 |1850 |1860 |1870 |1880 |1890 |1900 |1910 |1920

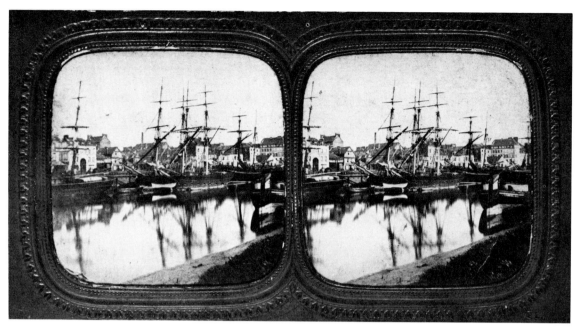

Calotype stereograph, about 1853. Photographer unknown. Stereography by calotypy is rare. In America, the Langenheim brothers pioneered both systems of photography. (*Collection HA*)

The American physician and author Oliver Wendell Holmes was an early photography enthusiast and critic. In his personal efforts to enjoy stereography, he developed an improved design for the boxy Brewster viewer, one that reduced both the size and the cost of the handheld device. The viewer was manufactured by Joseph L. Bates of Boston, where Holmes lived and worked, and their joint creation was widely known as the Holmes-Bates viewer. Today it is a $15 to $25 item in antique shops.

The new viewer rapidly became a standard feature in Victorian homes. The simple device, called a stereoscope or stereopticon, sold for as little as twenty-five cents at bookshops, stationers and galleries and at the agents for the publishers of the millions of stereo cards. Viewers were given free to purchasers of boxed sets of one hundred cards. One model was offered at nineteen cents by Sears, Roebuck & Company late in the nineteenth century.

Families dissatisfied with the handheld viewer that displayed one card at a time and had to be passed from hand to hand could opt instead for a table viewer, a machine that could be loaded with as many as fifty views, each changed rapidly by turning a knob. Some of the larger viewers permitted two persons to enjoy different views simultaneously.

While slide viewing was being automated, the basic stereo camera was not altered until about 1880, at the end of the wet-plate era. The photographers who accompanied survey teams to the Far West or expeditions to the Indian wildernesses were limited to view cameras with paired lenses. The battlefield photographers of the Civil War who created stereo views for Brady and other galleries also used the view camera adapted for stereo work. These cameras were the essential field equipment for the West's most acclaimed camera artists: Savage, O'Sullivan, Watkins, Russell and their contemporaries. A few years later, however, with the advent of the dry plate, stereo cameras became precision machines in a size that would fit into a coat pocket with accommodations for a dozen preloaded plates.

The survey, expedition, railroad and scenic photographers were the first generation of photojournalists. Their work was commissioned by the prominent galleries, by publishers such as D. Appleton and Company of Boston, by card sellers such as the American Stereoscopic Company of Philadelphia in the early days and Underwood & Underwood, Publishers, of New York later on. The stereo-hungry public created a vast demand for both educational and entertainment stereographs. To fill their orders, stereographers climbed mountains, toured deserts, visited native tribes, and risked their lives on the battlefront. They were the newsreel photographers of the period before the invention of cinematography.

That some of the early photographs were made under the most trying physical circumstances was rarely a factor in their selection either by the publisher or the public that bought them. T. H. O'Sullivan was one of the famed Civil War photographers who joined the Geological Exploration of the Fortieth Parallel led by Clarence King in 1867. The party of seventeen civilians and twenty cavalry left San Francisco on a route over the Sierra Nevadas, then headed east to the Great Salt Lake. Two mules and a packer comprised O'Sullivan's photographic team. At Virginia City, Nevada, O'Sullivan photographed the Comstock Lode mines, working hundreds of feet underground, illuminating caverns with magnesium flares that were dangerous and unpredictable anywhere and almost suicidal in the presence of inflammable gases. On the same trip he sweltered in the desert heat south of Carson Sink to photograph shifting hills of sand that were five hundred feet high.

The stereographer was required to employ a tripod to steady the camera during the long wet-plate exposures and to assist in positioning the camera far more carefully than was necessary for ordinary field photography. A bubble-level built into the camera helped to insure that it was aligned with the horizon.

For optimum stereo effect it was necessary that most views contain items of interest in both foreground and background. The evident distance between the two areas of interest increased the illusion of depth. To achieve this relationship in an artistically satisfying balance, the stereo photographer had to search the area of

• VIEWERS OF THE STEREO AGE

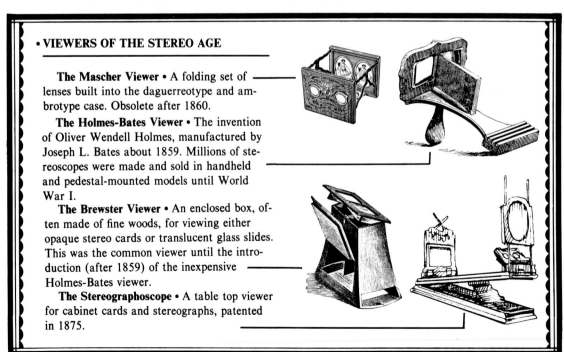

The Mascher Viewer • A folding set of lenses built into the daguerreotype and ambrotype case. Obsolete after 1860.

The Holmes-Bates Viewer • The invention of Oliver Wendell Holmes, manufactured by Joseph L. Bates about 1859. Millions of stereoscopes were made and sold in handheld and pedestal-mounted models until World War I.

The Brewster Viewer • An enclosed box, often made of fine woods, for viewing either opaque stereo cards or translucent glass slides. This was the common viewer until the introduction (after 1859) of the inexpensive Holmes-Bates viewer.

The Stereographoscope • A table top viewer for cabinet cards and stereographs, patented in 1875.

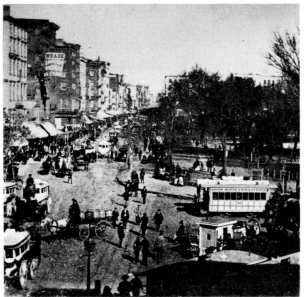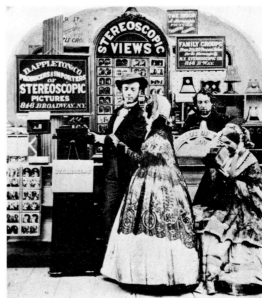

Left: A view of Broadway in New York City, in the middle 1850s, looking north from Barnum's Museum. (*From E. Anthony stereograph No. 2013; collection N-YHS*) *Right:* The showroom of D. Appleton & Co., publishers of thousands of stereo views. The seated woman uses a Brewster-type viewer. (*From an Appleton advertising stereograph; Collection N-YHS*)

each subject and consider the question of composition more carefully than the photographer doing a traditional landscape or mountain view. And because the success of his photograph depended on the near-far relationship, the stereographer had the critical task of camera focus.

Under battlefield conditions, in deep snow or in the presence of buffalo or other wildlife, the photographer's position was sometimes precarious. And the photograph he obtained under such difficult conditions rarely carried a credit line on the published card; his was the vital but anonymous contribution to a giant industry.

Thousands of stereographers also plied their trade less adventurously in the ordinary circumstances of small-town American life. They created stereographs of the village mall, the local churchyard and the nearby historic site for local families and the occasional tourist. Their card stereographs were sold from racks in the general store just as the souvenir postcards of a later time would be sold. Almost invariably each bore the imprimatur of the maker. The most successful of the local efforts sometimes found their way into the giant libraries of the major publishers, who continually sought new material for their customers.

Under optimum conditions, a photographer could produce fifty or more photographs during one working day in the field, but few of them met the criteria of story-telling interest, technical quality and artistry that would merit their addition to a publisher's offerings.

Between 1855, with the founding of the American Stereoscopic Company, and the retirement from the scene of the Keystone View Company in the 1930s, more than a thousand companies were established in the United States alone to market stereo cards. During this time, the cards sold for as little as a few pennies each up to a dollar or more per set. Then the myriad of small stereograph producers of the 1880s gave way around 1900 to a few manufacturers who used streamlined mass-production techniques.

Underwood & Underwood, Publishers, turning out 25,000 cards a day—more than 7 million annually—was typical of the more enterprising companies that developed ingenious marketing strategies. For a time, as exclusive representatives of the country's top stereo card companies, the Underwoods hawked their client's treasures from door to door. Thousands of young men in their early twenties, polite, studious and churchgoing, received training in neighborhood canvassing, selling the idea that a home without stereo views was like a body without a mind. They might call on their accounts as often as every four months. Local markets were saturated systematically, and the Underwoods engaged in furious direct mail and advertising campaigns. They introduced boxed sets of views (usually one hundred cards per package) complete with guidebooks, reference maps and categorized areas of interest. Bible series were sold to church groups. Libraries were hustled to purchase the war series. Families were a prime sales source for cards suggesting the romance and adventure of world tours.

The cards were also sold by such mail-order merchants as Sears, Roebuck and Montgomery Ward. After the 1880s, with the introduction of the halftone process

STEREOSCOPIC BOOKS.

Mascher's Stereoscopic Books.

Among the many improvements in the art of taking pictures by means of the action of light, one of the most interesting results is the Stereoscope. This consists of two representations of an object, taken at slightly different angles. In producing a stereoscope portrait, for example, two daguerreotypes are made, exactly alike in dimensions and all other respects, except that when one portrait is a view taken directly in front of the sitter, the other portrait must be taken at one side. If, now, the two portraits are placed side by side and looked at through a pair of magnifying spectacles or lenses, they will *seem* to have combined and formed *a statue*, cut by the unerring hand of Nature, standing out in bold relief, vivid, and absolutely perfect.

Those who have never seen a Stereoscope would be surprised at the extraordinary magical result produced by the lenses. The effect is the same whether the representation be portraiture or landscape. The stereoscopic view of a city shows not a mere drawing; the *real city itself* seems presented to the sight. So, too, with the portrait: the flat outline disappears, and the *living subject* seems to stand before the eye.

The common stereoscopes are spy-glass-looking instruments, and withal rather large and inconvenient. They were greatly improved upon by Mr. John F. Mascher, of Philadelphia, Pa., who, in 1853, patented the idea of placing a fly leaf or flap in the common daguerreotype miniature case, the flap being furnished with a pair of lenses. In this manner the stereoscope was reduced so as to occupy but little additional space.

Since Mr. Mascher's patent was granted the art of taking pictures upon paper and other substances has been much cheapened and simplified; a process has also been practicalized whereby any number of duplicate copies may be printed from a photograph. The inventor takes advantage of these circumstances for the production of *Stereoscopic Books*, or volumes in which the views and illustrations are presented stereoscopically.

Our engraving shows a couple of these books, which, outwardly, are like any other volumes. In the open book seen in the cut, B are the photograph pictures, C the lense flap or leaf, and C' C' the lenses. The lense leaf, C, folds in when the book is closed, like any fly leaf, and the volume presents the appearance shown at A. One lense leaf, it will of course be understood, serves for the examination of all the photographs.

We cannot conceive of any single acquisition to a library or a parlor table of more interest and value than a book filled with these stereoscopic pictures. The range of subjects capable of being embraced is inexhaustible. Family portraits, views of favorite localities, towns, cities, objects of art., &c., may be thus preserved in a permanent and useful form.

Further information respecting this excellent invention can be had by addressing the inventor, J. F. Mascher, No. 408 Second street, Philadelphia, Pa. His patent bears date Feb. 19, 1856.

The Chinese scour silk with a thin paste made of bean flour and water.

From *Scientific American*, 1856.

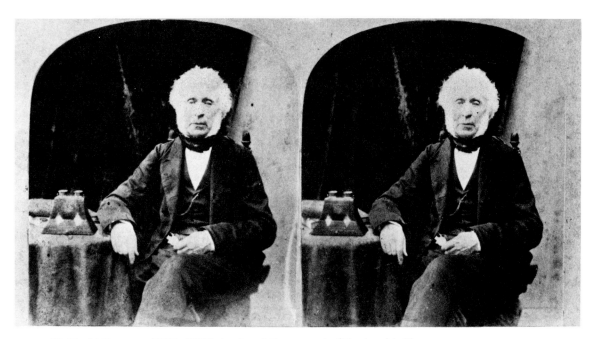

Sir David Brewster (1781–1868) developed the concept of the hand-held
stereo viewer using lenses as in binoculars to replace the mirror-based
Wheatstone tabletop design. The Brewster viewer, at left on table, simplified
the enjoyment of the stereographic dimensional illusion for millions starting
in the mid-1850s. (*Collection GG*)

that permitted the newspaper reproduction of photographs, printed cards joined
the formerly all-photographic cards. Special biblical and children's series were
created by color lithography on thin white cardboard. All cards could be viewed in
the standard stereopticon.

From the Civil War to World War I, the height of the stereo age, it is estimat-
ed that nearly 3 million different views were made available to the public. Today,
the largest known collection of stereo cards is that of the archives of the Keystone
View Company, Meadville, Pennsylvania, which has been acquired by the Univer-
sity of California at Riverside. There are 250,000 negatives and cards in the Key-
stone-Mast collection.

With the introduction of roll film, the American family could create its own
stereo cards. At one time or another there were stereo models of Brownies, Ko-
daks, Conleys and Delmar cameras. However, few families elected to use the cam-
eras that made possible paired stereo images on film normally used for single im-
ages; stereo photographs of Sunday picnics or the family at play were simply not
as entertaining as the commercially produced cards. Even the family that made
the Grand Tour rarely returned with photographs to match the splendors of pro-
fessional stereographs of European travel scenes.

By the 1920s the stereo age had come to an end. The final flurry of interest
generated by the battlefield scenes of the Great War sated the remaining stereo
enthusiasts. Automobiles took the family out of the parlor on Sunday afternoons,
and radio dominated the living room in the evening with a new kind of entertain-
ment. Rather quickly, the stereopticon became as quaint as high-button shoes.

After World War II an effort was made to reintroduce the stereo image as a
home photography system. A modern 35 mm all-metal camera and a plastic view-
er were produced by the David White Company of Wisconsin. The brief success
of this novelty camera between 1948 and 1956 led Eastman Kodak and other
manufacturers in Germany and Japan to introduce competing systems. All these

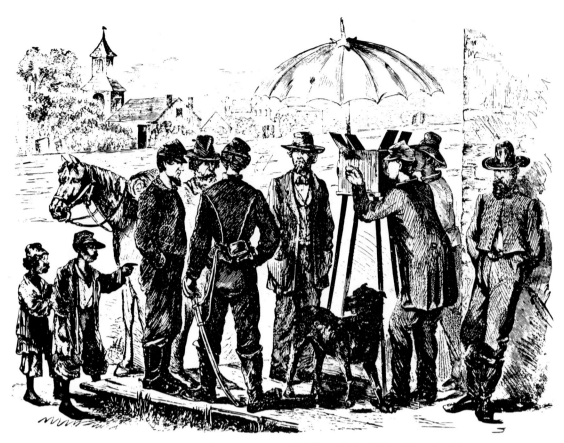

Soldiers of the Union Army looking at stereo views near Culpepper, Virginia, in this sketch by Edwin Forbes reproduced from *Frank Leslie's Magazine*.

STEREOSCOPIC VIEWS
OF THE WAR !
Obtained at great expense and forming a complete
**PHOTOGRAPHIC HISTORY OF THE GREAT UNION
CONTEST.**

Bull Run,	Nashville,
Yorktown,	Strawberry Plains,
Gettysburg,	Deep Bottom,
Fair Oaks,	Belle Plain,
Savage Station,	Monitors,
Fredericksburg,	Chattanooga,
Fairfax,	Fort Morgan,
Dutch Gap,	Atlanta,
Pontoon Trains,	Richmond,
Hanover Junction,	Petersburg,
Lookout Mountain,	Charleston,
Chickahominy,	Mobile,
City Point,	&c., &c.

Everybody is interested in these memorable scenes.
Catalogue sent on receipt of stamp.
Just published by
E. & H. T. ANTHONY & CO.,
498-501o 501 Broadway, N. Y.

Advertisement for war views by E. & H.T. Anthony in *Frank Leslie's Illustrated Newspaper* (May 13, 1865).

cameras were designed to be loaded with the widely available 35 mm color films. Slides were viewed in modern-day versions of the Brewster viewer popularized a hundred years earlier.

Ingenious designs in projectors and viewing glasses worn by the audiences were also developed to permit the slides to be projected on home movie screens, a facility that was unknown during the stereo age. Despite the versatility and convenience of the new stereo systems, however, the fad was brief. Some critics claimed that the handheld viewer showed an image too small and that the projector system cost too much. Others pointed out that the small cameras permitted few excursions into creative expression. There was no audience for quality stereo slides out-

Major General Burnside and Mathew B. Brady confer at "Head Quarters of
the Army of the Potomac" near Richmond, Virginia, in View No. 2433
published by E. & H. T. Anthony from a Brady negative. (*Collection MRI*)

side one's immediate family and friends; stereo photographs could not be published in a newspaper or magazine for a larger audience. Also, at this time, the age of television was roaring into prominence, and little else in the way of family entertainment could begin to compete with it.

A handful of stereo cameras are in use today by aficionados who make garden and travel photograph slides for their personal amusement. An ingenious child's toy is another remnant of the brief flurry of interest in stereo. An Oregon company pioneered the Sawyer's Viewmaster, a device that permits children to enjoy fairy tales and scenes from Hollywood comedies. The product is marketed today by GAF, successor to E. & H. T. Anthony & Company, which a century earlier sold millions of stock stereo cards.

∷ THE LANGENHEIMS AND AMERICAN STEREOGRAPHY

The concept of stereography was unknown to most photographers when in the late 1840s it came to the attention of William Langenheim (1807–1874) and Frederick Langenheim (1801–1879), the German-born photographic pioneers who are considered today the fathers of stereography in America. Frederick, a writer for the German language press who was attracted to the art of daguerreotypy, suggested that his brother join him in opening a studio in New York City in about 1842.

The Langenheims were relatives of the Voigtländers, a German camera and lens-making family well known to daguerreotypists, especially for a superior lens that was well suited to the needs of their craft. The Voigtländer lens and its reputation helped the Langenheims to make a start in the sale of equipment to gallery operators. Together with a Philadelphian, Robert Cornelius, who in 1840 had opened the first American daguerrean portrait gallery, the Langenheims introduced the new lens to American daguerreotypists. Until that time, American practitioners had been dependent on the widely available simple meniscus lens, which required lengthy exposure times of up to ten minutes for each portrait; the Petzval-design Voigtländer lens cut exposure time to less than a minute.

On expeditions into the Western wilderness, photographers' mules carried giant cameras for detailed mammoth views. They also took along smaller, more portable stereo cameras for depth illusion.

While waiting in the lobby, hotel guests could entertain themselves with stereoscopic views. This viewer in New York City showed local points of interest. (*Collection N-YHS*)

In 1845 the brothers broke with Cornelius and opened a gallery of their own, joining another Philadelphian, G. F. Schreiber. To call attention to their new venture in 1846, they sent gifts of daguerreotypes of Niagara Falls, New York, to six kings and heads of European governments. The view was one that few of the distinguished rulers were likely to see first hand. The gold medals and other accolades that the Langenheims received were almost predictable, and their new gallery made the leap from obscurity to fame.

In the same year the Langenheims imported from Vienna an optical projection system of a type previously unknown in America. The system used two oxygen burners to illuminate each daguerreotype brilliantly and to project it, magnified, onto a giant screen. In 1846 and 1847, using this device, they took their daguerreotypes of famous American scenes into the lecture hall. It was only the beginning; by 1849 the Langenheims had introduced on-glass photographic slides, and by 1851 they had begun employing the French albumen process, calling the slides they produced in this fashion *hyalotypes* (from the Greek *hyalo,* glass).

To make their slides, the Langenheims covered glass with albumen, which was then sensitized in silver nitrate. Following the exposure in the camera, a glass positive was made from the negative by binding the developed negative to another glass pane that was sensitized but unexposed. After a brief sunlight exposure, the second pane could be processed in pyrogallic acid and fixed in sodium thiosulfate

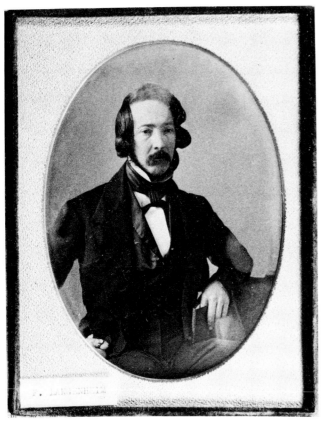 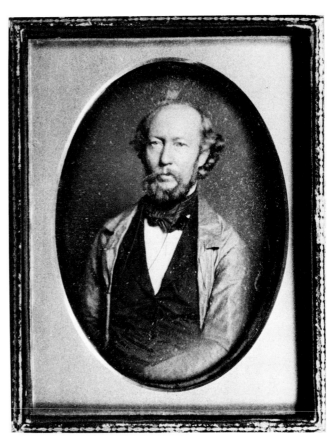

Frederick Langenheim (1801–1879) and his brother, William (1807–1874),
were daguerreotypists who sought to pioneer calotypy in America. They
created photographic magic lantern shows and then seized upon
stereography, leading the American family into a totally new field of home
entertainment and education.

Later the Langenheims combined
stereographic effects with magic lantern
presentations. Advertisement from
Frank Leslie's Illustrated Newspaper
(May 13, 1865).

(hypo). This was the positive projection slide; the master negative was stored for
later use, and many of them have survived to this day.

By means of the same process, the Langenheims entered three-dimensional pho-
tography. They made all-glass stereo hyalotypes that could be viewed in the Brew-
ster viewer. However, they had no system that would permit the slides to be dis-
played on a screen while giving the illusion of depth.

In 1849 William Langenheim visited England, met William Henry Fox Talbot,
the father of calotypy, and negotiated the purchase of the American patent rights
for the on-paper process for £1,000. The Langenheims planned to license calotypy
to American daguerreotypists to permit them to create portraits and views "de-
void of metallic glare" and to afford them the further benefit of a negative that
could be reprinted at a later time. But no American photographer would agree to
pay for a license, and this effort to launch calotypy in America failed.

Nevertheless, calotypy became an alternative procedure in the Langenheims'
own experiments with three-dimensional photography. Most early experimenters

saw in the stereographs only a laboratory novelty; the Langenheims saw in it a vast educational and entertainment industry. Between 1850 and 1855, using hyalotypy and calotypy, the Langenheims created a large number of stereo views of public parks and landmarks. In February 1855 they introduced the first commercial stereographs, using calotypy.

With the viewer and a stack of cards, one no longer needed to leave the privacy of one's home for the discomfort of the lecture hall. At the same time, lecture hall quality entertainment was made available to one and all. An industry was born, and many hurried to join the new photographic gold rush: photographers, agents, publishers, equipment makers, stationers, card printers. The Langenheims had opened the doors to the world of stereography; now the entire photographic industry poured through.

Above: An 1854 Langenheim view of the Niagara Falls made by the paper negative, paper positive (calotype process). *Below:* A Langenheim waterfront stereograph of the same era. (*Collection RR*)

An actual page from the hand-assembled 1856 catalogue of calotype
stereography, Langenheim *Photographic Views-2nd Series* in the Library of
Congress. From top to bottom: *Broadway, New York, from Barnum's
Museum; Elmira, N. Y., from Haight's Hotel;* and *Terrapin Tower and
Horseshoe Falls, fr. Goat Island* (Niagara Falls, N. Y.). (*Collection LofC*)

Langenheim views were the start of the first assortment of stereographs to be offered to the American public by the American Stereoscopic Company at William Langenheim's Philadelphia address. (*Collection MusCNY*)

Some early Langenheim stereographs are embossed at the right edge with a Langenheim imprimatur. (*Collection MusCNY*)

The Langenheims joined with William Loyd, a stereo exponent and the holder of a patent for a viewer, to expand the stereography market through sales of the American Stereoscopic Co. (*Collection MusCNY*)

The calotypes and hyalotypes that the Langenheims created as the first stereo products are rarities today. Two of the earliest known paper stereographs are a view of Niagara Falls and one of the Croton aqueduct outside New York City.

By 1858 the advantages of the wet-plate system then in use for ambrotypy and tintypery won the interest of the Langenheims. No further calotype stereographs are known to have been produced. The wet-plate system provided a glass negative that could be mass-printed on low-cost albumen-coated papers. According to Richard Russack, a student of early stereography, there are only some fifteen Langenheim paper stereographs in the thousand or more private collections in this country. A handmade catalogue of 1856, listing more than thirty stereo calotypes by the Langenheims, is filed in the Print Room of the Library of Congress.

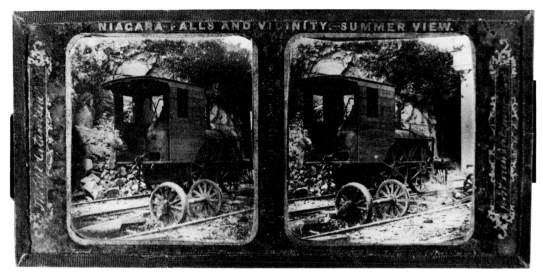

Hyalotype stereograph (on glass) by the Langenheims showed an
early steam engine, *The Old Catawissa*. (*Collection RR*)

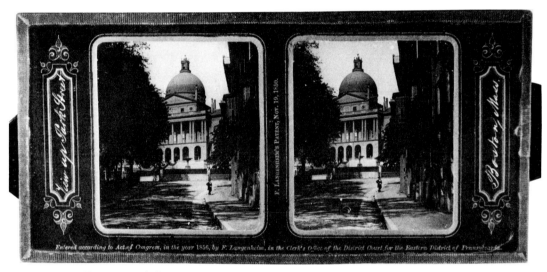

View up Park Street, a Boston Langenheim hyalotype stereograph.
(*Collection RR*)

Winter View of the Falls of Niagara, an 1854 calotype stereograph
by the Langenheims. (*Collection HA*)

▣ MAKING THE STEREOGRAPH

The stereograph appears in all of photography's forms from the daguerreotype to the modern roll film. The earliest were made with any gallery or field camera from two successive exposures done from slightly different vantage points. After 1855 the first commercially produced stereo cameras became available, and paired lenses were made to fit all popular cameras so that any photographer could quickly convert his camera for stereography.

Stereographs must be made from paired photographs that view the same subject from slightly different angles. Stereographs and the depth illusion cannot be achieved by printing two identical views and setting them side by side.

During the wet-plate era, all cameras for stereography required a removable back where the plateholder was fitted for the exposure. Following the introduction of dry plates, plateholders (for a single exposure), magazines (for numerous exposures) and finally roll film could be loaded into the specially designed cameras, which are immediately identifiable today by their twin lenses set side by side, approximately 3½ inches apart.

Plate processing and darkroom work followed the standard procedures of the period.

The earliest identifiable stereographs are readily authenticated. The images are each 2⅜ by 2⅝ inches, mounted ⁷⁄₁₆ inches apart on thin white cardboard. (Later views are mounted so that the images abut.) The card stock is thin, white and hard. Below the two images is the legend, *"Entered according to Act of Congress in the year 1854 by F. Langenheim in the Clerk's office of the District Court for the Eastern District of Pennsylvania."* The title of the view is handwritten on the reverse of the card. A label affixed shows the distributor's name, J. W. Queen, Optician, 264 Chestnut Street, Philadelphia (an early seller of photographic supplies and related items).

The Langenheims' growing library of stereo views was the basis for the formation of the American Stereoscopic Company as their distributor. It was the first of many companies to concentrate on selling the cards.

The Langenheims, Russack notes, were associates of William Loyd, with whom they formed the Philadelphia firm of Langenheim, Loyd & Co. Loyd held the patent to a very early American stereo viewer that could be used optionally with either glass (see-through) or paper (reflected light) views.

One of the viewers of the day resembled a book on a shelf, bearing the title "Stereoscopic History." Views imported by the Langenheims have been imprinted "Stereoscopic History," and there is some belief that these views and the book-shaped viewer were sold as a set prior to the 1860s. Among the stereographs imported were photographs taken by the English photographer and traveler Francis Frith in Egypt and the Holy Land.

A stereographic daguerreotype by an unknown photographer
around 1855, shows an odalisque in the French painting style of the
period; it could be viewed through the Brewster-type viewer.
(*Collection AH*)

A standing erotic stereo portrait by an unknown daguerreotypist,
around 1855, for private circulation only. (*Collection AH*)

An albumen print stereograph, around 1880, of an unidentified
actress or dancer was a risqué addition to any stereograph card
library. (*Collection GG*)

•SIZES OF STEREO CARDS AND SLIDES

The typical mass-manufactured stereo card of the period between the Civil War and World War I had a standard dimension: 3½ by 7 inches. This is the size commonly found in boxed sets. The earliest of these cards were made on flat cardboard mounts; later cards were made on slightly curved mounts that permitted greater clarity when they were seen in the stereopticon viewer.

A number of photographers, working with larger field cameras, created slightly larger cards: 4 by 7 inches, 4⅜ by 7 inches and 4½ by 7 inches.

Until about 1873, the smaller sizes were sold for twenty-five to thirty-five cents per card and the larger "artistic" size for fifty cents. Within a decade, sets of twenty or more cards sold for fifty cents. These cards were made on printing presses, not by a hand photographic printing process.

The on-glass slides, a stereo form more popular in Europe than in America, were available in two standard sizes, 45 by 107 mm and 6 by 13 cm. Both were smaller than the standard card stereograph.

The first stereographs owned by American families were staid scenes of the principal buildings of Washington, D.C., and the harbor at New York. Then imported cards brought a note of the exotic to the stereograph collection. The first violence in stereography appeared in the battlefield cards during the war between the states. Brady's teams in the fields and camps and the battle sites created thousands of stereographs. The best of them were displayed, within days of a major battle, at Brady's four New York and Washington galleries. Here card buyers stood in line in the gallery reception room, on the stairs leading to the gallery and in the street below, waiting for the opportunity to witness the war's destruction through the magic of stereography's three-dimensional images. The cannonadings of the Civil War exploded stereography into the life of every American.

The war put to the test the system of stereograph card sales created by the Langenheim brothers. The association of a photographer at a distant vantage point, a laboratory in a city in another country, a sales agent in every village and a card buyer in every home proved to be a viable chain, and stereography flourished. However, except for their name on a few of the cards in the family collection, the Langeheims disappeared from the scene. They are barely remembered today for their role in creating the stereo system for the home.

OTHER PROCESSES
A Guide to the Nineteenth Century

Photography was created by the private experiments of a handful of amateur scientists such as Niépce, Daguerre and Fox Talbot and the diligent scholarship of gentlemen scientists such as Herschel. Progress in the early years was rapid; a growing body of practitioners modified and improved on the crude pioneering efforts, and the first experiments developed into practical technologies that were applied not only by photographic technicians but by the craftsmen of the printing and clothmaking industries.

The goal of the early years was a fixed image, and the variety of media experimented with for holding the image was amazing: paper, cloth, wood, leather, glass, iron sheeting, stone and many others. The chemistries tried were similarly varied, but all of the major processes involved metallic salts, many of which are light-sensitive. Among the metals used were silver, gold, platinum, uranium, aluminum and iron. In daguerrean days gold and other metals began to be used for toning, but silver has always been the dominant photosensitive material, and silver nitrate has been the most useful of all of the salts for photographic purposes.

Many of the modifications came in. processes that started with silver nitrate sensitization of albumen or collodion coatings on glass or paper. In fact, in black and white photography, little has changed from the darkroom of the Civil War to the workroom of today's photographer. Electricity and electronics have added convenience and accuracy but little else to the fundamental procedures. Even in color processes, theories established in the 1850s were the basis for much of the experimental work that led to the systems of today.

For the most part, the processes of the nineteenth century survive in recognizable forms, especially in the graphic arts and printing industries. Modern materials exist for tintypery, platinum printing, carbon-process printing and calotypy. (The handful of contemporary daguerrean experimenters have difficulty locating suitable plates, and they depend mainly on using plates from which the original daguerreotype images have been removed.)

While many of the early practical methods, and even a number of partially successful experiments, were well documented at the time in diaries, workbooks and

reports to learned societies, the precise chemistry of some obscure processes has been lost. Some researchers reported successes that were apparently little more than kitchen-table modifications of the procedures of their more successful contemporaries. At least one commonly sought process, a system of color photography, was the subject of one of the great hoaxes of the period. In the 1850s the Reverend L. L. Hill wrote to the leading photographic journal of his success in creating natural color daguerreotypes. He promised samples, demonstrations, procedures and meetings with the photographic elite to claim his seat beside Daguerre as the foremost experimenter. Alas, Hill has disappeared into the darknesses of history, leaving only the name he gave his innovation, the Hillotype. No Hillotype is known to exist.

Fortunately, a fine body of manuals, histories and journals survive to detail the significant advances not described in readily available patents. The foremost discovery, that of daguerreotypy, was published in full detail by Daguerre in August 1839 as part of his agreement with the French government to make the invention of photography a gift to the world. For that process and for the further systems of the subsequent twenty years, the works of H. H. Snelling, Robert Bingham, Marcus Aurelius Root, S. D. Humphrey, Edward M. Estabrooke and J. Towler have been the usual departure point for forays into the darkrooms of yesteryear.

Nineteenth-century processes fall into two major groups and then into a number of additional smaller groups. The first group of processes was developed for application by photographers concerned with creating single images: portraits, landscapes, various indoor or outdoor subjects. The second group was intended for application to the mass-reproduction needs of lithographers, publishers, clothmakers, and even pottery manufacturers. These generally involved photographically derived master plates suitable for ink, dye, chemical and other printing processes. Of course there were crossovers. Glass negatives made for photographers lent themselves admirably to the printing industry; the raised relief surfaces made on gelatin and used for the ink-printing processes of the lithographic artist lent themselves in turn to the photographer seeking special effects in what became the gum process. But by and large the achievements and breakthroughs in one area only occasionally helped technological advancement in the other.

This guide to the nineteenth century considers the processes in groups according to their practical application.

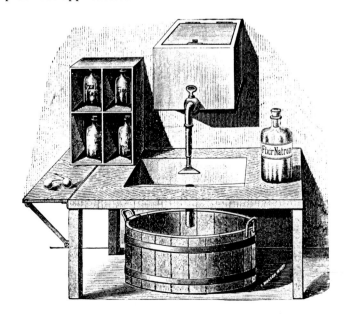

I. GALLERY PROCEDURES BASED
ON PAPER NEGATIVES AND PAPER POSITIVES

albumen print	crystallotype	melanograph
amphitype	cyanotype	melainotype
anthotype	Endemann's process	mosaic card
atrograph	energiatype	palladiotype
boudoir photograph	Feertype	paper negative
cabinet card	ferro-prussiate process	platinotype
calotype	fluorotype	printing-out paper
carbon process	Gaudinotype	promenade photograph
carte-de-visite	gum print	salt print
catalissotype, also catalysotype	imperial photograph	Talbotype
ceroleine process	kallitype	Uranium print
chromatype	LeGray method	Wothlytype
chrysotype	Mariotype	

albumen print • A printing paper using albumen (egg white) as the medium for the active chemicals. The paper was coated first with albumen and a metallic salt such as potassium iodide or potassium bromide. Then it was floated on a silver nitrate bath, where an emulsion of silver albuminate was formed. The albumen content of this emulsion provided a distinctive and characteristic gloss, and most of the common developing baths lent a warm-toned brownish hue to the image. The process was first announced in France by Louis Désiré Blanquart-Evrard (1802–1872) in 1850, and his procedure dominated paper sensitization almost to the end of the nineteenth century. Early albumen prints were generally done on papers that were 18 by 22 inches before they were trimmed to working size. *(albus,* Latin, white).

amphitype • An on-paper process in which a paper plate was sensitized by coating it in a solution of iron, mercury or lead salts. Camera exposures of this paper required periods from one-half to six hours to obtain a brown image that faded (even in the dark) within a few weeks to a year. The photograph could be viewed at different times either as a negative or, with further chemical treatment, as a positive. The process was proposed by Sir John Herschel (1792–1871) in the early 1840s. *(amphi,* Greek, on both sides).

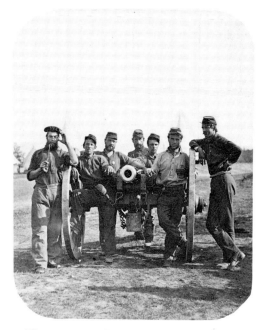

The warm-toned albumen print dominated almost all of the prints made on paper from the 1850s until the final days of the nineteenth century. See also Appendix C.

anthotype • An on-paper process developed jointly by Sir John Herschel, Michel Eugène Chevreul and Robert Hunt in the early 1840s, using a solution in alcohol of light-sensitive materials obtained from the petals of certain flowers. *(anthos,* Greek, flower).

atrograph, also **melanograph** • An on-paper positive image obtained by exposing silver nitrate sensitized black paper. The process was developed by Dr. Giles Langdell of Philadelphia in 1853, but his work was paralleled by French experiments by André A. Martin in the same year. (*atra,* Latin, black; *melano,* Greek, black).

boudoir photograph • A photograph in the format 8¼ by 5 inches, established in the 1870s. It was printed on albumen paper from a collodionitrate glass negative either by contact printing or by enlargement. This format was larger than the popular cartes-de-visite and cabinet cards, and it helped to establish a market for larger photographs suitable for display on tables and shelves (as opposed to those stored in albums). The size was small enough for a frame that could fit on a dressing table. (*boudoir,* French, lady's sitting or dressing room).

cabinet card • A mounting card bearing an albumen photograph, usually a contact print 6 by 4 inches made from a half-plate negative (6½ by 4¾ inches). This style and size was intro-duced in England about 1863 and became the basis for improved portrait photography, since the larger (than the carte) negative permitted retouching.

calotype, also **salt print, Talbotype** • An on-paper image invented and patented in England in the early 1840s by William Henry Fox Talbot (1800–1872). Talbot sensitized writing paper in baths of sodium chloride and silver nitrate. When the paper had been darkened by exposure in a camera, he washed the plate with a further salt or potassium iodide solution to make the unaltered silver salts relatively insensitive to light. (Later sodium thiosulfate was used as a fixing agent.) When the dried paper negative was held in contact with a second sensitized sheet, a positive image was formed. (*kalos,* Greek, beautiful).

carbon process, also **Mariotype** • A photograph on paper derived from a carbon-based (hence, carbon) pigment incorporated in bichromated gelatin and then spread on paper. Light made the unexposed areas of the carbon pigment more or less insoluble, thereby permitting "de-

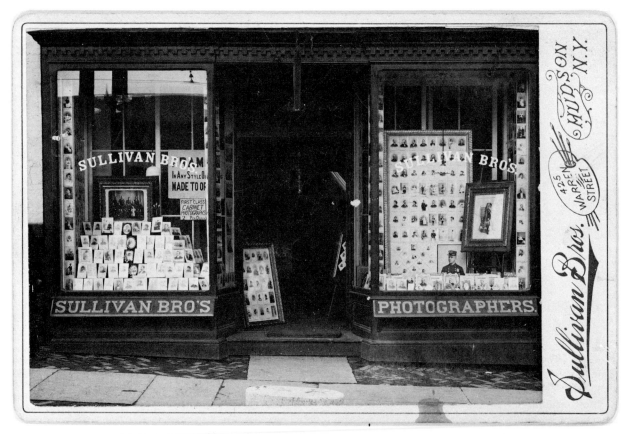

A front window exhibit of cabinet cards at *Sullivan Bro's Photographers,* in Hudson, New York, was shown on an actual cabinet card advertising the gallery; actual size. (*Collection GG*)

velopment" in warm water. The developed image was then usually transferred to a prepared adhesive paper. Though created starting with a photographic negative made in a camera, the result often resembled an etching or a lithograph more than it did a photograph—an effect sometimes sought by photographers for unusual portraits or scenic landscapes. Late nineteenth century.

carte-de-visite • A photograph mounted on a card about 4 by 2½ inches, the product of a multiple negative made in a camera with four or more lenses focused on a wet-plate. The system began in the mid-1850s in France after patenting by Adolphe-Eugéne Disdéri (1819–1890?) and reached America about 1860. The low cost of cartes permitted their extensive interchange among friends and families, giving birth to the family album. Cartes displaced the earlier daguerreotypes and ambrotypes. Their major competition was the lower-cost tintype. *(carte-de-visite,* French, calling card).

catalissotype, also **catalysotype** • An on-paper process suggested by Dr. Thomas Woods of Dublin, Ireland, in 1854. He sensitized paper with iron iodide and then immersed it in a bath of silver nitrate. *(katadysis,* Greek, dipping under water).

ceroleine process • An improved waxing treatment used to give greater translucency to paper negatives (calotypes). Developed along the lines of the earlier LeGray method, it combined sensitization of the paper with the wax saturation, thereby eliminating the need to do the waxing after the processing had been completed. By increasing the negative's translucency, this late 1840s process improved the calotype's second (positive) print. *(cera,* Latin, wax).

chromatype • An on-paper process of the 1840s attributed to Robert Hunt (1807–1887), an English photographic scientist, in which paper was sensitized in baths of copper sulfate solutions followed by baths in bichromate of potash. After the exposure was made in a camera, the image was developed in a silver nitrate bath to yield an orange positive on a white ground. Further bleaching and redevelopment in a common salt bath created a positive of a lilac hue. *(chroma,* Greek, color).

CARTES DE VISITE,

C. R. B. CLAFLIN,
ARTIST,
188 Main Street,
WORCESTER, MASS.

Front and back of typical early carte-de-visite. The cartes, made by affixing a small albumen print to a lightweight card, were mass produced.

chrysotype • An on-paper process announced by Sir John Herschel in 1843, based on sensitizing paper in ammonio-citrate of iron and ferro-sesquicyanuret of potassium. The exposed paper was developed in gold or silver solutions. (*chryso*, Greek, gold).

crystallotype • The first albumen print made by John A. Whipple of Boston in 1853 from collodion negatives on glass. These prints had a sharpness superior to calotypes made from the paper negatives of the period. (*crystallum*, Latin, cold, clear).

> 52
> ## Daguerreotype and Crystalotype.
> ### J. A. WHIPPLE
> Continues to devote himself to the Daguerreotype Art, at his old stand
> ## NO. 96 WASHINGTON STREET,
> ### BOSTON,
> AND IS NOW PREPARED TO FURNISH
> ### DAGUERREOTYPES ON PAPER,
> ### BY HIS CRYSTALOTYPE PROCESS,
> Thereby avoiding the disagreeable glare of the ordinary Daguerreotypes, and producing results
> ## EQUAL TO THE FINEST ENGRAVINGS.
> HE WAS AWARDED A
> ## Prize Medal at the World's Fair,
> AND THE HIGHEST PREMIUM
> AT THE LAST
> ## Mechanics' Fair, Boston,
> For the Perfection of his Work.

John A. Whipple, a well-known Boston photographer, advertises crystalotypes, paper prints made from a glass negative, "thereby avoiding the disagreeable glare of the ordinary Daguerreotypes"; about 1852.

cyanotype, also **blueprint, ferro-prussiate process, Pellet's process** • An on-paper process developed by Sir John Herschel in 1842 using ferrocyanate of potassium to form a white line on a blue field. This was the forerunner of the "blueprint" process of the twentieth century. In a variation by Pellet in 1871, blue lines were formed on white paper. (*kyano*, Greek, blue).

Endemann's process • An on-paper process of 1866 based on the aniline process but starting with the sensitization of paper with salt, potassium bichromate and sodium vanadiate. After it was exposed, the paper was developed in the fumes of aniline and water vapors to form an aquiline black image.

energiatype, also **ferrotype** (not the same as the synonym for tintype) • A process by Robert Hunt in 1844 that created a negative on paper sensitized in silver nitrate. The developing agent was ferrous sulfate. (*energos*, Greek, active).

Feertype • An on-paper color process patented in Germany by Dr. Adolph Feer in 1889 that sensitized paper with diazo-sulphonic salts of aniline, amido-azo-benzol, benzidine and other materials. The diazo compound was released by the energy of light, and the image was developed in various colors by combination with selected salts.

ferro-prussiate process, *see* **cyanotype.** •

fluorotype • An on-paper process introduced by Robert Hunt in the early 1840s as a variant process of his energiatype. It used a combination of potassium bromide and sodium fluoride (hence, fluorotype) to sensitize the plate.

Gaudinotype • An on-paper negative created by the sensitization procedure of Marc Antoine Gaudin (1804–1880), a French daguerreotypist credited with being among the first to photograph children (1843). No satisfactory description of his sensitization procedure has been found.

gum print, also **photo-aquatint** • Photographs made after about 1894 and later by the gum-bichromate process following an adaptation of the Alphonse Louis Poitevin collotype process of the 1850s. The print could be made from the relief (raised-surface) gum negative with art effects simulating charcoal drawings. Extensive handwork was possible in this process, even "on-canvas" effects achieved by exposing the negative to coarse canvas.

imperial photograph • A paper or canvas photograph of the late 1850s, 20 by 17 inches (also 17 by 14 inches), made by the albumen process with a solar enlarger. Called "imperial" by Mathew B. Brady, such giant photographs were often heavily painted and ornately framed. The imperial cartes of the mid-1860s were edge-to-edge portraits on a carte panel 2½ inches wide. In the 1870s the term was also appropriated to

designate a photograph 10 by 7 inches mounted on a panel 13 by 8 inches, a size and shape attributed to photographer Alexander Bassano.

kallitype • An on-paper process invented by W. W. Nicol in which iron salts are reduced by light to ferrous sulfate, which in turn reduces silver nitrate to the metallic state, yielding bluish or black images. Once sensitized, the paper was exposed under a negative in sunlight and then developed in any of a variety of baths to obtain black, sepia, maroon or purple tones. (*kalos*, Greek, beautiful).

LeGray method, also **ceroleine process, wax-paper print** • An on-paper process starting with the iodizing of pre-waxed paper to facilitate printing. Gustave LeGray (1820–1862), a French painter and teacher of photography, invented the procedure early in 1851. Because the wax filled all the paper pores, the process permitted creation of a paper negative nearly as transparent as glass. White honey and albumen were used to insure the adherence of the sensitizing chemicals to the waxed surface.

Mariotype • An on-paper process introduced by M. Mario in 1873 in which bichromated gelatin was exposed to light under a negative. The print was dampened and squeegeed into contact with ordinary unsensitized carbon tissue, then "developed" in warm water, after exposure to light, which reduced the chromium compounds absorbed by the carbon tissue. *See also* **carbon process.**

melanograph, melainotype, *see* **atrotype** •

mosaic card • A carte-de-visite novelty that combined many separate portraits on a single print. It was introduced in England in 1862 with photographs of the royal family, assemblages of bishops, etc., and in the United States with Lincoln's cabinet members, Civil War generals, etc. Disdéri, the inventor of the carte, patented the mosaic card in France in 1863 and created one carte on which there were 320 pinhead-size portraits of his contemporaries.

palladiotype • An on-paper process with the image formed in palladium, following a process developed in England by William Willis (1841–1923) and popularized after the 1870s. Willis, who also developed the platinotype printing process, created the Platinotype Company to market both processes.

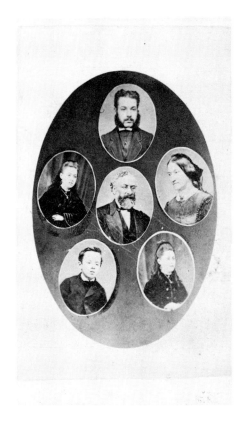

The mosaic card showed individual portraits of group members, whether a family, a cabinet, or a band. (*Collection GG*)

paper negative • A negative made on paper rather than on glass or film. The first paper negatives were made by William Henry Fox Talbot in a series of experiments in 1830, and he patented the subsequent negative-positive process as Talbotypes. A calotype, or salt print, is a paper positive made from a paper negative.

The Platinotype, patented in 1873, was in vogue until about 1890, when platinum became too costly.

platinotype • An on-paper printing process developed by William Willis and patented in England in 1873. Willis's Platinotype Company introduced in 1880 a ready-sensitized paper, which provided fine sepia-tone and black images by development of a faint printed-out (exposed to light under a negative) image of platinum. Black tones were obtained by development in a solution of potassium oxalate. Fixing (or clearing) was done with a weak solution of hydrochloric acid. The process faded after the 1890s when platinum paper became too costly compared to newer factory-made papers.

printing-out paper • A light-sensitive paper requiring no darkroom processing that was useful primarily for proofing. It was introduced after the 1870s to permit contact printing in sunlight. Following exposure, prints continued to darken in red-purple tones, becoming totally black.

promenade photograph • A photograph 7½ by 3¾ inches, a format established in the 1870s. The prints on paper were made by the collodio-albumen process. The promenade photograph was one size larger than the cabinet card introduced ten years earlier yet was slightly smaller than the boudoir photograph size offered at that time.

salt print, *see* **calotype** •

Talbotype, *see* **calotype** •

uranium print, *see* **Wothlytype** •

Wothlytype, *also* **uranium print** • A process achieved by coating paper with collodion containing the nitrates of uranium and silver. Developed by J. Wothly of Belgium in 1864, it never achieved popularity among photographers.

The Too Faithful Talbotype jibed at the pretenses of an unsatisfied client. A Talbotype was the calotype process by Fox Talbot. *Punch,* about 1855.

A panel print, 8¼ by 4 inches, was one of a number of shapes and sizes that enjoyed modest acceptance in the nineteenth century. All were made by the collodion negative–albumen print procedures. (*Collection GG*)

II. GALLERY PROCEDURES BASED
ON GLASS NEGATIVES AND GLASS POSITIVES

alabastrine process	Crystal Photograph	kromogram
albumen process	crystoleum process	Mayall's albumen process
ambrotype	diaphanotype	Niépceotype
Archertype	ectograph	wet-plate process
atrephograph	Ferrier's albumen process	
collodio-albumen process	hyalotype	

alabastrine process • An on-glass procedure of the 1850s, used for making positives. It was especially valuable when the photographer had to duplicate a thin gelatin negative to create a superior copy. The negative was mercury bleached, and after drying, it was backed with black velvet to obtain a positive appearance (ambrotype effect) and then copied in the camera. (*alabaster*, Greek, translucent hard stone).

albumen process • An on-glass process developed by French photographer Claude Félix Abel Niépce de Saint-Victor (1805–1870) in 1847, using the whites of chicken eggs as a coating that could be sensitized in the manner of salt prints. A mix of albumen with honey, syrup or whey formed the adherent emulsion. The process enjoyed a vogue among photographers who sought an alternative to the on-paper calotype process. Albumen became the standard coating for the photographic papers of the nineteenth century after Louis Désiré Blanquart-Evrard (1802–1872), a French photographer, showed in 1850 that the addition of potassium iodide and potassium bromide to the albumen

Collodion glass negatives drying on a folding rack.

readied the dried paper for a superior sensitization just before use by floating it in a bath of silver nitrate. The albumen process on glass was discarded following the introduction of collodion in 1851. *See also* **Ferrier's albumen process** and **Mayall's albumen process.**

Ambrotypes were on-glass negatives viewed as positives, protected after processing in leather and wood cases. (*Collection GG*)

ambrotype • A negative on glass coated with collodion sensitized in silver nitrate. After the plate was exposed, developed and fixed, a backing of black paint was applied, permitting the silver image to be viewed as a positive. It was patented in America in 1854 by James Ambrose Cutting (1814–1867) of Boston, following French and other American experiments in 1853 on blackened paper and patent leather. The process was named by photographer-historian M. A. Root. (*ambrotos*, Greek, immortal).

Archertype • A collodion process developed by the English photographer Frederick Scott Archer (1813–1857). *See also* **wet-plate process.**

Advertising card for *Crystal Photographs* describes the crystoleum process, patented in 1878, in which a paper print was affixed to a convex glass. (*Collection GG*)

atrephograph • A silver nitrate negative image formed on a skin of collodion on glass that had been first coated with India rubber dissolved in chloroform. After fixing and washing, the image-bearing transparent skin was rolled off the glass support and then adhered to thin cards or polished, japanned leather (that is, blackened, as in patent leather). The image was viewed as a positive "unreversed" image. (*atra*, Latin, black).

collodio-albumen process, *see* **wet-plate process** •

Crystal Photograph • An on-glass 1878 trademarked name for an American process in which a photographic image was supported on a fine convex glass lens, then sealed to the glass by heat treatment with glaze or other sealant. The glass covering of the photograph eliminated the need for varnishing the image (a common practice to enhance durability of the emulsion). (*crystallum*, Latin, cold, clear).

crystoleum process • An on-glass process in which a paper print was affixed to the back of a concave glass and the image then made transparent either by waxing or by gradual removal of the paper form the back, leaving only the emulsion adhered to the glass. Oil painting or tinting of the image could be done on a second glass placed inside the first. This made the procedure a costly and elaborate art process. (*cryst*, Latin, cold, clear; *oleum*, Latin, oil). *See also* **diaphanotype.**

diaphanotype • An image on glass made by cementing an oil-painted photographic image to glass in an effort to achieve durability. Developed in the late 1850s, this process used the technique of Hallotype, a multiple or combination image. In the finished product it had an enameled appearance. (*diaphanes*, Greek, transparent). *See also* **crystoleum process.**

ectograph • An on-glass process patented by William Campbell of Jersey City, New Jersey, in the 1850s. After making a negative on glass by the wet-plate process, a photo copy was made on a second plate of glass also sensitized by the collodion–silver nitrate procedure. This second image (a positive) was then coated with a thin layer of white wax that could be colored with oil or watercolors. The end product was a colorful transparent glass positive. (*ectos*, Greek, outside).

Ferrier's albumen process • An on-glass process of Claude-Marie Ferrier (1811–1889), a French photographer who between 1850 and 1860 coated glass plates with iodized albumen. When dry, they were sensitized in silver nitrate and then dried again. The plate was exposed in a camera, developed in pyrogallic acid and a few drops of the silver nitrate were applied hot (180°F.), any stains being rubbed off with cotton or wool before the plate was fixed. The process was known to have been used to make stereographic glass plates. *See also* **albumen process, hyalotype**

hyalotype • An 1850 on-glass positive albumen image patented by William and Frederick Langenheim and based on Niépce de Saint-Victor's earlier process. Albumen-coated glass was sensitized and exposed in contact with a finished glass negative to obtain a reversed (positive) image suitable for lantern slide projection. Also, an etched glass suggested by Hann in Poland in 1829 for use as a printing surface. *(hyalo,* Greek, glass). *See also* **Ferrier's albumen process.**

kromogram • An on-glass color image created by the Photochromoscope camera of Frederick Eugene Ives (1856–1937) of Philadelphia in 1892. Positives made from the camera's three color negatives were aligned for viewing as a single color photograph in the Kromskop viewer, which contained filters and mirrors to align images in the primary colors. *(chroma,* Greek, color).

Mayall's albumen process • An on-glass variant of the Niépce de Saint-Victor process of 1847 suggested by daguerreotypist John Jabez Edwin Mayall (1810–1901) of Philadelphia. Mayall coated a glass plate with albumen to which potassium iodide, potassium bromide and potassium hydrate were added. The dried plate was exposed to iodine vapor (as in the daguerrean process), then sensitized in a bath of silver nitrate and washed. Before exposure, it was again iodized. Development was in pyrogallic acid, and the image was fixed in hypo. When making positive plates (as for lantern slides), Mayall replaced the potassium bromide with sodium chloride.

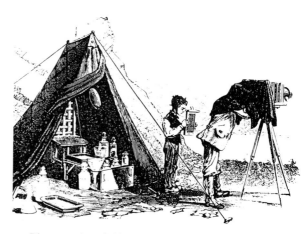

Photography afield until the dry-plate made a darkroom tent unnecessary.

Niépceotype, *see* **albumen process** •

wet-plate process, also **Archertype, collodio-albumen process, wet collodion process** • The basic on-glass process of the nineteenth century, invented in 1851 by Frederick Scott Archer (1813-1857). A clean glass plate coated with collodion was sensitized (in a darkroom) with silver nitrate and then exposed in the camera while still wet (hence, wet-plate process). Development was in pyrogallic acid. Once fixed and dried, this negative on glass lent itself to a number of variant processes: on paper as prints; on glass as transparencies or lantern slides; and backed with black paper, as an ambrotype. The wet-plate process served until the invention in the 1870s of the dry plate and continued to have graphic arts applications up to the 1930s.

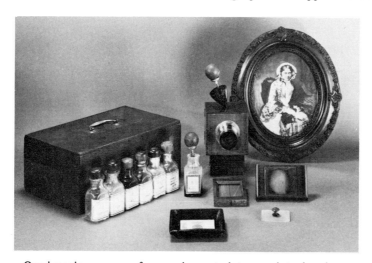

One ingenious means of processing wet-plates was introduced around 1865 in the Dubroni, a camera which also served as a developing tank immediately after exposure. (*Collection A-G-F*)

III. GALLERY PHOTOGRAPHS ON METAL

daguerreotype gem tintype
ferrotype melainotype

daguerreotype • A mercury-iodine process that produced an image on silvered copper. The silvered copper was highly polished, then sensitized by being placed in a small box near a saucer of iodine vapor. After the plate was exposed in a camera, it was developed in a fuming chamber containing heated mercury. The daguerreotype's mirrorlike surface limited its viewing to angles at which a dark background could be reflected. Each daguerreotype was unique; since there was no negative, there was no way to duplicate the image. The basic process was developed in France by Jacques Louis Mandé Daguerre (1781–1851), who named the procedure after himself. The process was in vogue between 1840 and 1860.

ferrotype, *see* **tintype** •

gem • Small tintypes made in a multilens camera patented by Simon Wing of Boston in 1863.

This camera could create up to thirty-two portraits, each 1 by 1⅜ inches, in a single exposure. The tiny gem images were affixed to carte-size mounts in order to fit the carte-de-visite albums of the period, and they could also be fitted into special tiny Gem Albums created for the petite portraits. *See also* **tintype.**

melainotype, *see* **tintype** •

tintype, also **ferrotype, gem, melainotype** • A process involving an image formed on thin sheet iron that had been japanned (blackened) and then coated with collodion and sensitized with silver nitrate. The first tintype experiments were done in France in 1853. In America the process was patented in 1856 as the melainotype by Hamilton L. Smith of Gambier, Ohio. The name ferrotype was created in 1857 by a competitive Ohio manufacturer, Victor M. Griswold. The process endured until the 1930s. (*ferro,* Latin, iron; *melas,* Greek, dark).

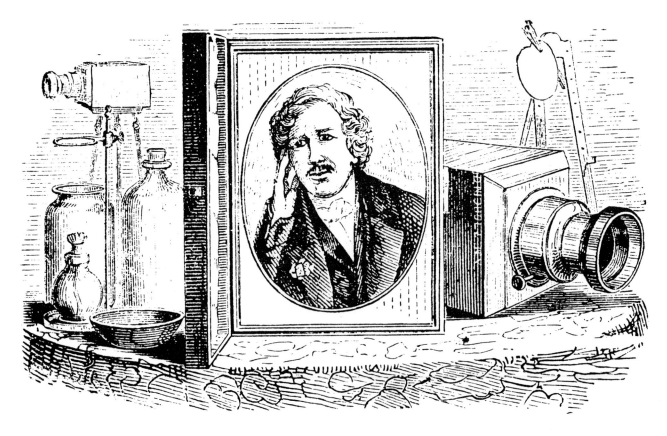

IV. PHOTOGRAPHIC PROCESSES OF THE PRINTING AND GRAPHIC ARTS FIELDS

Albertype	dusting-on process	photoglypty
algraphy	gum print	photogravure
Artigue's process	heliotype	photo-lithography
artotype	hydrotype	Plumbeotype
asphalt process	ink process	Poitevin process
atmograph	Leggotype	powder process
bitumen process	Obernetter's process	stannotype
chalkotype	oleography	Woodburytype
collotype	photo-aquatint	zincography
contretype negative	photo-autocopyist	

Albertype • An early form of the photo-lithographic process that depends on the principle that oil and water do not mix. Gum-bichromated gelatin was dried on a thick glass and exposed to light under a negative. The process was developed in 1868 by Josef Albert (1825–1886), who thus obtained a surface that could print up to two thousand copies without deterioration. Albert, court photographer of Bavarian kings, admittedly based his effort on the earlier Poitevin process. *See also* **collotype**.

algraphy, also **photo-lithography** • A photo-mechanical process in which a sheet of aluminum, flexible so it could be fitted to a rotary press, replaced the flat lithographer's stone used in the slower flatbed presses of early printing systems. (*al*[uminum] plus *graph*, Greek, writing).

Artigue's process • A variation of the gum-bichromated gelatin procedure introduced by M. Artigue of Paris, who in 1889 developed a gelatin-pigment-coated paper with hot sawdust and water baths.

artotype, *see* **collotype** •

asphalt process, *see* **bitumen process** •

atmograph • An image created on an exposed daguerreotype plate by iodine vapors, suggested by experimenter J. J. Pohl of Vienna in 1840. Pohl permitted vapors from an iodine-saturated wood slab to replace the customary iodizing box. In 1847 Niépce de Saint-Victor presented a paper to the Académie des Sciences, Paris, covering a similar use of iodine vapors on a copperplate engraving and the reproduction of the iodine vapor image on metal. (*atmos*, Greek, vapor).

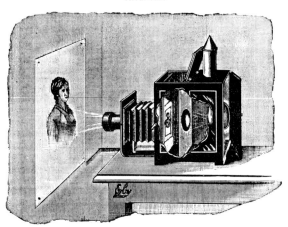

bitumen process, *also* **asphalt process, heliotype** • A process discovered by Nicéphore Niépce in 1826 when he noted that bitumen (asphalt) becomes insoluble following exposure to sunlight (hence, heliotype) for up to eight hours. Niépce created the world's first photographic image on a pewter plate coated with bitumen that dissolved away where exposed with a turpentine wash. The process on zinc or copper permitted the creation of a printing surface after etching with nitric acid. (*bitumen de Judée, asphalte,* French).

carbon process, *see under* **Gallery Procedures Based on Paper** •

chalkotype • A halftone typographic printing plate on brass sensitized with powdered asphaltum and then exposed to light through a negative. The process was developed about 1866 by Roese, a German at the Government Printing Office, Berlin. The process was the basis for the creation of cuprotypes (copper plates) in Czechoslovakia in the 1880s.

collotype, also **Albertype, artotype, heliotype, Poitevin process** • A printing process of 1855 patented in Paris by Alphonse Louis Poitevin in which glass (also stone, wood or metal) was coated with a thin layer of gum-bichromated gelatin that was then exposed to sunlight under a negative. The sunlight made the coating insoluble in direct proportion to the amount of light that reached it, and the image was "developed" in warm water. The gelatin film left on the surface was then ink-coated and prints were made in quantity on paper. The essential process was employed into the early years of the twentieth century in the so-called gum print process. (*kolla,* Greek, glue).

contretype negative • A reversed negative, produced on a gelatin dry plate sensitized with bichromate of potash. After it had dried, the plate was exposed under an ordinary negative, then soaked in water containing India ink, which was absorbed by those portions of the gelatin unaffected by light. It produced a duplicate but reversed negative. (*contra,* Latin, opposite).

dusting-on process, *see* **powder process** •

gum print, also **photo-aquatint** • A photograph made by the gum-bichromate process following an adaptation of the Poitevin collotype process.

The print could be made on rough drawing paper with art effects simulating charcoal drawings, and "on-canvas" effects could be obtained by exposing the negative to coarse canvas. The gum print was in vogue at the end of the nineteenth century and during the first years of the twentieth century.

heliotype, *see* **collotype** •

hydrotype • A process in which a translucent image in color is produced on a paper base coated with a bichromated gelatin. When the emulsion is soaked in soluble dye solutions, the dyes are absorbed only in the nonexposed parts. The process was patented by A. H. Cros in France and England in 1889, although it was created in 1881. It led to later dye-related processes.

ink process • A process in which the image was first created by exposing a glass plate coated with gum-bichromated gelatin under a negative. The plate was then immersed in a developer of pyrogallic acid and in sulfate of iron, by which an image in ink was formed.

Leggotype • A photoengraving process developed by William August Leggo and George E. Dasbarats in 1871. An image was printed from a negative on a grained film that was then transferred to stone or zinc for inking. The plate was first used commercially in New York in 1873 for printing a newspaper, the start of commerical photoengraving.

Obernetter's process • A mechanical printing process patented in the U.S. by the German J. B. Obernetter in 1878, in which an invisible or barely visible image on copper is developed by treatment with potassium thiocyanate followed by potassium ferrocyanide. The image is formed of cuprous ferrocyanide. Obernetter was also associated with a photogravure system based on the application of a gelatin positive to a copper plate prior to an etching procedure.

oleography • A transfer of a printed image to paper via greasy inks, suggested by Austrian photographer Emil Gariot in 1866. In the early part of the twentieth century the process was recreated by G. E. Rawlins in England, who manufactured and sold the materials for it.

photo-aquatint, *see* **gum print** •

photo-autocopyist • A simplified on-paper form of the collotype, made without the use of glass plates late in the nineteenth century. The image was printed on a sheet of bichromated parchment paper that was stretched on a frame, treated with a glycerine solution, then inked for letterpress printing.

photoglypty, *see* **Woodburytype** •

photogravure • A broad name for a number of systems for printing halftone illustrations and others that resembled fine copperplate engravings without the need for screening and halftone dots. All of the systems depended on the property of bichromated gelatin or bitumen to become essentially insoluble when exposed to light. In some, a gelatin relief was obtained that was electroplated with copper; in others, such as the Woodburytype, metal molds were made from the relief, which could then be etched and stippled. Issues of *Camera Work* and the Edward S. Curtis series on the North American Indians were created by photogravure, modern versions of the 1852 invention of Fox Talbot and the 1855 patent of Poitevin.

photo-lithography, *see* **algraphy** •

Plumbeotype • A process of 1845–1847, introduced by the American daguerreotypist John Plumbe, Jr. (1811–1857), for etchinglike reproductions of Plumbe gallery daguerreotypes.

Plumbeotypes varied in their style from linelike drawings to detailed multitone etchings, evidently depending on the skill of the studio artist.

Poitevin process • Patented in 1855 by Alphonse Louis Poitevin of France, this was a procedure for creating a relief image on gum-bichromated gelatin, which became insoluble on exposure under a negative to sunlight. The unexposed portions washed away in warm water, leaving a relief image that could be inked for printing on a press. It became the basis for numerous related subsequent printing processes such as the Albertype, the artotype and the Woodburytype. *See also* **Collotype.**

powder process, also **dusting-on process** • An on-paper or on-glass (lantern slide) procedure in which the plate was made tacky with gum arabic or a sugar-based solution and then sensitized with bichromate of potash or ammonia. Under exposure to light, the tackiness diminished in exact proportion to the action of the light. Fine powder of any color was then dusted onto the remaining tacky surface to adhere to areas not acted upon by the light.

stannotype, *see* **Woodburytype** •

Woodburytype, also **photoglypty, stannotype** • A photo-mechanical process of 1866, introduced by Walter Bently Woodbury (1834–

Left: Print drying by air flow in an overhead clip rack, around 1900.
Right: Multilevel apparatus for washing glass plates after processing; around 1900.

1885), which started with a relief image of bichromated gelatin made by sunlight exposure under a negative and developed in warm water. A mold of the contours in the relief was made by forcing a block of lead against the gelatin. Inked jelly was then pressed into the lead mold and paper pressed against the mold to generate a perfect facsimile. Variations in tone were reproduced by proportionate variations in the thickness of the ink deposited on the paper. The process permitted photographs to be reproduced on wood, ivory and glass. In the stannotype tin-foil replaced the lead block to make the master mold. Many stereographs on glass were made by the Woodburytype process between 1870 and 1880. (*stannum*, Latin, tin).

zincography • A process of printing launched in 1859 by experimenter Colonel Henry James to transfer a greasy ink from a bichromated gelatin (or gum) to a zinc plate for printing by the lithographic process. Photozinc plates date to the late 1860s, when they were made for maps, and their use continues to modern times.

V. PHOTOGRAPHIC PROCEDURES RELATED TO ART AND ENGINEERING

anthrakotype	linograph	photoceramics
Breyerotype	linotype	Playertype
ceramic photograph	Manul process	primuline process
catatype (also katatype)	opaline	reflectograph
crystal photograph	opaltype	stamp portraits
diazotype	pannotype	transferotype

anthrakotype • A process for making paper prints with a carbon pigmentary powder. First a sensitized bichromate gelatin surface is exposed under a positive. Then the bichromate is developed in a warm-water bath, the water washing away all the gelatin made soluble by exposure to light. Finally, the surface is dusted with carbon powder, producing a visible image where the carbon adheres to the gelatin remaining. (*anthrakos*, Greek, coal).

atmograph, *see under* **Photographic Processes of Printing and Graphic Arts Fields** •

Breyerotype, also **Manul process, Playertype, reflectograph** • An on-paper procedure invented by Belgian experimenter Albrecht Breyer in 1839. Breyer placed a silver-chloride-sensitized paper in contact with a printed page and then shone a light through the back of the sensitized paper. A negative impression introduced by reflection (hence, reflectograph) showed white lettering on a dark field. The Manul process and the Playertype are later variants.

ceramic photograph • A photographic image placed on ordinary chinaware or porcelain and then covered by a transparent ceramic glaze. The procedure started with a photographic im-age transferred by floating the collodion image from its glass base onto a metal plaque prior to retransfer to the china surface. Repeated coatings with glazes and heat treatments in a furnace were necessary to protect original image and to add various colors on or near the image.

Liébart's enlarging apparatus required direct rays of sun to enter an optical projection system; around 1870.

blueprint, *see* **cyanotype** *under* **Gallery Procedures Based on Paper** •

catatype, also **katatype** • An obscure process in which a developable image was obtained without the aid of light by placing in face-to-face contact a paper soaked in hydrogen peroxide and a silver or platinum image on paper. *(kata,* Greek, down).

crystal photograph • An on-glass process of 1878 in which the photographic image was supported on one side of a fine convex glass lens, sealed by heat treatment under a glaze or other sealant. Its proponents suggested that the glass covering of the photograph was imperishable and that the glass had none of the "blistering" common to varnish-coated photographs (as tintypes). *(crystallum,* Latin, cold, clear).

cyanotype, *see under* **Gallery Procedures Based on Paper** •

diazotype, also **primuline process** • A late nineteenth-century process on paper, silk or other fabric which obtains positive color effects from exposure of a positive onto treated material. The image was created in aniline dyes in various colors. *(diazeutikos,* Greek, disjoining).

ferro-prussiate process, *see* **cyanotype** *under* **Gallery Procedures Based on Paper** •

gum print, *see under* **Photographic Processes of the Printing and Graphic Arts Fields** •

heliotype *see* **bitumen process** *under* **Photographic Processes of the Printing and Graphic Arts Fields** •

linograph, linotype, also **pannotype** • A photograph made on sensitized linen and developed with gallic acid or pyrogallic acid. Discovered by J. Luttgens in Hamburg in 1856. The photographs made on linen were oil-colored and stretched on frames as canvas paintings. *(linium,* Latin, flax, linen; *pannus,* Latin, cloth).

Manul process, *see* **Breyerotype** •

Mariotype, *see under* **Gallery Procedures Based on Paper** •

opaline • A gelatin-soaked photograph squeegeed into optical contact with prepared glass.

The glass generally had beveled edges or else was ornamented with metallic borders and was used for paperweights and decorative furnishings.

opaltype • An on-glass process in which the basic photo support was an opal (milk-white) glass, usually coated with a gelatin-bromide emulsion. This glass plate was exposed from a negative and developed exactly as sensitized paper. The glass was occasionally finished with a polished or ground opal surface for a pleasing matte finish. Such objects were often used as paperweights, tourist memento ashtrays or positive transparencies.

pannotype, *see* **linograph** •

Pellet's process, *see* **cyanotype** *under* **Gallery Procedures Based on Paper** •

photoceramics • A process involving a collodion image treated with gold chloride or platinum chloride and then burned in on enamel in dark shades of color following a process developed by the French photographer Lafon de Camarsac (1821–1905) in 1855. A variety of improvements made possible the reproduction of photographs on various porcelain objects in Czechoslovakia, France, Germany and England by the mid-1860s.

Playertype, *see* **Breyerotype** •

primuline process, *see* **diazotype** •

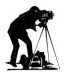

reflectograph, *see* **Breyerotype** •

stamp portraits • An on-paper process that provided gummed paper portraits in quantity of any portrait. These were often made with the special Hyatt camera by copying an existing photograph, following a procedure patented in 1887.

transferotype • An on-paper process by which a bromide print was transferred to opal, wood, ivory, etc., and the paper support later removed to leave the image alone in position. The process depended on first coating the paper to be sensitized with a gelatin coating that could be dissolved away (after the image had been formed) by the application of hot water.

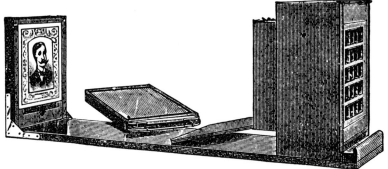

VI. CURIOSA AND NOVELTY PROCESSES

breath printing	microphotograph	stanhope
Hillotype	nature prints	thermography
interference image	sphereotype	tithonotype
(also Lippman process)		

breath printing • A novel discovery of Sir John Herschel, who treated paper in the dark with silver nitrate and ferro-tartaric acid, then exposed it under a negative for thirty seconds to a minute. This produced no visible effect by itself, but an image could be made to appear simply by breathing upon the paper, which was developed solely by the addition of the warm, moist atmosphere.

Hillotype • An 1851 daguerreotype variant, named after experimenter Reverend L. L. Hill of New York, who claimed that he had achieved daguerreotypy in which "all colors of nature are faithfully represented." Hill said he had forty-five specimens and that some had been made by instantaneous exposure. Despite numerous announcements of his "successes," no samples were provided to the waiting public.

interference image, also **Lippman process** • An image formed on a plate exposed through glass with its film touching, and forming one of the sides of a trough of mercury (which acts as a reflector). The rays of light are thrown back on themselves, or "interfered with," and a latent image is formed inside the substance of the sensitive film, which, on development, reproduces the way the waves of light have traveled. The picture in fact consists of a microscopic layer of metallic silver that possesses the property of again arresting and decomposing light in the same way as happened during exposure. The eye sees, in consequence, a photograph in natural colors, and the picture so formed is known as an interference image. A development of Gabriel Lippman (1845–1921).

microphotograph, also **stanhope** • A tiny, usually circular image, less than ⅛ inch set into jewelry, watch fob ornaments, desk items and tourist mementos. The image is viewed in its own integral lens system, a slim glass rod with a lens end that serves as a magnifying glass focused on the positive transparency affixed by balsam cement to the rod end. Often called a stanhope

FIG. 1.—MAGIC CIGAR HOLDER.

FIG. 2.

Magic Cigar Holders.—Some years ago, dealers in tobacco sold cigar or cigarette holders inclosed in cardboard cases in which they were accompanied with a small package of photographic paper, entirely white and about the size of a postage stamp.

These cigarette holders opened at the center like a

FIG. 3.—CIGARETTE HOLDER OPEN.

needle case. Some were so made that the photographic postage stamp was placed externally to the cylindrical part forming the sheath (*b b*); in this case, *b* contained an aperture, *a*, that allowed the smoke to pass. Others, which were simpler and more diverting, opened like the preceding, at the center, but the sheath consisted of a small white glass tube, in the interior of which was placed the loosely rolled little sheet of magic paper.

In both cases, the tobacco smoke comes into contact with the photographic paper. After the smoking was finished, the magic paper showed a portrait or some other image that had developed upon it.

Novelty processes included a preexposed photographic print which was "developed" by the passage of tobacco smoke. *Scientific American* (Sept. 6, 1890).

after Lord Charles Stanhope (1753–1816), who designed the simple lens system.

nature print • Prints made by a variety of procedures dating from Leonardo da Vinci and pursued into the eighteenth century. Leaves and other natural surfaces were printed using smoke, ink, greases, etc., to effect a transfer from the object to the paper.

sphereotype • A positive image on glass named for its spherical appearance after finishing and encasement. The process was patented by Albert Bisbee in the United States in 1856.

stanhope, *see* **microphotograph** •

thermography • A "heat-sketch" (hence, *thermo* plus *graph*) following a now obscure process developed by Moser of Koenigsberg (then Prussian Poland).

tithonotype • A reversed duplicate of a daguerreotype created on a copper plate by an electrotype procedure. (*tithon,* from the legendary Tithonus, a figure symbolizing immortality).

The Stanhope was an optical novelty of the nineteenth century. It had a very small, usually hidden, lens that magnified a tiny image.

ENJALBERT'S PHOTO-REVOLVER

(Fig. 1.—One-half actual size. Fig. 2.—Slightly reduced. Fig. 3.—Sensitive plates—actual size.)

APPENDIX A
Essential Chemistry of the Nineteenth Century

The dominant chemistry of the nineteenth century was the wet-plate process, which was launched during the daguerrean era and which hastened daguerreotypy's end. The invention of collodion provided a medium that would adhere to glass and could absorb light-sensitive chemicals. It set the stage for the ambrotype (on glass), the tintype (on sheet iron) and the making of collodion negatives as a basis for albumen prints.

Four basic chemicals dominated the early photographic field: collodion (essentially a transparent blanket clinging to the glass or metal), silver nitrate (the light-sensitive silver salt), pyrogallic acid (the developing agent) and sodium thiosulfate, or hypo (the fixing agent). Other chemicals added speed to the process, improved tonal relationships or slowed deterioration of the chemicals in the trays. Still others toned the images to colors that some found more pleasing to the eye or in other ways modified the process.

Collodion. Prepared by dissolving pyroxyline in a mixture of alcohol and ether to form a transparent glutinous liquid. When poured onto the photographic glass plate, it formed a highly transparent film as the solvents evaporated. The usual strength was

Alcohol, sp. gr. 725	2½ fluid ounces
Sulfuric ether, sp. gr. 805	5 fluid ounces
Pyroxyline (guncot ton)	60 grains

The alcohol was poured into a large-necked bottle. The guncotton was introduced, the ground-glass stopper replaced and the bottle shaken. Finally, the sulfuric ether was added and the mixture shaken until the guncotton was dissolved. The syrup was allowed to stand for forty-eight hours before it was decanted into a clean, dry bottle.

Silver Nitrate $(AgNO_3)$. Solubility: 100 grains is soluble in 50 drops of distilled water, and the mixture will measure 80 drops. When undistilled water is used, a thick, curdy-white precipitate of carbonate and chloride of silver is formed. For the wet-plate process the collodion-coated glass plate was immersed in a bath of

Silver nitrate	240 grains
Potassium iodide	1 grain
Distilled water	8 ounces

Pyrogallic Acid $(C_6H_6O_3)$. Not in fact an acid, its correct chemical name is pyrogallol ("pyro" to the trade). In the presence of alkalies in solution, it absorbs oxygen from the air, turning black as a carbonate and acetate of the alkali is formed. As it was easily oxidized, a number of preservatives were commonly used, among them a mixture of glycerine and alcohol, metabisulfite of potash, sodium sulfite, citric acid.

A typical pyro-potash developer was

Solution A

Pyro	1 ounce
Sodium sulfite	1 ounce
Distilled water to make	9 ounces

Solution B

Potassium carbonate	1 ounce
Sodium sulfite	1 ounce
Distilled water to make	9 ounces

Equal quantities of solutions A and B were mixed immediately prior to use; the bath was discarded after use.

Sodium Hyposulfite, sodium thiosulfate, hypo ($Na_2S_2O_3 \cdot 5H_2O$). This salt was formed by passing sulfurous acid gas through sodium sulfide until no further precipitation of sulfur occurred. Hypo is soluble in cold water (1:2), in boiling water (1:1) and is insoluble in alcohol. It is important to photography as a solvent for the unacted-upon silver salts. This property was discovered by Sir John Herschel. When a salt of silver is added to sulfite, two salts are formed:

$$AgCl + Na_2S_2O_3 = AgNaS_2O_3 + NaCl$$

Silver chloride + sodium hyposulfite = Double hyposulfite of silver and sodium + sodium chloride

$$2AgCl + 3Na_2S_2O_3 = Ag_2Na_4(S_2O_3)_3 + 2NaCl$$

Silver chloride + sodium hyposulfite = Hyposulfite of sodium and silver + sodium chloride

Photographic negatives were fixed in a bath of

Sodium hyposulfite	4 ounces
Water to make	16 ounces

The dry sodium thiosulfate was generally poured into a pint jar to which warm water (70°F. to 80°F.) was added to fill the container. Experienced operators often worked with two fixing baths, each of the same strength, allowing the negative to be fixed for ten minutes in the first bath and five minutes more in the second bath. Baths weakened with use; one pint was ordinarily sufficient to fix twelve quarter-plate negatives. After the collodion era, alum was added to the hypo bath to harden the gelatin emulsion (which softened during the developing stage). A water wash removed hypo from the fixed negative, lessening the likelihood of a hypo stain in the image.

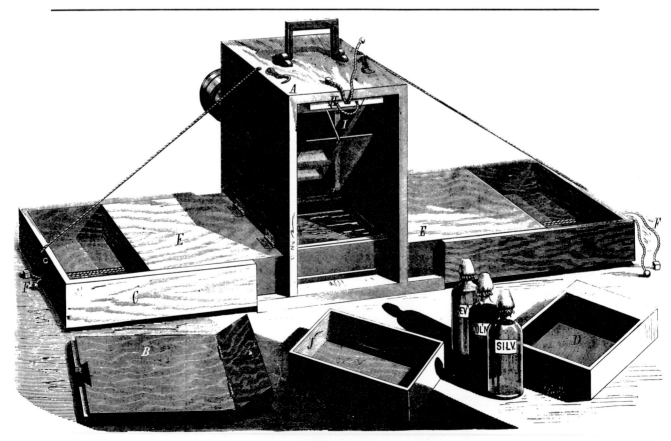

BRICE'S PORTABLE PHOTOGRAPHIC APPARATUS.

APPENDIX B
Making Calotype (Salt Print) Paper

MAKING THE NEGATIVE PAPER

In the nineteenth century a thin paper especially suited to the needs of the photographer was available in sheets 18 by 22 inches, known as *papier saxe*. The paper was finished with one surface smooth and the other slightly matte. The smooth side was coated after it had been cut to sizes appropriate for the plateholder of the camera (most often 6½ by 8½ inches, but also up to 11 by 14 inches).

STEP ONE—(IN ROOM LIGHT)

Ammonium chloride
 (or sodium chloride) 160 grains
Distilled water 16 ounces

Pour enough of this solution into a shallow porcelain tray to fill it to a depth of ½ inch; immerse up to six *papier saxe* sheets, one sheet at a time. When the last sheet has been added, turn the sheets one at a time, then remove them in sequence, hanging each to dry with a paper clip on a line.

STEP TWO—(IN A DARKENED ROOM, BY CANDLELIGHT)

Silver Nitrate
 (crystals) 60 grains
Water 1 ounce

Prepare this solution in sufficient quantity to fill a shallow porcelain tray to a depth of ¼ inch to ½ inch. Take one sheet of the dry salted paper and hold it by its opposite corners, smooth side down. Lower one corner onto the solution and steadily lower the rest of the sheet so that the air is driven out and the entire surface exposed to the action of the silver. When the paper is lowered properly, it will be floating on the solution. It should float for a minimum of two minutes, then it should be carefully raised from the solution and hung to dry in a perfectly dark room.

When the sheet is dry, hang it above a tray of ammonia so that it is exposed to the ammonia fumes for five to ten minutes. Following this ammonia exposure, which increases the sensitivity to light (an optional step), the paper is placed in a plateholder, ready for exposure in a camera.

MAKING THE POSITIVE PRINT PAPER

Paper for the calotype print is readied in two stages.

STEP ONE: IODIZING

The paper is saturated with a solution of

Potassium iodide 20 grains
Distilled water 1 ounce

The paper may be hung to dry in any room.

STEP TWO: SENSITIZATION

The treated paper is taken to a darkened room and made sensitive by a soaking in a bath of

Silver nitrate 20 grains
Glacial acetic acid ½ drachm
Distilled water 1 ounce

This paper is now dried in a dark room.

APPENDIX C
Making Albumen Paper

Albumenized paper, usually created on a thin paper with one smooth side, one matte finish (as *papier saxe*), is made in two steps.

STEP ONE: ALBUMENIZATION

Mix the white of one egg and water in equal parts; add 5 grains of potassium iodide (or sodium chloride) and one ounce of distilled water. Using a brush, coat the paper with this solution. Dry.

STEP TWO: SENSITIZATION (IN A DARKENED ROOM, BY CANDLELIGHT)

Make a bath of

Silver nitrate	120 grains
Distilled water	1 ounce

Immerse the albumenized paper in this solution. Dry in a dark room.

EXPOSURE

Place any developed negative over this paper in sunlight, usually under the weight of glass, for ten to fifteen minutes. After exposure, fix the image in hypo, wash and dry.

READYING ALBUMENIZED GLASS

New glass should first be placed for a few minutes in a nitric acid solution to remove grease and fingerprints

Nitric acid	1 ounces
Water	3 ounces

After three to five minutes in this bath, wash in clear water.

While the glass is still wet, pour upon it a solution of

White of egg	1 ounce
Water	20 ounces

This albumen and water solution should be readied earlier (after it has been beaten thoroughly and the froth has settled, the solution should be filtered).

When the glass has been thoroughly dried, it may be sensitized (in a dark room) in a bath of

Silver nitrate	240 grains
Potassium iodide	1 grain
Water	8 ounces

Processing will be in pyrogallic acid (as in the wet-plate process), followed by fixing in hypo and a water wash.

APPENDIX D
Guide to Sizes of Nineteenth-Century Photographs

During the first twenty years of photography (1840–1860), the daguerrean era and the ambrotype age, the camera retained a basic shape and size, and this determined the size of the finished photograph. The basic camera in its largest (standard) size was the whole-plate camera. Cameras in smaller sizes took smaller photographs, and modifications of some of the smaller cameras permitted the very smallest standard sizes.

Full (whole) plate	6½ by 8½ inches
Half plate	4¼ by 6½ inches
Quarter plate	3¼ by 4¼ inches
One-sixth plate	2¾ by 3¼ inches
One-eighth plate	2⅛ by 3¼ inches
One-sixteenth plate	1⅝ by 2⅛ inches

Standard leather and wood and even molded design cases were made by casemakers to encase the plate, the gilt frame and the protective glass panel.

Beginning with the carte-de-visite (one-sixth plate size), which became a vogue in America starting about 1860, a series of card mounts and ornate metal, wood and glass frames enhanced the appearance of the larger paper photographs. A novel design of the camera's back permitted the largest camera to take the smallest photographs—and any of the larger standard sizes as well.

The most popular mount sizes were:

Carte-de-visite	4¼ by 2½ inches
Cabinet card	6½ by 4½ inches
Victoria	5 by 3¼ inches
Promenade	7 by 4 inches
Boudoir	8½ by 5¼ inches
Imperial	9⅞ by 6⅞ inches
Panel	8¼ by 4 inches
Stereograph	3 by 7 inches

PHOTOGRAPHIC TRICYCLE.

APPENDIX E
**Photographic Sensitivity and Exposures
of the Nineteenth Century**

	Year	Exposure
Engraving with bitumen (Niépce)	1826	6 hours
Daguerreotypy with silver iodide	1839	30 minutes
Talbotype with gallic acid developer	1841	3 minutes
Wet-plate (collodion) process	1851	10 seconds
Collodion silver bromide emulsion	1864	15 seconds
Gelatin silver bromide (dry plate)	1878	1/200 second
Gelatin silver bromide (improved dry plate)	1900	1/1000 second

APPENDIX F
Revenue Stamps on Ferrotypes, Cartes-de-Visite and Stereographs

As part of the effort by the Congress to fund the Civil War, among a number of taxes levied was an 1864 Act which provided that sellers of photographs affix stamps at the time of sale, to "photographs, ambrotypes, daguerreotypes, or any sun pictures," according to the following schedule, exempting photographs too small for the stamp to be affixed:

Less than 25 cents:
2 cents
25 to 50 cents:
3 cents
50 cents to one dollar:
5 cents
More than one dollar:
5 cents for each additional dollar or fraction thereof.

Stamps were applied from August 1, 1864, to August 1, 1866.

Photographers of the period affixed either the *Internal Revenue* or the *Proprietary* stamp, but since the law required only that a stamp of the appropriate denomination be so affixed, some photographers used *Express* and even *Bank Check* stamps on photographs. Blue *Playing Card* stamps are known to have been used in the summer of 1866 as other stamps were unavailable as the levy came to an end. The stamp was to be canceled in the original Act by requiring that the seller cancel the stamp by initialing and dating it in ink. At least one photographer, Abraham Bogardus of New York, canceled stamps of his gallery's cartes with a specially made hand stamp.

During the two-year period, countless tens of thousands of photographs datable to the period were stamped. Twenty different stamps with values of 3 cents or less, and seven 5-cent were issued in that period, none specifically for the photographic trade's tax.

The following denominations, types and colors have been found:

1-cent stamps red.
Express; Playing Cards; Proprietary and Telegraph.

2-cent stamps blue.
Bank Check; Certificate; Express; Playing Cards; and Proprietary (ultramarine).

2-cent stamps orange.
Bank Check; Certificate; Express; Playing Cards; Proprietary and Internal Revenue.

3-cent stamps green.
Foreign Exchange; Playing Cards; Proprietary and Telegraph.

5-cent stamps red.
Agreement; Certificate; Express; Foreign Exchange; Inland Exchange; Playing Cards and Proprietary.

According to values set by numismatic experts, as evidenced by values set for these stamps in Scott's *Specialized Catalog of United States Stamps,* the most rare of all of these stamps is the 1-cent "Playing Cards" and the most common is the orange 2-cent "Playing Cards." Values for all of these stamps appear in the Scott and other numismatic catalogs.

176/

BIBLIOGRAPHY

Andrews, Ralph W. *Picture Gallery Pioneers, 1850 to 1875*. New York, Crown, 1964.

Darrah, William Culp. *Stereo Views*. Gettysburg, Pa., Times and News Publishing, 1964.

Darrah, William Culp. *The World of Stereographs*. Gettysburg, Pa., William C. Culp, 1977.

Estabrooke, Edward M. *The Ferrotype and How to Make It*. Cincinnati, Ohio, Gatchel & Hyatt, 1872.

Gernsheim, Helmut and Alison. *The History of Photography, 1685–1914*. New York, McGraw-Hill, 1969.

Gilbert, George. *Photographic Advertising from A to Z*. Vols. I, II, III. New York, Yesterdays Cameras, 1970, 1974, 1976.

Gilbert George. *Collecting Photographica*. New York, Hawthorn Books, 1976.

Horan, James D. *Mathew Brady, Historian with a Camera*. New York, Crown, 1955.

Meredith, Roy. *Mr. Lincoln's Camera Man, Mathew B. Brady*. 2nd revised edition. New York, Dover, 1974.

Naef, Weston, in collaboration with James N. Wood. *Era of Exploration*. New York, Albright-Knox Art Gallery and Metropolitan Museum of Art, 1975.

Newhall, Beaumont. *The Daguerreotype in America*. New York, New York Graphic Society, 1961.

Newhall, Beaumont. *The History of Photography*. New York, Museum of Modern Art, 1964.

Root, Marcus Aurelius. *The Camera and the Pencil, or The Heliographic Art*. New York, Appleton, 1864.

Taft, Robert. *Photography and the American Scene*. New York, Dover, 1964 (reprint of 1938 edition).

Wall, Edward J. *Wall's Dictionary of Photography*. 16th edition. London, Illiffe & Sons, 1941.

A PICTURE FOR THE INTEMPERATE.
PHOTOGRAPHER. "Now, Sir, step in and have your Likeness taken. It might be useful to your Family!"

INDEX

CREDITS

The author is indebted to a number of curators, researchers, librarians and amateur and professional collectors of images in five countries and in universities, public libraries, research archives and historical societies for the photographs and illustrations assembled to illustrate this work. We sought and received special permission to take photographs in the Museum of the City of New York and in the homes of leading collectors in New York, New Jersey and Connecticut.

The special courtesies provided at the Library of Congress and at the National Archives, Washington, D.C., were invaluable in locating materials which proved to be of special interest.

We are grateful to Cliff Krainik of Illinois for his cooperation in providing valuable material relating to the John Plumbe historical materials which one day will be the basis for his own book on this major figure in America's earliest days in the burgeoning photographic era.

The members of the Photographic Historical Society of New York, Inc., were especially patient in accepting requests for privately held materials never before published until this work and special thanks are offered to Harry Amdur, Grete Mannheim, Keith de Lellis and Alfred Lowenherz. The encouragement of Matthew R. Isenberg of Connecticut and Jerome and Shirley Sprung of New Jersey has been a special source of pleasure to the author. Upstate New Yorkers N. M. Graver and Leon and Hilde Jacobson were never too busy to respond to inquiries by phone or mail.

AD Andrew Daneman, Los Angeles, Calif.
A-G-F Agfa-Gevaert-Fotomuseum, Germany
AH American Hurrah Antiques, New York, N.Y.
A/HW Allen and Hilary Weiner, New York, N.Y.
AL Alfred Lowenherz, Long Island City, N.Y.
BLUofC Bancroft Library, University of California, Berkeley, Calif.
C/MK Cliff and Michele Krainik, Arlington Heights, Ill.

DPLWC Denver Public Library Western Collection, Denver, Colo.
GG George Gilbert, Riverdale, N.Y. (author)
GH George Hart, Cortland, Ohio.
GM Grete Mannheim, Brooklyn, N.Y.
HA Harry Amdur, Ridgewood, N.J.
HS Het Sterckshof Museum, Belgium
HSh H. Shaviv, London, England
IMP/GEH International Museum of Photography at George Eastman House, Rochester, N.Y.
JC John Craig, Norfolk, Conn.
J/SS Jerome and Shirley Sprung, Teaneck, N.J.
KdeL Keith de Lellis, Queens, N.Y.
L/HJ Leon and Hilde Jacobson, Syracuse, N.Y.
LofC Library of Congress, Washington, D.C.
MCUofO Moorehouse Collection, University of Oregon Library
MG Martin Gordon, Inc., New York, N.Y.
MoHS Missouri Historical Society
MRI Matthew R. Isenberg, Hadlyme, Conn.
MusCNY Museum of the City of New York, New York, N.Y.
NatA National Archives, Washington, D.C.
NMG Nicholas M. Graver, Rochester, N.Y.
N-YHS New-York Historical Society, New York, N.Y.
NYPL New York Public Library, New York, N.Y.
PK Pearl Korn, Riverdale, N.Y.
PKap Philip Kaplan, Long Island City, N.Y.
RAV Rocco A. Verilli, Longmeadow, Mass.
RR Richard Russack, Fremont, N.H.
SCP Society of California Pioneers, San Francisco, Calif.
SG Sharon Goffe, Miami, Fla.
SHSC State Historical Society of Colorado, Denver, Colo.
SI Smithsonian Institution, Washington, D.C.
SM Science Museum, London, England
SOSH Southern Oregon Historical Society, Jacksonville, Oreg.
ST *Sunday Telegraph,* London, England
TWMcGLibr,UofVa Tracy W. McGregor Library, University of Virginia, Charlottesville, Va.